second edition

Non-Western Art
A Brief Guide

Lynn Mackenzie

College of DuPage

Upper Saddle River, New Jersey 07458

Library of Congress Cataloging-in-Publication Data

Mackenzie, Lynn.
 Non-Western art: a brief guide / Lynn Mackenzie.—2nd ed.
 p. cm.
 Includes bibliographical references and index.
 ISBN 0-13-900036-4
 1. Art—History. I. Title.
 N5300 .M23 2001
 709—dc21 99-086441

For Kate

Publisher: *Bud Therien*
Assistant editor: *Kimberly Chastain*
Editorial assistant: *Wendy Yurash*
Production editor: *Judy Winthrop*
Director photo research: *Melinda Reo*
Photo researcher: *Barbara Scotts*
Prepress and manufacturing buyer: *Sherry Lewis*
Copy editor: *Cheryl Smith*
Cover design: *Bruce Kenselaar*

 © 2001, 1995 by Prentice-Hall, Inc.
A Division of Pearson Education
Upper Saddle River, New Jersey 07458

This book was set in 10/12 Palatino
by Carlisle Communications and was printed and bound by Phoenix Color Corp.
The cover was printed by Phoenix Color Corp.

Printed in the United States of America
10 9 8 7 6 5

ISBN 0-13-900036-4

PRENTICE-HALL INTERNATIONAL (UK) LIMITED, *London*
PRENTICE-HALL OF AUSTRALIA PTY. LIMITED, *Sydney*
PRENTICE-HALL CANADA INC., *Toronto*
PRENTICE-HALL HISPANOAMERICANA, S.A., *Mexico*
PRENTICE-HALL OF INDIA PRIVATE LIMITED, *New Delhi*
PRENTICE-HALL OF JAPAN, INC., *Tokyo*
PRENTICE-HALL ASIA PTE. LTD., *Singapore*
EDITORA PRENTICE-HALL DO BRASIL, LTDA., *Rio de Janeiro*

Contents

Preface

Five years ago I composed a slim volume to address a specific need in art history. It had puzzled me to find no textbook on Non-Western art in an academic environment where global studies were at a premium. *Non-Western Art: A Brief Guide* was my first, hesitant attempt to design a publication for a topic we were mandated to teach, although from the beginning we all were unclear on exactly what we were to teach. Needless to say, I welcomed Prentice Hall's invitation to rewrite the text for a second edition, to reconfigure material, correct factual mistakes, and add topics and images. While changing neither the audience nor the goals of the 1995 edition, I have tried to improve the quality of the text to facilitate the learning process and foster a greater appreciation for the topic.

The material following this Preface has been written for students and represents what I, having taught Non-Western art for over a decade and art history for twenty-five years, feel we reasonably can expect a college student in an introductory course to know. It is a primary text for one-semester and one-quarter college-level courses in Non-Western art, Advanced Placement Art History in high schools, and a supplemental text for Non-Western humanities and history courses with strong visual components. Whether one reads this book because it is required or because of personal interest, it will function as a handbook for a first encounter with an immensely varied, complex, and fascinating topic. Although small, the book is intended to give an enormous topic direction, organization, and emphasis. It consolidates a vast amount of information—usually found scattered about in libraries, on bookstore shelves, and just about anywhere in art history survey textbooks—into a portable, affordable guide to Non-Western art.

The approach—a chronological survey of art and architecture—organizes material by geographic regions beginning in Africa, moving east to Asia and the islands, and crossing the Pacific to the Americas. This traditional art history format was chosen over a topical approach because I feel it is important to reinforce the fact that Non-Western cultures *have* histories, that known events occurred, important people with names lived, and the arts changed through time. A chronological survey orders unfamiliar material in a familiar way and permits valid comparisons. Only China breaks the mold a bit because readers can become mired in the dynastic sequences and lose sight of the art. The book is about art and is written in the language of art. It is not a history book or an anthropology book or a religious studies book. Time is spent describing individual works so readers will have grounding for articulation and evaluation in the visual arts. Driving the text is my firm belief that cultures are encoded in art. Because art makes ideas and values visible, the context of each work is developed with material on religion, philosophy, social structure, and historical events. Where possible, the works were selected from American museums to underscore the fact these objects are accessible although no longer in their original contexts.

Having devoted years to this material, both in personal research and talking through ideas with colleagues and in the public forum of the classroom, I have come to sense themes that make the material manageable, intelligible, and memorable. I write this statement knowing full well that the problems with teaching Non-Western art are legion. No one wants to touch it because too much material is covered and nothing can be developed in depth. On this point I offer the words of Chacoan specialist Stephen Lekson, who wrote that selection involves weeding *and* pruning. We, as educators, are charged with determining what is worth knowing as well as the depth to which knowing should be taken in an introductory course. Topics can be added and others expanded. We all have our specialties and presenting them to students only enriches their education and makes their encounter with us unique. Any text merely provides a platform or a foil for our own views and experiential resources. For example, to the reviewer who requested the addition of Laplander art, I would recommend outside readings to augment this intriguing subject. When covering the Asante, I always include kente cloth, although you never would know it from this text. Sometimes I begin the course with Chapter 7 (the Americas), other times with Chapter 1 (Africa), and occasionally I use Chapter 6 (Oceania) for the Introduction. Flexibility is the key. Start with your strength.

Others shy away from teaching Non-Western because the names are unfamiliar, difficult to pronounce. And tied to the problem of foreign words is the reality that the subjects themselves are "foreign" to those of us who have had a classical Western education. Two thoughts on this issue: First, no one person can know the artistic, religious, social, philosophical, historical, etc. nuances of all these cultures. It is an impossible and unreasonable expecta-

tion. Unfortunately, the most difficult sentence for a professor to utter in public is "I DON'T KNOW." Confucius offers all of us who stand with our backs to the screen a liberating strategy with the following advice from the *Analects:* "Shall I teach you what knowledge is? When you know a thing, maintain you know it, and when you do not, acknowledge it. That is knowledge." (I am quite sure he was talking about "expertise.") The second thought on this issue of foreign pertains to our obligation in higher education. Equipping students with a basic understanding of Non-Western cultures will spare them the anxieties we suffer now when eventually they take our places. I truly believe it will cease being a problem in a generation.

Finally, others will not teach Non-Western because they argue the topic is invalid and "Non-Western" creates the notion of "The Other" by lumping together cultures that share nothing. These are major issues, and ones which cannot be addressed in a preface, although the situation is pitiful, indeed, if we are shackled by inherited methodologies. I always have been dissatisfied with the term "Non-Western" but do not feel the term has pejorative implications. The subject reflects our awareness of the richness of world cultures, even if a satisfactory word has yet to be coined.

And to these ends, this text has been rewritten for clarity, accuracy, and readability. As many changes were made in response to students' questions as to reviewers' questions. Because students were asking for clarification on the same topics (Who *was* the Sixth Patriarch?), I assumed the questions were being raised elsewhere. Errors were corrected, some my misunderstandings and others in light of recent findings. Professors who disagree with information, analyses, or interpretations should use the text as a foil. With the classroom mantra "But the book says. . . . " students place a textbook on par with the Gospels, but one of the thrills of teaching has always been to be wiser than the text. All chapters have new material, notably Africa and the Americas. And as disappointed as some will be, I am still unable to harness enough marble horses from ancient Greece to drag Egypt out of Africa. Hopefully, the nine maps are welcome additions and will help secure cultures in space. The bibliographies were expanded and placed at the end of each chapter to encourage readers to purse the topics and to provide students with a starting point for research papers. Reviewers prompted the inclusion of study and discussion questions, and while I resisted my editor on this point, I now recognize them as valuable tools in the learning process. To the Glossary have been added general art terms, such as "abstraction" and "realism," to provide a common language. They are more than adjectives; they are at the core of image making and art analysis.

Turning to the mechanical aspects of the publication, a few remarks on usage may be helpful. In descriptions of works of art, "right" and "left" refer to the right and left sides of illustrations. Chinese words are pinyin and diacritical marks have been added for Spanish words. Only one date indicator is used, BCE (meaning "Before Common Era" and corresponding to BC, meaning

"Before Christ"). A date in the Common Era (corresponding to AD, meaning *Anno Domini,* or "The Year of Our Lord") has no prefix. Although "a little pretentious and a little too 'politically correct' " for some (quote from *Cahokian*), it is concise and it works. For sites and cultures with contested dates and for cultures beginning and ending at different times in different regions, a slash separates the earliest and latest possible dates (1000/500 BCE-200/600).

In conclusion, pages could be filled with the names of people who contributed to this project. Regrettably, I do not know the names of many who provided invaluable assistance. A note of thanks is due the vanload of women who picked me up at North Rim Overlook on the frightful road up to Mesa Verde and to Ranger Sherrie who helped me break into my car to retrieve the keys locked inside. At Chichén Itzá, thanks to the white-haired man who helped me count backwards from 365 in Spanish after my backpack shifted and I froze on top El Castillo. Thanks also to the eagle-eyed proofreaders at Prentice Hall for their thoroughness, and to the reviewers across the country for their comments and suggestions. Others I can thank directly. At Prentice Hall, for their persistence, insistence, and patience, Bud Therien, Publisher Art, Humanities and Social Sciences, and Kimberly Chastain, Assistant Editor Art and Music; also, Production Editor, Judith Winthrop, to whom goes all the credit for the look of the book you hold. Among my colleagues, special thanks to Misty Sheehan, Associate Professor of Humanities at College of DuPage, for her insight on Asian cultures, and to a cenote of information on Mesoamerica, Jeff Kowalski, Professor of Art History at Northern Illinois University. Also at College of DuPage, thanks to Ed Kies, Dean of Liberal Arts, and Ed Storke, Associate Dean. In Louisiana, to Robert Connolly, then Station Archaeologist at Poverty Point, for opening the resources of that vast site to me; and at Watson Brake, to Joe Saunders, Regional Archaeologist stationed at University Louisiana at Monroe, and Reca Jones, who first mapped the site, for the same opportunities there. I would like readers to know the monuments they curate figure much larger in the story of world culture than the space I could give them in the text. From among the thousands and thousands of students whose ideas have shaped this book, and in a very real sense, who I am, I single out Corinne Louw, who helped structure many of the questions at the end of each chapter and suggested the expanded glossary; she is one of the people who will take our place. And finally, love and gratitude to my parents, Helen and Eric Yaeger, and, as always, to Kate.

Lynn Mackenzie
Glen Ellyn, Illinois

Introduction

Picture yourself on a tour through an American museum that takes pride in its collection of world art. Some people in our group will marvel at an artist's technical ability to transform white marble into flesh or to maneuver oil paint into an illusion of miles. Many will feel comfortable in corridors where angels materialize on canvas, while others will be drawn to galleries where portraits of doe-eyed children share wall space with narrow tables overflowing with fruit and dead deer. Then we approach rooms where cases are filled with statues of four-headed men, ten-armed women, and blocks of wood bristling with nails. In these rooms paintings stand free of the wall, zigzagging out to intrude into our space; around the corner, gnarly old vessels sit on the floor, exposed like so many stones on the beach. At this point the group's expectations may be challenged by objects whose images, materials, and functions seem to have few counterparts in the previous galleries. We have entered a world where a different visual language is spoken.

Collectively these works have been categorized under the heading "Non-Western," a less-than-satisfactory term-of-convenience for all the world's artistic traditions that have matured independently of the "Western" tradition, which began in Greece, was adopted in Europe, and finally shipped to the Americas. Non-Western art flourished in Africa, Asia, and the Americas. By colonization, conquest, or commercial exchange with the West, some Non-Western cultures were modified or eliminated. Others are living traditions.

Non-Western objects that Western audiences are now inclined to label "works of art" fulfilled several often overlapping and interrelated functions for the people who made and first used them. One function can be identified as *art for intervention*. With sacred objects, people could tap the powers of

unseen forces by providing repositories for extra-natural entities, as well as bridges to other dimensions of existence. Usually, access to these objects was restricted, and encounters were rapturous. Many works had no living human audience because they were sealed in tombs for the dead to use, or they were enshrined in the dark for a deity's enjoyment. A second function is *art for affiliation*. Claims to lineage, membership in fellowships, and, most importantly, the right to rule, were validated by the possession and public display of art. People fashioned objects, buildings, and environments to organize themselves within the community. Third is *art for documentation*. Accounts of creation and migration, the adventures of deities, culture heroes, and civic or military leaders, as well as momentous events—real or contrived—were components of the communal past recorded in art. Documentary art preserved a people's history, but it rarely found time to tell stories of laborers' lives. Finally, there is *art for aesthetic contemplation*. Objects and settings could stimulate the appreciation of beauty by appealing to the audience's sensitive temperament. Art could be personally enjoyable and environmentally enhancing.

This last intention for Non-Western art comes closest to the prevailing Western attitude toward art. In nearly all instances, however, the museum setting providing the aesthetic experience for Western audiences is foreign to the traditions that produced the objects. In the original context the opportunity to experience art was a privilege, as was the right to its possession. Occasions for the display of art were mysterious and celebratory. Rarely was the experience informal, like our tour of the galleries. Viewing art was regulated by age, gender, social class, and level of initiation. Commissioning art depended on status, and making art was usually a hereditary profession. Art was neither democratic nor casual in Non-Western communities.

When we experience works in a museum, on the other hand, our responses are tempered by the silent setting as we examine inert, isolated objects once activated by motion and augmented with sound, intentionally disposable objects, and objects we never would have seen had we lived in the communities where they had been created. While specialists bemoan these barriers, any knowledgeable viewer can overcome the artificiality of a museum setting. To the museum we owe the opportunity to experience the variety of world cultures.

Whether created in first-century China or twenty-first-century Chicago, art is a storehouse of experiences. Art speaks about relations—the individual to the community, the community to the environment, the seen world to the unseen world. Art is about people, the choices they have made and their attitudes toward life. What has motivated people? What was worth their time and resources? Whom did they revere? What did they fear? Spending time with art provides insight.

FOR DISCUSSION AND REVIEW

1. What does "Non-Western" mean? What were your first thoughts on its meaning? Is it a negative term? A separatist term? Any alternative suggestions?

2. What basic functions can art fulfill? In Non-Western contexts? In Western contexts? What are the advantages and disadvantages of exhibiting Non-Western art in a Western museum? Have you ever visited a museum specifically to look at Non-Western art? Why or why not?

3. Return to these questions at the conclusion of your Non-Western studies. Any changes in your responses?

FOR FURTHER READING

Barker, Emma, ed., *Contemporary Cultures of Display*. New Haven and London: Yale University Press with The Open University, 1999.

King, Catherine, ed., *Views of Difference: Different Views of Art*. New Haven and London: Yale University Press with The Open University, 1999.

Messenger, Phyllis M., ed., *The Ethics of Collecting Cultural Property. Whose Culture? Whose Property?* Albuquerque: University of New Mexico Press, 1999.

1

Africa

To begin an appreciation of African art we might compare its complexity to the physical character of the continent itself. Variety in style and purpose should be expected from the arts created across a land so vast the United States would fit comfortably in its Sahara Desert with room to spare on both sides. Africa's contrasting terrain—over one-quarter desert and about one-tenth dense rainforest—is a metaphor for the stylistic extremes to be found in its art. Sometimes we confront a near-speaking likeness, and at other times a face may be so far removed from the physical world it clearly records pure idea. African artists could recreate the look of the natural world or endow the supernatural world with physical form. Realistic images exist alongside those with purified, amplified, and reassembled natural clues.

When taking a wide temporal and spatial sweep across the history of African art, it becomes clear that the continental vision has tended toward abstraction. Two factors account for the predominantly abstract quality. First, only what is relevant to the meaning of the work is included; incidental information is eliminated, and significant aspects of the subject are emphasized. Second, images combine aspects from different, often unrelated, subjects. The quality of one subject, such as an animal, can be transferred to another subject, a person, by combining visual clues from each. In this way a statement on the character of the subject is made, rather than a record of its external appearance.

As abstraction has been the major style, the human figure has been the principal image in African art. Sculpture is seen as the major medium, primarily because the survival rate of fiber arts, painting, and architecture in perishable materials is poor. Small-scale statues in wood, clay, and metal are prevalent, while monumental stone sculpture is a regional expression.

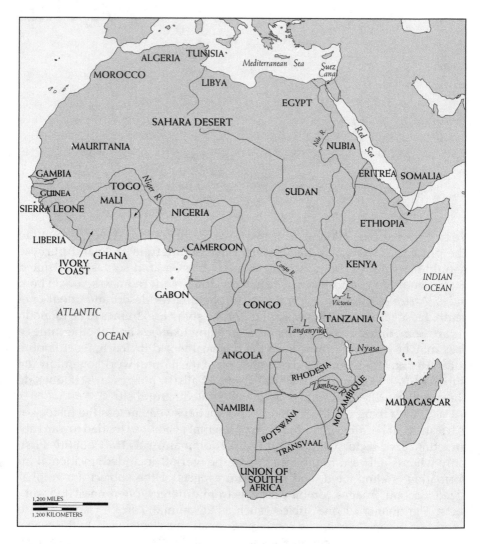

Colonial Africa, ca. 1914

Works of art served many purposes in Africa, depending on the special needs of the people who commissioned them, but in general, they assisted in maintaining the physical and spiritual well-being of the community. Art helped organize society and solve its problems. Specially crafted prestige items with restricted ownership identified elite groups. When art functioned as a sign of social distinction, the display of certain objects could indicate kinship, political rank, or economic success. Groups with restricted membership possessed their distinctive objects, which others were not permitted to see. Some objects made political statements on the power of the governing institution, while others addressed people's day-to-day problems by connecting with an unseen audience of spirits who could provide solutions. These invisible entities—the forces of nature and the spirits of the dead—interacted with the community and were capable of intervening or offering advice. The perspective is based on the belief that dynamic energies, which roam freely, can be made to occupy inanimate objects, such as stones or statues, where their knowledge or assistance is elicited. Because the dead are perceived to be immediate and especially powerful, the theme of ancestral spirits is important in African art.

Our final general observation on African art concerns the people who made the objects in this chapter. For cultures known only through the archaeological record, such as Nok, Ife, and Jenne, little is understood about an artist's position. In historically known kingdoms such as Benin, we know that metalsmiths were held in high regard and lived in prestigious districts near the king's palace. In other kingdoms, such as the Asante, Yoruba, Luba, and Kuba, the profession of artist was esteemed and hereditary. Being creative was a requisite of Kuba divine kingship, and several Kuba kings are known to have been artists. Among the most revered people in a Dogon village is the blacksmith, who is also the woodcarver. In Senufo villages, where woodcarvers, blacksmiths, and ceramists have been treated with respectful contempt, artists live apart from the rest of the village or they are itinerant. While some communities have ostracized artists because of their perceived magical powers, the Luba encouraged individuals with physical deformities to become artists because their abnormalities indicated a closeness to the spirit world. A Yoruba sculptor serves an apprenticeship to learn the mechanics of his craft, while a Senufo apprentice is taught symbolism, as well as the many ritual taboos of his profession.

Few artists' names can be assigned to old objects any longer, although they would have been well-known in their communities. When names have been forgotten, scholars have attempted to attribute groups of works to individuals, such as the Luba sculptor nicknamed the Master of the Cascading Coiffure, based on consistent style. Some artists, notably the early twentieth-century Yoruba sculptor Olowe of Ise, acquired regional and international reputations.

Our brief survey of African art is divided chronologically into three periods, the Ancient, the Medieval, and the Colonial. Themes to consider through the sections include the relation between men and women as an expression of social ideals; the pose, posture, and proportions of the human body as a statement of physical and moral ideals; animal symbolism as a statement of political and ritual power; the functional and aesthetic implications of materials and surface treatments; and the use of objects to assist the interaction between spiritual and physical domains.

ANCIENT

Ten thousand years ago Africans were painting and pecking pictures on rock surfaces in the Sahara Desert. While they appear to document a semi-sedentary lifeway based on raising cattle and a culture with ritual costumes and ceremonies, none among the tens of thousands of recorded pictures has an inscription to explain its meaning or purpose. Nevertheless, rock art offers a tantalizing if enigmatic pictorial account of the organization and belief systems of early African communities.

Nilotic Cultures

We must turn east to the Nile Valley for surviving evidence of Africa's earliest complex civilizations, the *Nilotic cultures.* In the future, other civilizations of great antiquity might be rediscovered on the continent, but Africa's climate has not been sympathetic to the preservation of objects and buildings. Political instability and hostile terrain have also impeded investigations in many areas.

Ancient Egypt. The modern North African country of Egypt was home to the longest-lived Nilotic culture. Throughout their three thousand years of political and cultural autonomy (ca. 3100 to 30 BCE), ancient Egyptians expended exceptional energies on the creation of works to aggrandize divine kings (the *pharaoh*) and to enable earth-bound spirits of the dead (the *ka*) to thrive in a life after death.

As repositories for the ancestors' vital spirits, mortuary statues were lively entities; they were activated by incantations, dressed, fed, and sealed in tomb chambers (the *serdab*) where they could watch the living without themselves being seen. The statue of Old Kingdom (ca. 2700–2180 BCE) pharaoh *Menkaure* (in Greek, *Mycerinus*) and his senior wife and principal queen *Khamerernebty* (Fig. 1) was recovered from a temple near his tomb, the last of the three Great Pyramids built at Giza. The image exemplifies the classic ancient Egyptian interpretation of the human body, with an anatomical stylization created by generalizing natural elements to abstract geometric units. For example, the queen is constructed of cylinders and spheres, while her hard-edged husband is given squares for knees and sharp-cornered flat

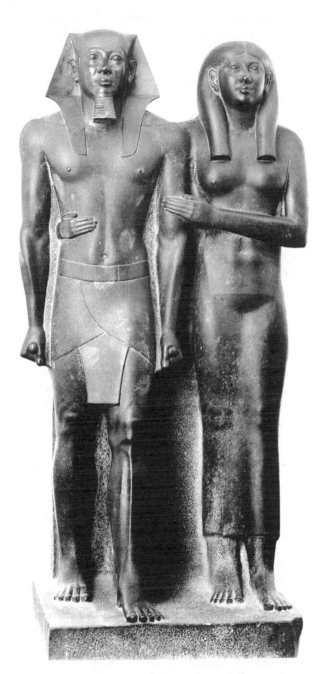

Figure 1 Nilotic (Egypt; Old Kingdom, ca. 2700–2180 BCE; Fourth Dynasty, ca. 2615–2500 BCE). Menkaure and Khamerernebty, ca. 2520 BCE; slate; H. 56″ (142 cm). Courtesy, Museum of Fine Arts, Boston. Fund Howard/MFA Excavations. No. 11.738

planes for calves. Tempered by plausible anatomical details which tend, on a first inspection of the statue, to mask the abstraction, the meaningful geometric shapes—angular for the man and round for the woman—have been assembled into an ideal rendition of ageless people at the prime of life. In addition to the abstract rendering of the body, the statue illustrates another aesthetic sensibility, which persisted in subsequent continental art: the design principles of *symmetry* and *frontality* communicating attitudes of composure and control. In this particular statue a balanced composition isolates the man from the woman. However, the design suggests equality between the two because the sculptor took liberties with the traditional presentation of women, who ordinarily are shown appreciably smaller than men and posed with both feet together. With visual understatement the statue underscores the important role played by the senior wife and the *queen-mother* (the woman who has borne the reigning king) in African politics.

In ancient Egypt, as well as later cultures on the continent, tradition was prized; change rarely was pursued aggressively. Artists were taught correct presentation and symbolism, and we can assume they did not seek to be conspicuously different from their instructors. Nilotic patrons expected time-tested good art, not novel art.

When circumstances were more conducive to innovation, ancient continental artists were sensitive to the nuances of personality and individual appearance. The *Amarna period* (1378–1362 BCE) was a brief moment in ancient Egyptian history when the exploration of these avenues enjoyed official endorsement. The new artistic vision, sponsored by the pharaoh *Akhenaten,* is evident in the ebony head representing his mother, *Queen Tiy* (Fig. 2). The physical and psychological realism of the Amarna attitude defines the little sculpture. By fusing the regal manner of Khamerernebty with the visual reality of a mature woman, the sculptor created an imposing image with a psychological impact exceeding its small size. The aggressively chiseled drooping mouth and heavy eyelids contribute to the statue's expressive quality, as well as adding a note of honesty that idealism would not permit. The original function of the statue is unknown, although we may speculate it was a token from mother to son, perhaps a momento like a locket, or a talisman to transfer the power of the resourceful woman to her physically and politically ailing son. The innovations of the Amarna period did not outlast the pharaoh and his mother, however, and after Akhenaten's death Egyptian art resumed its conservative tone for the next thirteen hundred years.

Kingdoms of Kush. Other Nilotic civilizations, referred to collectively as the *Kingdoms of Kush,* were located south of Egypt in *Nubia,* a geographical and cultural area in Sudan. The Kushite kings who came to rule their imposing northern neighbors from 730/712 to 664 BCE (the *Twenty-fifth dynasty*) considered themselves legitimate heirs to Egypt's throne, rather than usurpers.

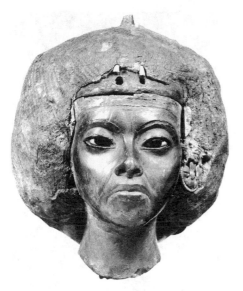

Figure 2 Nilotic (Egypt; New Kingdom, ca. 2133–1786 BCE; Amarna period, ca. 1378–1362 BCE). Queen Tiy, ca. 1375 BCE; ebony, lapis lazuli, gold, mud, wax, paint; H. 3 3/4" (9.5 cm). Egyptian Museum, Berlin. No. 14145

The Nubians' admiration for Egyptian culture is evident in the portrait sphinx (Fig. 3) of the fourth Kushite pharaoh, *Taharqa* (died 664 BCE). Drawing inspiration from monumental public statues such as the Great Sphinx at Giza, the Kushite artist interpreted ancient Egyptian models from his cultural perspective. Ethnicity and heightened abstraction, coupled with regionally specific symbols of authority, notably the double-cobra diadem, set the Kushite sphinx apart from Egyptian prototypes. For example, when considering Taharqa's profile it is apparent that the nose and mouth have been carved to the same plane of the stone block, flattening the face so the jaw and chin square the contour into a fleshy cube. The lion's mane is integrated into the composition as a circular sweep of radiating lines framing the face. The Kushite interpretation of the sphinx communicates a sense of self-satisfaction while retaining the implication of human intelligence united with animal strength. The relation between people and nature is a recurring theme in African art, as is the use of animal attributes—the lion's physical beauty and regal bearing in this instance—to visualize human qualities or aspects of a public office.

Nok

On the opposite side of the continent, in the modern country of Nigeria, the *Nok* culture flourished for at least seven hundred years (500 BCE to 200).

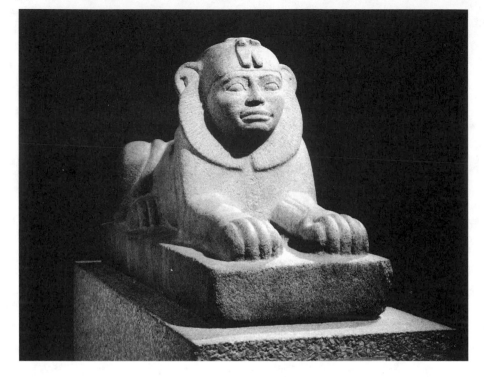

Figure 3 Nilotic (Kushite; Twenty-fifth dynasty, 730/712–664 BCE). Taharqa Sphinx, ca. 680 BCE; granite; H. 16 1/2" (42 cm). British Museum, London. EA 1770

Presently it is identified as the oldest artistic tradition in West Africa, although the sophisticated style suggests the remains of its predecessors have yet to be discovered. Little is known about the people who created the ceramic head (Fig. 4), other than that they were skilled farmers and ironworkers whose history, social organization, and belief systems are still points of conjecture.

Nok figures were handbuilt of fine red clay with incised, modeled, appliquéd, and stamped details; pupils and nostrils were punched through the clay wall to help with firing. Most represent people, probably distinguished individuals or the ancestral dead, and animals, particularly snakes. Usually only the heads, some nearly life-size, survive. Our example possesses the elongated face and compact silhouette characteristic of the Nok style. Oversized eyes defined with appliquéd clay lines dominate the hollow, cylindrical head. Also consistent with a Nok-style eye treatment is the lower rim connecting with arched brows to form an oval, which the lid bisects. The facial hair, known to indicate an elder in later West African art, may identify this man as an important individual in Nok society. With an economy of means, the Nok ceramist endowed the figure with dignity and wisdom commensurate with a person of authority.

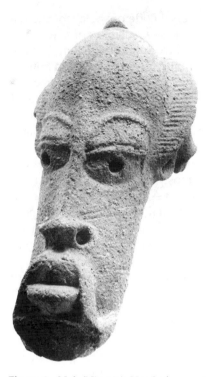

Figure 4 Nok (Nigeria). Head of a man, 500 BCE–200; ceramic. © Werner Forman Archive/Art Resource, NY. Jos Museum, Nigeria

MEDIEVAL

During the thousand years of the Medieval period, Africa experienced the founding and flowering of its wealthiest and most culturally effectual kingdoms. From the eighth through the early nineteenth centuries, a cosmopolitan air pervaded culture on the continent. In every sense, it was Africa's Golden Age. Economic prosperity, made possible by international trade, encouraged the production of the visual arts. Commodities exchanged in the commercial network included ivory, tin, salt, furs, and people, but the gold trade was the economic mainstay during this time. In the world of medieval African commerce, merchants in Mali negotiated between the gold procurers south of the Sahara and the gold consumers to the north and east. Goods bound for export were transported by camel caravans across the desert to the new city of Cairo. Many merchants were *Muslims* (followers of Islam), and their religion became synonymous with wealth, prestige, and education.

Islamic Architecture

The Medieval period in Africa commenced with the arrival of *Islam* in the seventh century. Founded by the Prophet, Muhammad (meaning "Praise-worthy" in Arabic; d. 632), Islam brought unifying elements to the

continent, including the religion itself, a universal code of social conduct, a single written language, and scholarship. Of course, social codes, writing, and learning had existed in Africa prior to the introduction of Islam, but the new religion established a cultural commonality that had not existed before. With Islam came an aversion to three-dimensional representations of the human figure, as well as an architectural style of arches and two-dimensional nonrepresentational decorations.

The center of life in an Islamic region was the *mosque*, the public place of worship where Muslims offered prayers to *Allah* (meaning "God" in Arabic) five times a day. A mosque unified the community through personal veneration performed publicly. Constructing a mosque, often adjacent to the main marketplace, in a newly converted region of Africa was as much a political as a spiritual statement because it was a visual affirmation of the people's affiliation with the international community of Islam. Close ties with the Near East encouraged the development of a classic Islamic style, especially in North Africa.

A typical mosque is a somewhat rectangular building where prayers are recited in an interior, open-air courtyard. The essential components of a mosque are few. Each has a fountain or pool where Muslims wash before praying, as a gesture of respect, and a decorated niche (*mihrab*) in the *qibla*, the wall closest to Mecca, to orient prayers to the holy city. The *muezzin* (crier) announces the prayer hours from the calling tower (*minaret*), the spiral structure topped by a domed kiosk (pavilion) in the center of Figure 5.

Among the world's oldest and finest mosques is the Great Mosque in Cairo (Fig. 5). Pointed arches and recessed lobed roundels, both motifs anticipating architectural elements in later European Gothic design, are characteristic of the style. *Compass-work* on the *soffits* (underside of the arches) reveals the complexity of Islamic surface design. The placement of intersecting lines, incised in stucco, is as structured as a geometry formula. In Islamic design, precision and balance represent Allah's divinely ordered universe, and stylized plants allude to the beauties of Paradise awaiting a Muslim after death. Islam's *aniconic* perspective, prohibiting anthropomorphic representations, caused artists to think in new directions. Intricate patterns, often incorporating texts from the holy scripture of Islam, the *Qur'an*, offered an alternative to figural art and became a strength of Islamic aesthetics. With its predisposition for flat, overall pattern, Islamic art added a nonrepresentational counterpoint to Africa's figural tradition, enriching ceramics, fiber arts, and sculpture regardless of the patron's religious affiliation.

A different aesthetic interpretation of the mosque was present in Mali, where the building was conceived as flowing sculpture. The organic shapes seem to rise from the savanna like wind-abraded rock formations, the hard-edged geometry of traditional Islamic architecture having given way to a free-form design where the standard vocabulary of column, arch, and dome is out of place. Clay, the material used for public and residential architecture across

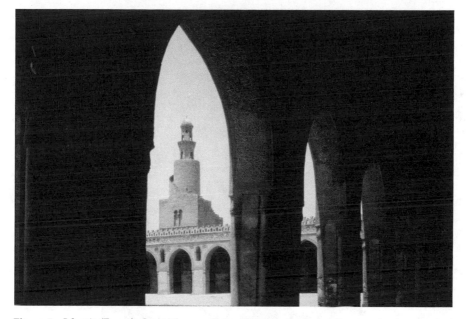

Figure 5 Islamic (Egypt). Great Mosque, Cairo, 876–79; view across courtyard, minaret in distance. R. and S. Michaud/Woodfin Camp and Associates, 1983

the continent, was smoothed over walls constructed of torpedo-shaped, sun-dried bricks. Bright lights play off plain surfaces bristling with exposed rafters and the permanent wooden scaffolding (*torons*) used as ladders for the frequent repairs clay buildings require. Tall projecting buttresses, another functional component of a thick-walled clay building, add to the distinctive appearance of a sub-Saharan mosque.

These features are evident in the Friday Mosque (Fig. 6), the main mosque in the Malian city of Mopti. Only an important urban center had a *Friday mosque,* the building made larger-than-normal to accommodate a city's male population when it assembled for the weekly sermon following noon prayers on Friday. Mopti was prosperous because it was situated at the crossroads of international African trade, on the confluence of the Bani and Niger rivers. Travel along the natural water highways in and around the inland island city expedited trade in textiles, cotton, rice, millet, and the medieval staple—gold—in Mopti's famous marketplace.

Jenne

The extent to which pre-Islamic traditions remained viable in medieval Africa depended on the attitudes of local rulers. People in some sub-Saharan cities were Muslim, but they also retained old beliefs, ceremonialism, and, especially, reverence for the ancestors. As a result, hybrid practices and art

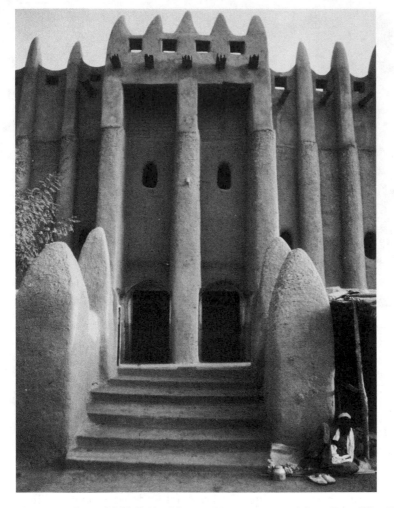

Figure 6 Islamic (Mali). Friday Mosque, Mopti; entrance. © Betty Press/Woodfin
Camp and Associates

forms emerged in several regions. Where it was perceived that Islamic pre-
cepts were being enforced too strictly, people relocated. Other communities
remained independent of Islamic cultural influence, although they main-
tained commercial links.

An example of a figural statue created in Africa's Islamic heartland is
the large fragment of a kneeling figure with coiled snakes (Fig. 7). It is attrib-
uted to a cultural tradition that flourished in Mali on the bow of the Niger
River from at least 300 BCE through the seventeenth century. The corpus of
clay statues, dated from the eleventh through the fourteenth centuries, is re-

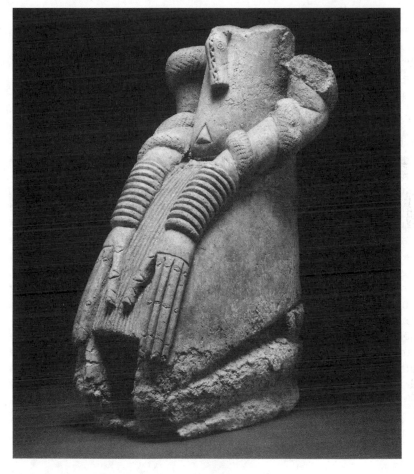

Figure 7 Jenne, also Inland Niger Delta (Mali). Kneeling figure with snakes, eleventh–fourteenth centuries; terra cotta; 18 3/4″ (47.6 cm) × 9 1/4″ (23.5 cm) × 12″ (30.5 cm). Courtesy of The Art Institute of Chicago. Maurice D. Galleher, Ada Turnbull Hertle, and Laura R. Magnuson Funds (1983.917). Photograph © 2000, The Art Institute of Chicago. All rights reserved

ferred to as the *Inland Niger Delta style* or the *Jenne style*, after the abandoned city of *Jenne-Jeno* (old Jenne), where many examples have been found in the foundations and walls of medieval buildings. More Jenne images have been unearthed by looters than archaeologists, so we lack the reliable context necessary for a reasonable reconstruction of their original meaning and purpose. Possibly they were household shrine images depicting ancestors, entities in the local cosmology, or reenactments of ritual activities; possibly they had mortuary or commemorative associations. The ritual overtones of poses and accouterments suggest that the people who made and used the statues chose

to remain outside the Islamic religious sphere. However, they certainly had close ties with Muslim merchants because Jenne-Jeno was a major urban center, trading with the principal city in the region, *Timbuktu*, and Mopti, located only fifty miles to the north.

The solid terra cotta figure is an assemblage of two flexible cylinders affixed to a heavy, brick-like, wedge of a body. The elongated fingers with articulated joints and nails are characteristic of sculpture from the region, as is the inclusion of snakes. In this example, the visual rhythm established by the serpents looping around each arm—themselves rolled like big, fat snakes—accelerates in the circle of bracelets. The jewelry, presumably socially defining, is similar to the objects of personal adornment, cast in copper alloys and gold, that have been recovered from ruins in the vicinity of Jenne-Jeno. Thin, deeply incised fingers flowing into the garment's shallow grooves continue the integration of form through process. Using the most basic tools—hands and a sharp stick—the artist rolled, incised, and punctated the clay to create an image with a rich surface treatment and smooth geometric shapes. From surviving intact clay figures we can imagine a restoration with an extruded, wedge-shaped mouth and telescoping eyes on a flat, oval, upward-tilting face. Jenne faces resemble masks, suggesting the figures may represent ritual impersonators, such as priests performing in a ceremony.

The serpent-head pendant completes the image. A motif appearing in many African visual and oral traditions, the snake was a rainmaker to some and to others a kingmaker who designated the heir with its touch. Because a snake sheds its skin, it was associated with new life, the ancestors, and the changing seasons. Often linked with women, it carried implications of fertility, perhaps as a life-sustaining earth deity and, according to regional stories, virgins sacrificed to appease serpent-spirits.

Ife

Of all the non-Islamic city-states founded by the Yoruba-speaking people during the Medieval period, *Ife* was the most spiritually, politically, and culturally influential. It was the center of the world and the place where humans had been created. As the site where the gods had instituted divinely ordained kingship, Ife remained the city from which kings of smaller southern Nigerian states received their authority long after it lost political control of the region.

Early twentieth-century scholars attributed Ife sculpture to Greek and European artists because its naturalistic style and technical sophistication did not conform to prevailing perceptions of African art. Subsequent research has shown that African artists created the clay and cast brass statues to glorify and memorialize the divine kings of Ife (the *oni*) and members of the palace circle. Specialists in West African art also propose links between the Nok and Ife traditions.

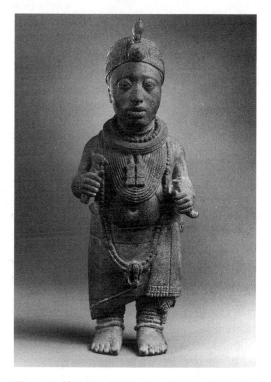

Figure 8 Ife (Nigeria). Standing Oni, early fourteenth–early fifteenth centuries; brass;
H. 18 1/2" (47.1 cm). The National Commission for Museums and Monuments,
Museum of Ife, Nigeria. © Dirk Bakker 1980

 Had Ife art been known only by its life-size portrait heads, we would be
left with the impression that the artists had made faithful copies of reality.
However, Ife artists tempered visual realism with meaningful abstraction to
create works addressing the nature of divine kingship. This perspective is ap-
parent in a full-length brass statue depicting a standing oni (Fig. 8). The pro-
portion of head to body states a fundamental principle of African art and cos-
mology, that one's destiny resides in the head. The head is emphasized
because it is the seat of a person's intelligence and character. The oni's ideal-
ized face is a reflection of his "inner head" (*ore inu*), rather than his physical
appearance. His fleshy body, with its corpulent stomach and fat-folds under
the chin, indicates health and physical well-being. He is perfect in body,
mind, and spirit because he directs the destiny of all his subjects. An impas-
sive attitude, a frontal pose, and the symmetric composition express the re-
strained vitality of a god-man.
 Aspects of this particular brass statue—the beaded cloth scepter, the
ram's horn containing ritually potent substances, the close-fitting beaded

crown with braided rosette and pompon, and the many pieces of jewelry—
have led to the interpretation that it is a coronation image. When an oni died,
statues were placed in shrines where the reigning oni could consult his an-
cestors. The statues also documented the royal lineage by reinforcing oral his-
tories with visual images, a function for art in many communities in the Me-
dieval and subsequent Colonial periods.

Benin

Shortly before 1300 a prince of Ife, named *Oranmiyan,* subdued Edo-
speaking chiefs who had been ruling a region in southern Nigeria for four
hundred years. He founded a new city about one hundred miles from his
home and named the newly acquired territory *ibini.* By the seventeenth cen-
tury the city of *Benin* boasted a population of about fifty thousand elite resi-
dents. So impressed was a Dutch traveler to Benin that he declared the me-
tropolis to be cleaner and more beautiful than any in Holland. The kingdom
of Benin was militarily and economically aggressive; by trading directly with
Europeans Benin maneuvered itself into position to reduce the surrounding
Yoruba city-states to tribute-paying satellites. Benin prospered until 1897,
when a gross misunderstanding with the British resulted in the city being
burned to the ground, the government disbanded, and all the works of art
seized and shipped to London for public auction.

The kingdom's strength resided in the *oba,* the divine king whose magi-
cal powers enabled him to link directly with the spirit world. Benin art was as-
sociated exclusively with the oba and his court. His weighty costumes of coral
beads, brass bells, and ivory belt masks gave him a supernatural appearance,
as did the ritual paraphernalia used in renewing ceremonies. Other objects,
such as brass heads crowned by carved ivory tusks, were placed on com-
memorative altars to memorialize deceased obas and to provide the reigning
oba with access to their knowledge. With a symbolic language of disembod-
ied human hands and elephant trunks, crocodiles, snakes, mudfish, long-
beaked "birds of prophecy," and ethnically specific Europeans—to mention
only a few—Benin art spoke in veiled terms of the oba's secret powers.

The long galleries and spacious apartments in the oba's walled palace,
located in the heart of the city, provided the setting for this elaborate state-
craft. Its wooden columns were covered with rectangular brass plaques,
about nine hundred of which have survived. The plaque in Figure 9 records
an oba in procession, one of the rare occasions when he appeared in public.
His close-fitting crown and layered necklaces are made of coral, the exclusive
property of the oba. Coral symbolizes wealth, because of its association with
the sea deity *Olokun,* and the oba's right to take human life, because of its
bloody color. He and his attendants wear leopard-face masks attached to
their belts. The leopard, another politically restricted symbol, was the oba's
imperial counterpart in the animal kingdom. He rides a horse, an animal as-
sociated with military strength, political supremacy, and material affluence in

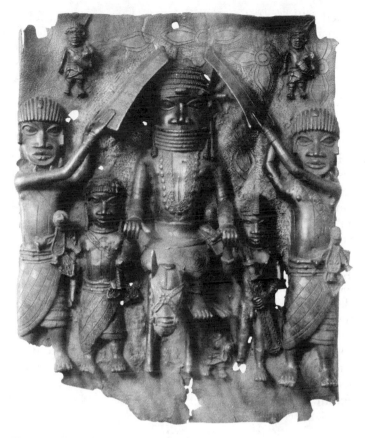

Figure 9 Benin (Nigeria). Oba and Attendants, ca. 1550–1680; brass; H. 19 1/2″ (49.5 cm). The Metropolitan Museum of Art, New York. The Michael C. Rockefeller Memorial Collection. Gift of Nelson A. Rockefeller, 1978 (1978.412.309). Photo, Charles Uht

African art from the time of Islam's arrival. Two attendants shield him with fans, while a pair of court pages, the sons of local chiefs, hold his hands. Frequently, Benin art shows two men stabilizing the oba to represent that, despite all his power, he relies on the support of his subordinates. Superior size, central location, and elevated position signal the oba's importance in Benin society. Graduated size, from the small, floating soldiers to the large, grounded oba, means rank rather than distance.

Benin art synthesizes the two medieval traditions we have seen, the naturalistic Ife and the geometric Islamic styles. The 1:4 ratio of head to body is identical to the oni of Ife and carries the same associations of destiny. However, the stocky Benin body forgoes the anatomical definition of its predecessor. The decorative background, present on many plaques, provides a linear foil to the boldly projecting figures cast in high relief. The pattern of four-lobed

river leaves, associated with medicinal substances and the water world of Olokun, is less rigid than the Islamic architectural reliefs it resembles.

Benin art is a living tradition, and an oba resides in the capital city today. Many works we will see from the Colonial period grew out of older medieval heritages and continue today, in a form modified from when the kingdoms were politically viable.

COLONIAL

While the mechanisms of colonialism had been set in place earlier, the Colonial period was clearly demarcated by 1885 when, at an international conference in Berlin, delegates from European nations officially divided the African continent among the interested European parties. As foreign presence encroached on traditional social structures and belief systems, artists continued creating objects that both upheld the old ways and further defined African aesthetics. Many forms of prestige art were made to identify the socially elite and to glorify the politically powerless kings. Others served the private needs of less socially distinguished individuals or the public needs of the community at large. In all instances, sculpture from the late nineteenth through the mid-twentieth centuries possesses the formal abstraction and spiritual essence we have come to anticipate in African art.

Figures by West African Asante and Yoruba sculptors introduce us to the range of abstraction in Colonial period African art. The portable wooden statues share an identical subject, the infant, but their appearances and purposes are quite different.

Asante

The Akan-speaking *Asante* people of southern Ghana consolidated a culturally influential gold-trading kingdom in the early eighteenth century. Many objects created by the carvers, weavers, and metalsmiths were, and continue to be, publicly displayed emblems whose ownership is confined to the politically powerful and socially elite. The Asante state has been governed by kings of divine descent, who rule with advice from a council of regional chiefs. Gold-covered stools, staves, and umbrellas are only a few among many prestige items in Asante high society. Prestige objects tend to be nonrepresentational, with a pattern aesthetic overlaid on traditional utilitarian objects, a result of Muslim-dominated commerce in the early years of the kingdom.

An *akuaba* (Fig. 10), on the other hand, is an unassuming wooden statue designed for private use. A woman would carry an akuaba in her clothing in hopes of giving birth to a beautiful child. She would care for it until her own child was born, at which time it could be given to a shrine as a gesture of gratitude. Neither a spirit nor a "fertility goddess," an akuaba is best described

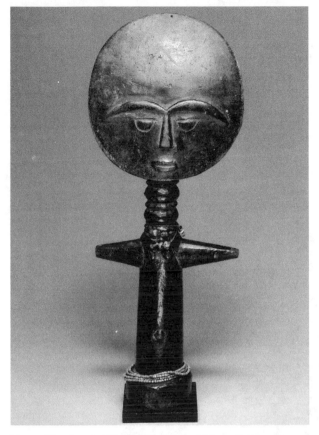

Figure 10 Asante (Ghana). Akuaba, mid-twentieth century; wood, glass beads, string; 10 3/8" (26.3 cm) × 4" (20.1 cm) × 1 7/8" (4.6 cm). Courtesy of The Art Institute of Chicago. Gift of Gwendolyn Miller and Herbert Baker (1963.850). Photograph © 2000, The Art Institute of Chicago. All rights reserved

as a good luck charm. An akuaba is recognized by its large discoidal head and cylindrical body with tiny limbs extended in expectation. Facial features, clustered in the lower half of the face, are balanced against the broad flat forehead. Eyebrows connect with the fine-line nose to create a flower-petal motif above the closed mouth. Fat-folds and a shiny, blackened surface indicate physical well-being; in other words, the child is desirably pudgy, and her glowing skin radiates health. An akuaba is always female because lineage, property, and political office pass through women in the matrilineal Asante society. Expressively, the statue is a lyrical interpretation of the perfect baby, and although described by one art historian as "rather mediocre," its whimsical innocence captures the essence of any mother's dream for a healthy, well-behaved child.

Yoruba

The Yoruba *ere ibeji* (Fig. 11) is associated with death rather than birth. A vessel for the spirit of a deceased twin baby, the statue was dressed, fed, and kept indefinitely by its mother. The Yoruba respect and fear twins because they are considered to be powerful spirits. By having the ere ibeji participate in all family activities as if it were a living person, the privileges enjoyed by the living twin also continue for the dead twin in the statue. Without it the dead twin would feel neglected, tormenting the parents and enticing the surviving twin to join it in death. A *diviner* (ritual specialist) prescribes an

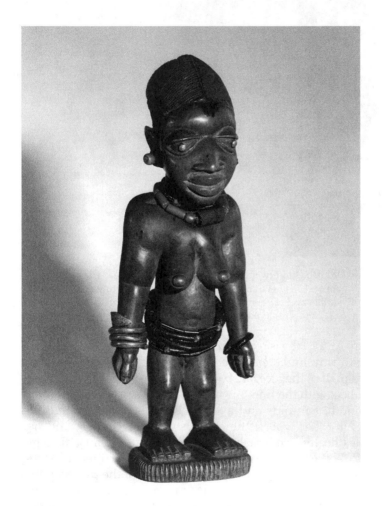

Figure 11 Yoruba (Nigeria). Ere ibeji, before 1877; painted wood, metal, coral; H. 10″ (25.4 cm). Linden Museum, Stuttgart. Photo, Frank Willett

ere ibeji, or two if both twins have died, which the mother purchases from a display in the marketplace. The baby "arrives" after the diviner has performed ceremonies to make the statue real. From a human perspective, the mother can come to cope with the loss of a child by tending the statue, knowing it still needs her.

Although more volumetric than the severely geometric Asante baby, the Yoruba interpretation of the baby is not visually realistic, but it is conceptually logical. For example, the adult body with child-like proportions makes an appropriate container for the enduring spirit because it would not want to remain an infant forever. It is also considered physically appealing because, according to the Yoruba, maturity is beautiful. Other features, notably the large, protruding eyes with half-closed lids and the full, smiling mouth, are general characteristics of the Yoruba art style. The facial treatment recalls Nok ceramics, and the stocky proportions are adapted from Ife and Benin brasses, all earlier traditions in the same region.

Yoruba-speaking people live in cities, some with populations in the hundreds of thousands, in southwestern Nigeria and the Republic of Benin. They are organized in city-states, each governed by a divine king, who traces his ancestry to the oni of Ife, and a council of elders, which functions as a countercheck to the king. Metalsmiths and woodcarvers also create objects to identify and celebrate the two political entities.

Inside a Yoruba king's palace were courtyards and audience halls where dignitaries were received. The king (the *ogoga*) of the city of Ikere commissioned **Olowe of Ise** (ca. 1875–1938) to design wooden posts for the veranda of his audience hall. The center post (Fig. 12) shows the king and symbols of his power. The chair signals his authority, and the crown validates his right to rule. By legend, the founder of Ife gave each of his sixteen sons a conical crown (*ade*). Modeled after the mythical prototypes, the intricately beaded examples of African fiber arts worn by Yoruba kings are the foremost symbol of royal power in Yorubaland. The faces on the crown are said to represent the founder of Ife, *Odudua,* as well as *Eshu,* the Yoruba trickster god (an *orisha*) of fate, who is also the messenger to the spirit world. The bird represents the occult powers of old women (the *iyami*), without whose cooperation, the Yoruba say, a king could not survive. Dominating the composition is the imposing senior wife, the individual who crowns the king at his coronation and controls the state treasury. Auxiliary figures include a kneeling junior wife and a flute-playing attendant who announces the king to the guests. In this monumental architectural sculpture Olowe combined intricate surface details with complex shape–space interactions to visualize the concept of dependent power.

Senufo

Under pressure from Islam the *Senufo* people immigrated to their present homeland in Ivory Coast from the Inland Niger Delta some three hundred years ago. As might be expected, their sculpture resembles the figural traditions

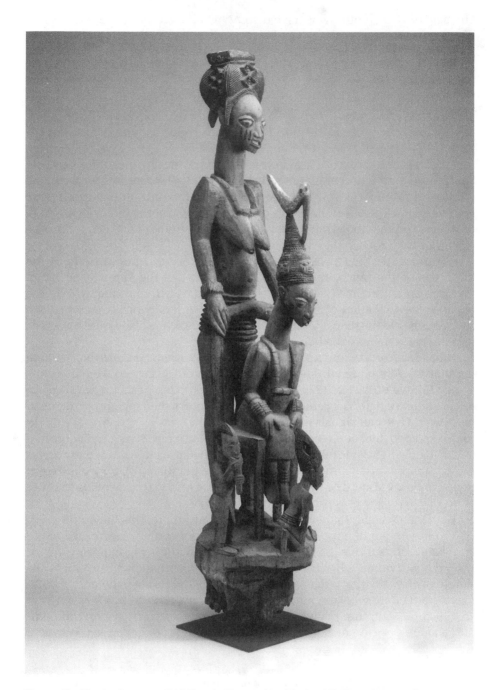

Figure 12 Yoruba (Nigeria, Ekiti, Ikere). Olowe of Ise (died 1938). Veranda post of an enthroned king (Opo Ogoga), from the palace of the Ogoga of Ikere, 1910–14; wood, pigment; 60″ (152.5 cm) × 12 1/2″ (31.74 cm) × 16 (40.6 cm). Courtesy of The Art Institute of Chicago. Major Acquisitions Centennial Fund (1984.550). Photograph by Bob Hashimoto. Photograph © 2000, The Art Institute of Chicago. All rights reserved

of medieval Jenne, as well as the Colonial period Dogon people (discussed shortly), who also emigrated from the Inland Niger Delta in the late fifteenth or early sixteenth century. The Senufo share the Yorubas' awe of twin births, but they have an entirely different social and political structure.

Organized by gender and age, the Senufo create art primarily as an adjunct to their gender-exclusive sociopolitical associations called *poro* and *sandogo*. Poro is the men's association, and sandogo is the women's. Through the associations, which are found in many West African communities, Senufo males and females receive training in gender-specific tasks and an education in gender-exclusive ritual information. People are taught to be responsible contributing members of society as they learn the rights and obligations of men and women. They become civilized, which makes them human beings. Without initiation into one's respective association, a Senufo is not a person. Although restricted by gender, poro and sandogo are complementary and mutually sustaining. For example, the leader of a poro association is always the oldest woman in sandogo.

People in a Senufo village live and work in separate, enclosed, kinship-defined districts. Sanctuaries in the districts include shrines, divination huts, and a sacred grove where poro activities take place. Each district has its own branch of poro, but like sandogo, loyalty to the association transcends that to family, district, or village.

A spiritual dimension of poro is represented on the prestigious wooden door in Figure 13. In this world of ideas, spatial perspective shifts between aerial and profile views, and shapes relate to groundlines only when compositional divisions produce them naturally. In the upper compartment, which is the poro time–space zone, armed equestrians salute a *kpele* mask, worn during poro initiations and funeral ceremonies. Representing a beautiful woman, the distinctive mask is recognized by antelope horns, flanges and limb-like appendages on the sides of the face, an elongated nose-and-eyebrow unit, and a small rectangular mouth with visible teeth. By wearing masks embodying the female ideal, poro members reaffirm ties with the Ancient Woman, foremost spirit-being in the matrilineal Senufo society. The men also draw on the strength of women, who, with exclusive rights to *divination,* have learned from sandogo the secrets of negotiating in the dangerous zone between spirit and human worlds.

The threshold between the two worlds is represented in the middle and bottom compartments. The configuration of four arched lines in the middle, miniaturized as its own center, is interpreted as a diagram of the Senufo cosmos. The cross-hatched background in this area is carried over to the reptilian skin of the crocodile below, characteristically shown with human hands. The crocodile, which functions as a protector, holds in its mouth a snake, the messenger to the spirit world. Especially important in Senufo art and cosmology is the hornbill, shown in the center compartment and in the top corners of the upper compartment, where they float above flat-topped pyramids resembling

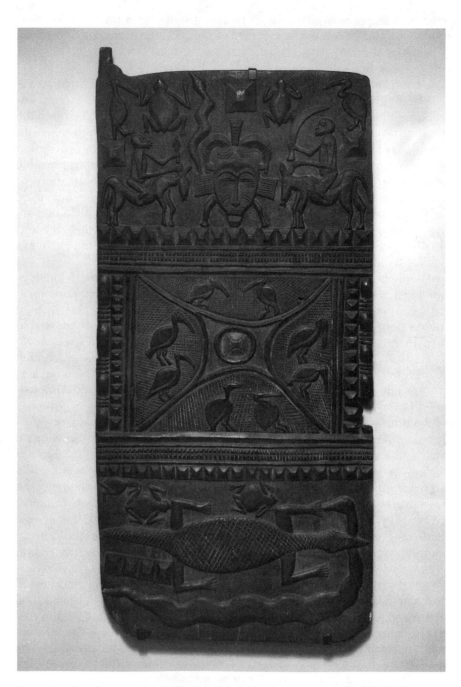

Figure 13 Senufo (Ivory Coast). Door, mid-twentieth century; wood; 53 3/4" (136.5 cm) × 25 1/2" (64.7 cm) × 1 1/2" (3.8 cm). Courtesy of The Art Institute of Chicago. Restricted gifts of Anita Glaze, Marshall Field, and Robert J. Hall; through prior gifts and acquisitions of various donors (1992.732). Photograph © 2000, The Art Institute of Chicago. All rights reserved

clay altars in sacred poro groves. Because of its peculiar nesting habits the bird symbolizes the diviner, who penetrates the spirit world. Called the "first ancestor" and the "mother of the poro child" (the initiate), the hornbill was present at creation, along with the crocodile, snake, chameleon, and turtle. Together they represent animals with the special abilities to move between land, water, and air.

Baule

The Akan-speaking *Baule* people reside in villages of a few hundred in central Ivory Coast. Oral histories describe their descent from an Asante princess, who left Ghana to marry among the Senufo. Baule art borrowed from the Senufo style, as well as the tradition of prestige items, such as gold and stools, from the Asante. In the gender-coded Baule society, women perform a sacred dance, which men may not see, and men possess sacred masks, which women may not see.

Two types of wooden sculpture, both single figures rendered standing or sitting, are nearly identical in form and posture. The surface textures provide the only clue to the statues' very different purposes. One type (*asye usu*), which houses a troublesome nature spirit, is encrusted with sacrificial matter; the other, a *spirit spouse,* has a smooth, oiled surface.

The Baule spirit-spouse statue is a personal object. An individual's intimate companion, the statue represents the husband or wife whom the Baule believe every person has had in the spirit world before birth. A spirit spouse becomes jealous when it sees its lover with a human spouse; it feels betrayed and may act vengefully, causing emotional or physical suffering for its earth-locked partner. To remedy the problem—infertility, for example—the individual consults a diviner, who diagnoses the ailment as the vindictive act of a spirit spouse whose feelings have been hurt by the woman's infidelity with her earthly husband. The diviner prescribes a wooden statue, a husband (*blolo bian*) for a woman and a wife (*blolo bla*) for a man. To convince the spirit spouse it is still loved, the owner lavishes attention on the statue, tending it privately in the bedroom where it is only accidentally seen by another person. A spirit spouse is a confidant, someone to be devoted to, someone who shares private thoughts and appreciates what is done for it. A lifelong personal commitment is made to the statue because in a Baule household one may neither display nor neglect "the art."

Spirit-spouse statues represent the ideal partner. Proportions, pose, and details are the visual codes for physical, social, and moral perfection. The seated blolo bian (Fig. 14) is a Baule woman's dream man. The stool indicates that he is a successful and respected man in society. The high forehead and the beard signify his intelligence and maturity, respectively. Beautifully carved hair, which curls outward in a delicate tail on this example, is another indication of his prosperity because he has leisure time to devote to his personal appearance. It also shows he is loved because someone has cared

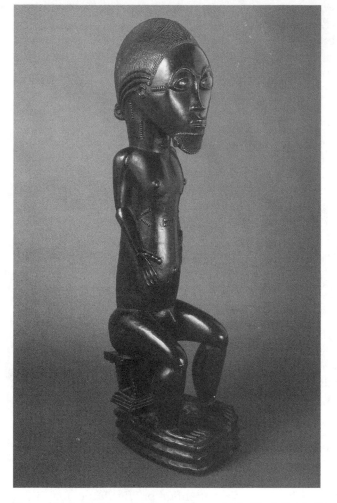

Figure 14 Baule (Ivory Coast). Seated man (blolo bian), first half twentieth century; hardwood with shiny black patina; H. 24.8″ (63 cm). © Phototheque des Musees de la Ville de Paris. Photo: Delaire Neg. 85MAR0584VA2

enough to attend to the tedious task of braiding. The smooth glowing surface, which has been oiled and massaged by the owner, indicates he is in excellent health, with nourishing food and ample water for drinking and bathing. The line of the body, with a columnar torso expanding to thick thighs and calves, is considered highly attractive. Flexed legs, characteristic of seated and standing figures in Baule art, suggest latent strength. Straight arms and delicate hands, which express calmness, reinforce the figure's dignified yet distant attitude. In his original context he would have been clothed, as were all Baule figural statues.

Dogon

Sculpture created by *Dogon* artists is as austere as the uncompromising terrain in which the people live. Since the late fifteenth century they have been building villages of cubical houses and cylindrical granaries on the barren cliffs and dry plains near the Niger River in Mali. In their age-grade, patrilineal society the Dogon have used figural statues as altars, prestige items on buildings, objects for funeral celebrations, and educational tools.

Possibly the wooden statue of a seated couple (Fig. 15) was a shrine image used as a visual aid and a teacher's prompt during the long lectures in Dogon cosmology that children received before their rites of passage. Using selective abstraction and a minimalist approach, the artist summarized one episode in the Dogon creation story. The large figures are said to represent the first parents, by analogy only with Biblical creation accounts, the Dogon Adam and Eve. To emphasize the theme, the man places one hand on his genitals, as the progenitor, and the other on his wife's breast, to indicate she is the nurturer. Dogon statues frequently depict kneeling women with both hands resting on their thighs, like the Jenne statues. In this work her vertically positioned limbs mark the Dogon feminine number, four, while the male's three vertical limbs count the masculine number. According to the Dogon, the stool is a metaphor for the universe, with the seat representing the heavens, the base the earth, and the center post the cosmic *World Tree* connecting the zones. The small flexed-leg figures represent the four sets of twins born to the ancestral couple.

The lean Dogon figures were conceived in clarified segments with twig-like limbs, pellet-shaped hands and feet, and tubular bodies we might describe as bony but not skeletal. As ancestral beings, both have breasts and protruding navels with radiating scarification patterns. Because the anatomy of the two figures is so similar, we must focus on pose and accouterments to determine gender. Both faces are mask-like, with characteristically Dogon-style dart-shaped noses, but the man has a beard, to indicate wisdom and social prestige, while the woman has a cylindrical lip plug, a testament to her good grooming and fashion consciousness. They are independent individuals, each with an indispensable role in society, yet they are mutually supporting. The specifics of religion aside, the most important lesson this statue taught children was that responsibility and respect were the foundations of society.

The village blacksmith who carved the seated couple managed his *adze* (a heavy ax with the blade secured at a right angle to the handle) with forceful precision in an expressive carving method that produced evident cut marks. While many voids penetrate the shape, the silhouette preserves the contour of the single block of wood from which the statue was carved. Wood is a precious commodity in Dogon territories, and it was selected because rare materials have enhanced the sacredness of works of art throughout history.

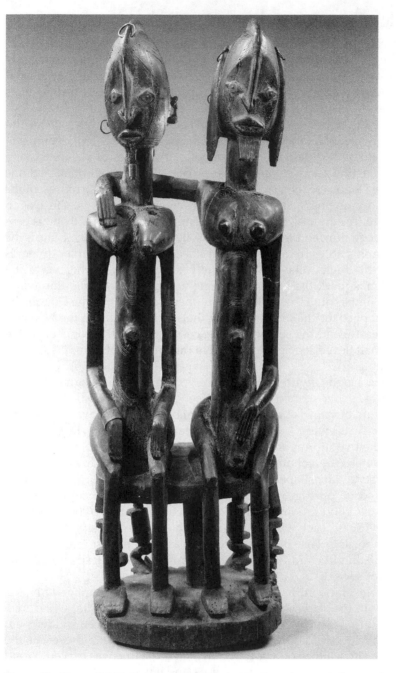

Figure 15 Dogon (Mali). Seated couple, late nineteenth–early twentieth centuries; wood, metal; H. 28 3/4" (73 cm). The Metropolitan Museum of Art, New York. Gift of Lester Wunderman, 1977 (1977.394.15)

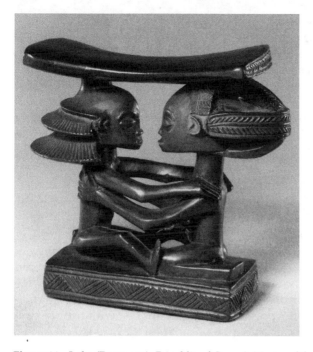

Figure 16 Luba (Democratic Republic of Congo). Master of the Cascading Coiffure. Neckrest, late nineteenth–early twentieth centuries; wood; H. 7 1/2" (19 cm). Hamlyn Group. The National Museum od Denmark, Department of Ethnography. Bequest of Carl and Amalie Kjersmeier. Photograph: Lennart Larsen

Ancient Egyptians, for example, had imported Kushite granite for imperial mortuary sculpture. Both the Egyptian and the Dogon artists respected the integrity of their materials, one fashioning an image that conformed to the cubical stone block, the other to the cylindrical tree trunk.

Luba

While Dogon art is visually stark, the sculpture of certain *Luba* carvers is serene and elegant. Luba art catered to members of a wealthy nobility whose leisured lives required specialized articles such as the neckrest, a prestige object designed to support the aristocrat's imposing hairdo while sleeping. Whether the neckrest (Fig. 16) attributed to the **Master of the Cascading Coiffure** was the work of an individual or a regional workshop has not been determined, but the object possesses the stylistic features—a monumental fanned hairdo and a smooth polished surface—that have helped specialists isolate the group of works. The sculptor reveals his design mastery in the play of interlocking limbs; the alternating bent and straight legs establish a gentle rhythm quite unlike the Dogon couple's ramrod-stiff frontality.

As we have seen throughout this chapter, surface treatment often provides a clue to the purpose of the piece and adds an important dimension to its aesthetic appreciation. The sleek oiled surface of the Luba neckrest exudes a genteel air, implying it has been attended to, like the Baule spirit spouse. The chopped Dogon surface, by contrast, retains evidence of the act of artistic creation. Old original Dogon statues are heavily encrusted with sacrificial matter because they were used as altars. Dogon statues with smooth surfaces were prestige, didactic, or funerary objects, or they have been cleaned up to make them presentable for display in Western art collections.

Kuba

The *Kuba* and the Luba, who live in the central and coastal regions of the Democratic Republic of Congo (formerly Zaire), respectively, share many ideas about the function of art because the two peoples were interactive. Until well into the nineteenth century, the militarily assertive Luba empire encroached on Kuba territory; however, Luba concepts most likely inspired Kuba divine kingship and prestige art. Luba prosperity was based on the slave trade; Kuba aristocrats enjoyed work-free lives because they supplemented the labor of slaves, purchased from Luba traders, with tribute payments exacted from the impoverished free population they ruled.

At the top of the Kuba social hierarchy was the divine king (the *nyim*). When performing the royal *Mwaash-aMbooy* mask at court ceremonies, he assumed the persona of the first ancestor in a reenactment of the mythic origins of Kuba kingship. The *Mukenga* helmet mask (Fig. 17), a regional variation of the royal mask, symbolizes the first man and the founder of the Kuba royal line, *Woot*. In the manner of the Kushite sphinx, the mask borrows animal characteristics to make a political statement. Presenting the idea of power, rather than the appearance of the mythic ancestor, the mask envisions Woot as a composite elephant-human highlighted with touches of chameleon and leopard. The chameleon refers to the king's supernatural powers and the leopard to his political powers. Because the Kuba economy was based on ivory trade, the elephant trunk and tusks refer to the king's wealth, an idea underscored by the mask's currency-covered surface (cowrie shells). The king could convey the privilege of wearing the royal mask to regional chiefs, when it would appear during funeral ceremonies for the elite.

The Kuba mask combines wood, copper, fabric, animal skins, pigment, raffia, blue and white glass beads, and cowrie shells in an assemblage of contrasting colors and textures. The restless but controlled surface was stitched, carved, and painted in an adaptation of natural materials to an artificial, traditional design. Copper bells, sunk in beaded eyestalks, stare beyond the pompon of parrot feathers, suspended like a spray of red water from the stylized elephant trunk. The mask is one of several examples of the continental predisposition to mixed-media sculpture we have seen in our brief survey, beginning with the wax and wood Queen Tiy.

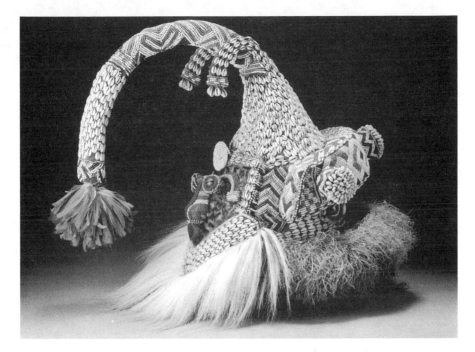

Figure 17 Kuba (Western Kasai Province, Mweka Zone, Democratic Republic of Congo).
Mukenga helmet mask, late nineteenth–early twentieth centuries; wood, glass beads,
cowrie shells, feathers, hair, fiber, skin, metal; H. 27 2/3″ (70.25 cm). Courtesy of The Art
Institute of Chicago. Laura T. Magnuson Fund; X-Hautelet Collection (1982.1505). Photo,
Robert Hashimoto © 1994, The Art Institute of Chicago. All Rights Reserved.

Kota

For the *Kota* people, who live in small villages in the rainforests of
Gabon and Cameroon, ancestor veneration had been the dominant theme of
and motivating force for art until the 1920s. The sacred bones of the ancestors
documented lineages and possessed medicinal powers. They were stored in
baskets (a *reliquary*) and were protected from evil by reliquary guardian stat-
ues (Fig. 18). The wooden cores of these abstract figures were wrapped with
metal sheets, wound in wire, and studded with tacks. The head of our exam-
ple was distilled to a collection of geometric shapes, with the three-dimen-
sional pyramidal nose laid on a two-dimensional concave oval ground.
Wing-like projections frame the face in a design reminiscent of the Senufo
kpele mask. The pierced lozenge, an exceptionally abstract version of a torso,
makes the Asante akuaba seem robust by comparison; the actual basket of
bones completed the body of a reliquary guardian.

The Kota reliquary guardian represents, for our study, the culmination
of a continental tradition that sought the essential, meaningful elements of

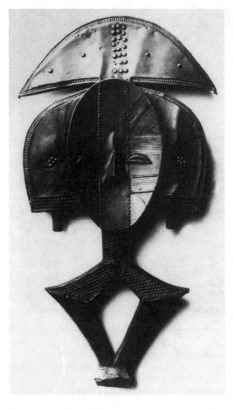

Figure 18 Kota (Gabon). Reliquary guardian, late nineteenth–early twentieth centuries; brass sheeting over wood. Smithsonian Institution, Washington, DC. Department of anthropology. Catalogue No. 323686

the subject. In twentieth-century Western art the intellectual process has been called "the search for significant form." With their tradition-inspired search for significant form, Kota artists affected Western art in ways they never could have imagined. The process of abstraction, which had preoccupied European artists throughout the nineteenth century, was accelerated by contact with African aesthetics. In 1906 Europeans, including soon-to-be cubist artists Pablo Picasso and Georges Braque, encountered Kota reliquaries in a Parisian exhibition of "curiosities," as African art was called in the early twentieth century. There they saw the work of artists attuned to the body's design potential, works with torsos fractured into hard-edged shards and solid shapes opened to penetrating voids. Confronting Africa's alternatives to illusionism accelerated the development of modern Western art.

FOR DISCUSSION AND REVIEW

1. Review the geographic location for all cultures in this chapter. Discuss the diversity of African art referring to the geography of the continent.

2. What functions has art fulfilled in African cultures? Give specific examples of each. Suggest reasons why it is often difficult to determine the original function and exact meaning of many works.

3. What influence has "the unseen world" played in African art? How do spirits, deities, and the ancestral dead "look"? Which works had, as their primary audience, something other than human? Supernatural entities have many names around the world. List those covered in this chapter with their culture and characteristics.

4. What is the role of the artist in African communities? Has it been the same across the continent? Throughout history? What is the role of the diviner? The patron?

5. How have African artists incorporated animal and plant motifs into their works? Catalog the examples, listing the meanings and purposes of each. Any commonalties across cultures?

6. Discuss the variety of human relationships suggested in examples of the man-and-woman theme.

7. Order, balance, and stability are associated with power in African art and society. What examples support or refute this statement?

8. A primary function of African art has been to promote the well-being of the community. Agree or disagree with the statement, using specific examples.

9. Review the images representing people. Explore the types and meanings of "proportion" for the human body. Also consider the role of anatomical accuracy, muscular definition, and facial expression.

10. Review the Nilotic artistic traditions. Consider the importance of innovation in Nilotic art. A major issue in African studies has been "What shall we do with Egypt?" Your thoughts on the question of "Egypt in Africa."

11. What characteristics identify the Nok style? The sophistication suggests there may have been an earlier culture, but consider whether a culture can be "sophisticated" without prior or outside influence. Do cultures really "develop," like creatures?

12. Review the influence of Islam on African art and culture. How did Islamic religious beliefs shape the mosque? Compare the two mosques, using the architectural vocabulary and an analysis of form.

13. How did commerce change the character of Africa during the Medieval period? The Colonial period?

14. Which Medieval period African cultures were non-Islamic? What are formal features, subjects, and materials for works of art from each?

15. What was the oni's function in Ife society? Discuss the Standing Oni as a combination of abstraction, realism, and idealism to reveal his essence.

16. The oba of Benin connected with the ancestors and the gods for the benefit of the kingdom. What role did art play? Consider objects and symbols.

17. What is colonialism? How did it influence art on both sides of the Atlantic?

18. Review each of the Colonial period cultures discussed in this chapter for 1) geographic location; 2) social structure; 3) functions for art; and, 4) at least two unique stylistic features that identify the work as belonging to that culture.

19. What historical relations exist among the Asante, Senufo, Baule, Dogon? Ife, Benin, and Yoruba? What formal features in the sculpture suggest interaction?

20. Consider the concepts "quality" and "effectiveness." To an art historian the akuaba is "mediocre," but why may it still be "effective"? Why might a "mediocre" charm be effective while a "mediocre" prestige object would not be?

21. What are poro and sandogo? What are the benefits of a social system organized by gender? Any drawbacks?

22. What is a spirit spouse? What makes a spirit husband desirable? Could displaying a spirit spouse in a museum pose a problem? Your thoughts on assembling a collection of spirit spouses.

23. Discuss specific works of art that show social prestige and/or political power.

24. With the Benin plaque and the Senufo wooden door, discuss principles for designing on a two-dimensional surface. What or where is "space" or "location" in each? What subject does each depict?

25. As a Dogon elder, use the Seated Couple as a teaching device to summarize your week-long lectures. What points are you trying to get across? How does the form of the statue emphasize your ideas?

26. Many African works were not seen "at rest." Select examples that were animated. What are the strengths and weaknesses of performance art? What is mixed-media art? What is multimedia art?

27. After reviewing all the material, discuss whether or not "abstraction" and "metamorphosis" can be considered essential features of African art, using specific examples.

28. Comparing the names of countries in Africa, as they are currently called, with their Colonial period counterparts on Map 1, discuss the meanings of national, political, and cultural identities. Which is enduring? Self-defining? Focus on the Kuba empire, which was in the Belgium Congo, renamed Zaire, and currently known as the Democratic Republic of Congo. What role does art play in national or cultural identity?

29. For some art historians and Africanists, the last paragraph in Chapter 1 is controversial. Formulate ideas to support and refute the following statement: Presenting African art as a contributing element to the emergence of modern Western art undermines the cultural traditions of Africa.

FOR FURTHER READING

Africa: The Art of a Continent. New York: The Solomon R. Guggenheim Museum, 1995.

Aldred, Cyril, *The Egyptians.* London: Thames and Hudson, 198 .

Anderson, Martha and Christine Mullen Kreamc, *Wild Spirits, Strong Medicine: African Art and the Wilderness.* New York: Center for African Art, 1989.

Ben-Amos, Paula, *The Art of Benin.* Washington, DC: Smithsonian Institution Press, 1995.

Berlo, Janet Catherine and Lee Anne Wilson, *Arts of Africa, Oceania, and the Americas: Selected Readings.* Englewood Cliffs, NJ: Prentice Hall, 1993.

Blair, Sheila S. and Jonathan M. Bloom, *The Art and Architecture of Islam, 1250–1800.* New Haven: Yale University Press, 1994.

Blier, Suzanne Preston, *The Royal Arts of Africa: The Majesty of Form.* Upper Saddle River, NJ: Harry N. Abrams and Prentice Hall, 1998.

Bravmann, Rene A., *Islam and Tribal Art in West Africa.* London: Cambridge University Press, 1974.

Corbin, George A., *Native Arts of North America, Africa, and the South Pacific: An Introduction.* New York: Harper and Row, 1988.

Ettinghausen, Richard and Oleg Grabar, *The Art and Architecture of Islam: 650–1250.* New Haven: Yale University Press, 1994.

Ezra, Kate, *Art of the Dogon: Selections from the Lester Wunderman Collection.* New York: The Metropolitan Museum of Art, 1988.

Gillon, Werner, *A Short History of African Art.* London: Penguin Books, 1991.

Grabar, Oleg, *The Formation of Islamic Art.* New Haven: Yale University Press, 1987.

Lapidus, Ira M., *A History of Islamic Societies*. Cambridge: Cambridge University Press, 1993.

Meyer, Laure, *Black Africa: Masks, Sculpture, Jewelry*. Trans. Helen McPhail. Paris: Terrail, 1992.

Nooter, Mary H., *Secrecy: African Art that Conceals and Reveals*. New York and Munich: The Museum of African Art and Prestel-Verlag, 1993.

Paudrat, Jean-Louis and Lucien Stephan, *Art of Africa*. Trans. Marjolijin de Jager. New York: Harry N. Abrams, Inc., 1993.

Perani, Judith and Fred T. Smith, *The Visual Arts of Africa: Gender, Power and Life Cycles*. Upper Saddle River, NJ: Prentice Hall, 1998.

Prussin, Labelle, *African Nomadic Architecture: Space, Place, and Gender*. Washington, DC: Smithsonian Institution Press and the National Museum of African Art, 1995.

Rice, David Talbot, *Islamic Art*. London: Thames and Hudson, 1991.

Roberts, Allen F., *Animals in African Art: From the Familiar to the Marvelous*. New York and Munich: The Museum of African Art and Prestel-Verlag, 1995.

Taylor, John H., *Egypt and Nubia*. Cambridge: Harvard University Press, 1991.

Vogel, Susan Mullin, *Baule: African Art, Western Eyes*. New Haven and London: Yale University Press, 1997.

Willett, Frank, *African Art*. London: Thames and Hudson, 1985.

2

India

From a cultural perspective, the subcontinent of India was advantageously situated to receive and disseminate ideas. Located at the crossroads between the East and the West, India was an obligatory stopping point for merchants, including the ancient Romans, and a haven for displaced peoples, notably the founders of the Indian Kushan dynasty, who came from China's western border. With features assimilated from both directions, Indian artists and their patrons synthesized a new visual expression. As the style and symbol system traveled eastward it affected art across Asia. From a political perspective, however, India was disadvantageously positioned because it was vulnerable to invasion and occupation. Northern India, in particular, was subject to hostile military takeovers, while southern India endured the political realignments of short-lived regional kingdoms. Today, India's borders reflect something of its tumultuous history, with the politically estranged modern countries of Pakistan, Bangladesh, and western Afghanistan important in India's cultural geography. From each encounter Indian art absorbed important ideas, which contributed to the formulation of its unique worldview.

As the embodiment of that worldview, Indian art can be described as limitless diversity in changeless design. It presents life as a multitude of vaguely similar, repeating, interdependent essences and entities governed by a cosmic logic. As it vacillates between the minute and the infinite, the particular and the universal, Indian art envisions a world in which parts may be understood, but in its complexity, the total picture always remains slightly beyond human comprehension. Coupled with this immersion in multiplicity is a profound love of life, manifest in abundant flora, fauna, and especially, youthful men and women. Indian art is never self-conscious in its celebration of physical beauty, but alongside its admiration for worldly things is the

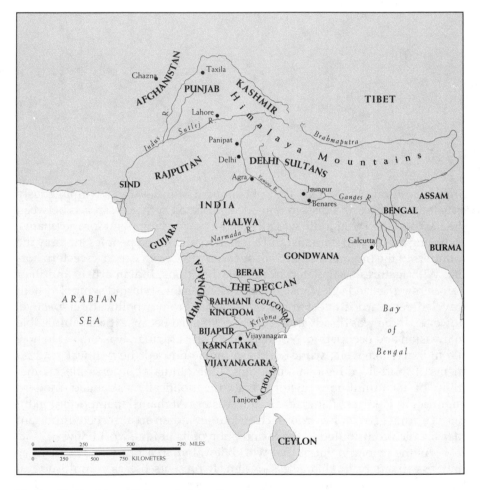

Medieval India, thirteenth through sixteenth centuries

deepest respect for the contemplative life, the solitude of meditation and spiritual maturation. Life becomes an interplay of body, mind, and soul. As the visual embodiment of the love for life and the quest for peaceful reconciliation, rhythmic curves establish hypnotic movements of turning wheels and interlocking elements; circles, arcs, and undulations unify the compositions, joining men to women, people to nature, sculpture to architecture, and idea to form.

Overwhelmingly so throughout its history, Indian art has been motivated by religion. It was the birthplace of Buddhism and Hinduism, two religions whose worldviews helped mold the character of Far East and Southeast Asian art. Both used art as a visual sermon for instruction, a role model for virtuous behavior, a focus for meditation, and an access point for supernatural powers. In the latter case, the object was not considered to be the deity, but the god or goddess could be implored to reside in it temporarily. Just being in the presence of Buddhist and Hindu images (called *darshan* in Hinduism) was a spiritually beneficial act, as was commissioning, making, and donating them.

The four major sections in this chapter trace the development of Indian visual expressions from the ancient Harappan civilization through Buddhist, Hindu, and finally, Islamic art. Accommodation of such diverse concepts within the Indian artistic vision illustrates its ecumenical attitude.

ANCIENT INDIA

Harappan Civilization

The earliest known Indian civilization, the *Harappan* (also called the *Indus Valley Civilization*, 2600–1750/1500 BCE), is named after the first archaeological site of the type to be discovered, the city of *Harappa* near the Ravi River in northwestern India. Excavations at other Harappan cities, especially *Mohenjo-daro* on the banks of the Indus River in modern Pakistan, have revealed that among its estimated thirty-five thousand residents were farmers who cultivated subsistence staples and trade commodities such as cotton, merchants who traded goods with Mesopotamians, and artisans who fashioned ceramic vessels, created small-scale sculpture, and built the city with fired clay bricks. Designers laid out the city on a precise grid, and engineers enhanced the quality of urban life with an effective sanitation system.

The products of Mohenjo-daro's image-makers provide additional insight into Harappan lifeways and cosmology. Recovered in abundance from the ancient city are stone seals (Fig. 19) believed to have been merchants' marks for identifying shipments of Indian commodities destined for the Near East. A Harappan seal is an approximately two-inch-square piece of steatite (soapstone) suspended on a cord passed through a raised loop carved on the back. On the obverse, images are carved in sunken relief (*intaglio*) so a raised

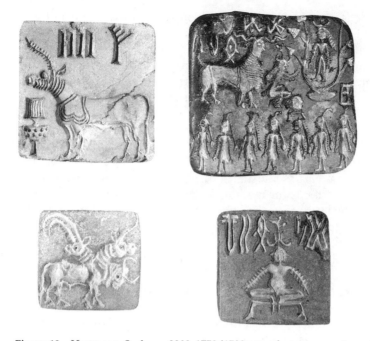

Figure 19 Harappan. Seals, ca. 2300–1750/1500 BCE; plaster impressions of steatite
originals; each approx. 2″ (5.01 cm) square from Mohenjo Daro. National Museum of
Pakistan, Karachi, Pakistan. Borromeo/Art Resource, NY

design is produced when the seal is impressed in damp clay. Subjects on
Harappan seals range from naturalistic renderings of plants and animals to
highly abstract composite beings. The bull appears most frequently; some are
shown in a full profile pose and others with horns from a frontal view. Within
the small spaces the carvers created keenly observed renditions of the ani-
mal's muscular structure, picked out here and there with crisp-edged ridges.

 Although nothing about Harappan cosmology is known with certainty,
specialists have associated the bull with ancient virility cults. The sacred con-
notation is reinforced by the presence of a structure included on several bull
seals; interpreted as a feeding trough by some, most see it as a fire altar. Evi-
dence of sacred fire altars has been found in Harappan cities, but no build-
ings with specific religious connections have been identified. Religious rites
other than the most basic may have taken place outside the cities at auspi-
cious natural sites. Abstractly rendered horned humanoids on other seals
suggest that named male and female deities were worshipped, and possibly
these intriguing beings were ancient forms of important Hindu deities. Cer-
tain elements, including a meditating pose, multiple faces, trident-shapes,
and a prominent phallus, point to some depictions being prototypes of the
Hindu god Shiva. All seals possess a ceremonial quality, which has led to
the proposal that they also were worn as protective amulets. Perhaps when

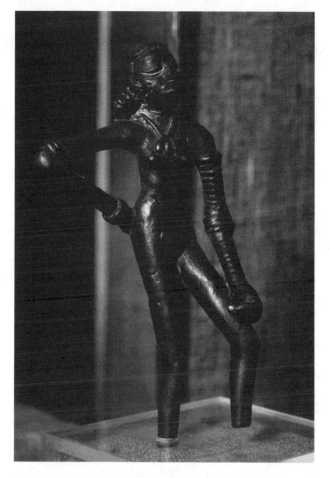

Figure 20 Harappan. Young female, ca. 2300–1750/1500 BCE; bronze; H. 4 1/4″ (10.79 cm). from Mohenjo Daro. Indus Valley Civilization. National Museum, New Delhi, India. Borromeo/Art Resource, NY

the writing on the seals is deciphered to everyone's satisfaction, additional light will be shed on the meaning of the images.

The small bronze statue of a young female (Fig. 20), also from Mohenjo-daro, was possibly associated with ancient fertility cults. Both the material and the open design make it an unusual Harappan item. Numerous compact, summarily executed clay figurines, also ascribed to an earth goddess cult, have been found in ancient Harappan garbage dumps, suggesting they were used and discarded. Metal such as this bronze, on the other hand, was a coveted material all over the ancient world and one not likely to be abandoned.

The scarcity of Harappan metal sculpture is tied to the desirability of the material, and no doubt many statues were melted down in succeeding eras to make currency and weapons.

Stylistically, the handling of the figure anticipates characteristics of later Indian art, such as the distinctive hip-shot pose. Her nudity, accentuated by the pendants and armbands of a high-ranking individual, documents the antiquity of the Indian attitude toward the body in art. The woman's self-assured and nearly confrontational posture shows no trace of uneasiness. Even at this early date in Indian art, nudity is a natural and desirable state. Eventually it will become an expression of spiritual confidence and physical well-being. The ethnicity of the indigenous Indians of the Harappan civilization, the *Dravidians,* is also stressed.

Vedic Period

Between 1750 and 1500 BCE, groups of semi-nomadic, militant foreigners from the Iranian plateau had begun moving into the Harappan territories. The appearance of these people, who called themselves *Aryans* (nobles), undermined a civilization already deteriorating under the impact of deforestation and flooding. The appearance of the Aryans pushed the Dravidians south, and those who remained in the old Harappan heartland in the north were assimilated into a new sociopolitical system.

The *Vedic period* (1750/1500–500 BCE) is named for a body of sacred ritual texts, the *Vedas.* It was a millennium dominated by ideas, rather than objects. To date, no art has been ascribed to the Vedic period or to the Aryans, but with them came a new language (*Sanskrit*), social structure (*caste*), and complex cosmology which, together, profoundly affected Indian thought, life, and art. Important writings dated to the later centuries of the Vedic period include the *Upanishads,* ninth-century philosophical texts on the meaning of existence, and possibly the narrative epics the *Mahabharata* and the *Ramayana* in the fifth century.

Paramount in the new worldview was *Dharma,* the cosmic Law governing nature, human society, and the supernatural world. The Law was perfect order and the interrelatedness of all things. Caste, the religiously sanctioned social division of the population into four ranked hereditary groups (priestly *brahmin;* ruler-warrior *kshatriya;* merchant-artisan *vaishya;* and laboring *sudra*), was a divinely ordained aspect of the Law. Violating any part of the Law, willfully or unknowingly, had dire consequences because punishment was doled out in a future life. Similarly, obedience was rewarded in another life. An individual experienced the reality of action and consequence, called *karma,* as the soul (*atman*) moved in and out of countless lives. The concept of endless rebirths in different forms is *samsara.* Death was always the beginning of a new existence, never the end of existence. For each single lifetime a person's indestructible soul temporarily assumed the form of an animate being, anything from an insect to a god.

The goal of life was the cessation of rebirth, achieving a blissful rest, or nonexistence, which came to be called *nirvana* among Buddhists and *moksha* among Hindus. Liberation was attained by uniting the individual soul with the eternal World Soul, *Brahman*. Methods to achieve liberation included ritual, meditation, solitude, and self-mortification; denying the reality of the physical world, which was only illusion, brought one closer to Brahman, the only reality. None but the most disciplined person of the highest caste could aspire to eternal rest. Everyone else was doomed to move through the ceaseless rounds of samsara, obeying Dharma and gradually inching closer to desirable extinction. Then the Buddha was born to give a new perspective on the Law and suggest a new way to cope with samsara.

BUDDHIST ART

The historical Buddha (ca. 556–483 BCE) was an Aryan prince born in Nepal near the Indian border. He is known by the names Gautama, Siddhartha, and the honorific title *Shakyamuni*, which means "wise man of the Shakya clan." At age twenty-nine he left his family and the pampered palace life, setting out on the hermit's path to discover why people seemed doomed to lives of sickness, suffering, old age, and death. After six years of wandering and fasting he sat down under a tree and meditated until coming to the realization that people suffer because they are attached to the things of the world. By following his eight steps of self-discipline and virtuous behavior any person could achieve nonattachment and cessation of suffering. Henceforth, he was known as the Buddha, the "Enlightened One."

The Buddha Shakyamuni shared the *Eightfold Path* (see Glossary) by preaching in the Ganges River Valley to all who would listen. Many people were attracted to his teachings, and he acquired a sizable following. At age eighty Shakyamuni lay down and died a peaceful death; he attained freedom. His disciples formed a monastic order of men and women, devoting their lives to attaining personal enlightenment. They did not proselytize, yet the new attitude about life and the Law took hold across India.

Early Buddhist Art and Architecture

Before the third century BCE Buddhists created no works of art, apparently requiring only solitude for their meditations. As the Buddhist community burgeoned, images were designed to clarify doctrine and to mark sacred locations. The religion flourished under the official state sponsorship of Emperor *Ashoka* (reigned ca. 269–232 BCE), and sacred sites numbered into the tens of thousands under his patronage.

Buddhists outside the monastic order could gain merit on the path to enlightenment by visiting sacred sites. The visual focal point of a pilgrimage site was a solid earthen mound, inspired by ancient burial mounds, covering the spiritual focal point, a relic associated with Shakyamuni or a

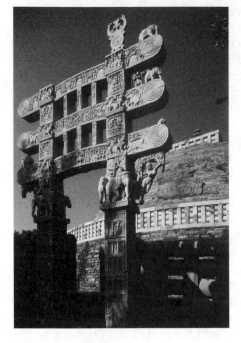

Figure 21 Buddhist. Great Stupa and east torana with yakshi bracket, Sanchi, Madhya Pradesh, first century BCE to first century CE; rubble mound faced with stuccoed stone; stupa H. 55′ (16.67 m), D. 130′ (39.6 m); vedika H. 10′7″ (3.2 m); torana H. 35′ (10.67 m); yakshi bracket H. 60″ (152.4 cm). Photo © Anil A. Dave

holy Buddhist monk. The mound (*stupa*) would be surrounded by a fence (*vedika*) with four gateways (a *torana*) oriented to the cardinal points. From the most ancient times the fence had been used in India to mark a sacred spot.

The Great Stupa at Sanchi (Fig. 21), in central India, is a superb example of this classic form of Buddhist architecture. First built during Ashoka's reign, the Great Stupa was doubled in size about two hundred years later when the old wooden vedika and toranas were replaced with the current stone versions. The solid rubble and brick hemispherical mound, originally faced with white plastered stone, sits on a drum-shaped base. On the summit a square terrace (*harmika*) surrounds a pole with three discs. Symbolically, the mound is the World Mountain, *Mount Meru,* and the pole is the World Tree, the cosmic *axis mundi* (World Axis) uniting physical and spiritual dimensions; in Buddhism, the axis mundi is Shakyamuni's *bodhi* (meaning "enlightenment") tree. The discs represent umbrellas, an emblem of royalty in India, and the number three signifies the *Three Jewels of Buddhism* (*triratna*)—the Buddha, the Law, and the monastic community.

Between the vedika and the stupa is a continuous walkway (*ambulatory*). To use the building, a Buddhist would proceed along the ambulatory, walking clockwise around the stupa in the act of meditation called *circumambulation*. A double ramp provides access to a second vedika-encircled ambulatory on the drum. The building is closed-form architecture; oriented to the exterior, it possesses no "useful" space in the traditional Western sense of architectural functionalism.

Images carved on the vedikas and toranas at early pilgrimage sites form visual encyclopedias of Buddhist ideas. The crisp carvings on the east torana at Sanchi (Fig. 21) are especially complex and well preserved. The number three is restated in the horizontal crossbars, the vertical connecting posts, and the trident shape on top of the right support. The repeating circle motif, representing the Wheel (*chakra*) of Law, ties the two-dimensional carvings to the three-dimensional stupa. Umbrellas and elephants, the vehicles of royalty, reminded pilgrims of Shakyamuni's high social status. Additional symbols for the Buddha include miniature stupas, the lion (he was "the lion of the Shakya clan"), and the bodhi tree. At other sites, narrative scenes of dogmatically sanctioned miraculous events from the Buddha's life were mixed with popular stories (*jataka tales*) about his former lives, such as his incarnation as a monkey that sacrificed its life to save other monkeys from hurtful humans, or as a man who threw himself off a cliff so his body would feed a starving tigress and her young.

Also noteworthy on the east torana is the bracket connecting the lower horizontal beam with the vertical post on the right. The architectural member is designed as a female figure called a *yakshi*, a robust nude representing the abundance of nature. Yakshis were nature spirits surviving from the most ancient Indian religious traditions. While some are named deities, they represent the more general concept of physical well-being. With her body zigzagging in the distinctive Indian hip-shot, or *triple-flex* pose (*tribhanga*), the Sanchi yakshi illustrates a popular Indian saying that a yakshi can cause trees to bloom with the kick of her heel. In this example, her languid body hangs from the branches like a drop of rain giving life to nature. Dynamically conceived with exceptional interior carving, the Sanchi yakshi is the descendant of the Harappan young female and the precursor to the voluptuous women of later Buddhist and Hindu art.

Early Buddhist architecture can also be seen at monastic complexes. In some areas, such as the site of Karli (Fig. 22) near Bombay in west central India, assembly halls, called *chaitya halls* (also the name for the horseshoe-shaped arch with pointed top) were excavated into the mountainsides. Instead of joining materials to enclose a space—that is, "constructing" a building—Karli artisans worked in a subtractive method, removing tons of stone to introduce a space into the solid mountain. Starting at the ceiling, they chipped their way down to the floor and back through the mountain in a method more akin to sculpture than architecture.

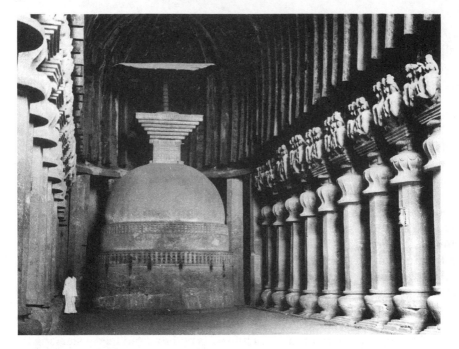

Figure 22 Buddhist. Karli, interior chaitya hall, first century BCE, ca. 120; L. 124′ (37.8 m),
W. 46′6″ (14.2 m), H. 45′ (13.7 m). Department of Archaeology, Government of India

The chaitya hall has a rectangular plan ending in a semicircular space
where the focal point of the interior, a stupa, is found. A colonnade divides
the interior into a large central nave and two side aisles. The aisles form the
ambulatory, allowing passage along the walls and behind the stupa. The
columns are surmounted by amorous couples (a *mithuna*) and gigantic lotus
blossoms, symbolizing purity. Because the columns support nothing, it is
clear that the designers were replicating another form of architecture in stone.
This is particularly evident along the barrel vaulted ceiling, where nonfunc-
tional wooden rafters were introduced. The chaitya hall imitates a monk's
hut, an ordinary building of wood and thatch. The implication of this labor-
intensive act may be that substance is only illusion.

A large relief carving of a mithuna (Fig. 23), located on the otherwise
badly damaged facade of the Karli chaitya hall, introduces us to the mature
Indian aesthetic of the human body. The woman is full to bursting with the
abundance of life, her tapered waist and ankles emphasizing ample hips and
globular breasts. Both figures are adorned with fine fabrics, jewels, and the
huge earspools of wealthy individuals. Sensuous energy flows through the
swaying scarves, intertwining arms, and curvaceous hips. In their smiling ex-
pressions we sense the pleasure they take in their physical well-being. Indian

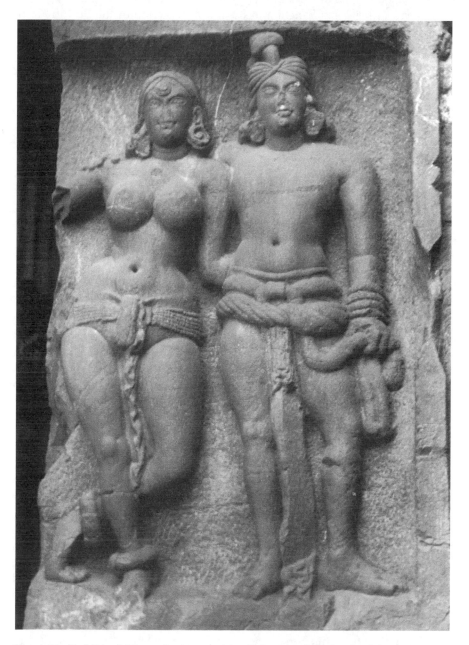

Figure 23 Buddhist. Mithuna (loving couple), relief carving from facade of the chaitya hall, Karli, ca. 120; stone. Department of Archaeology, Government of India

artists translated a generous spirit into bounteous flesh, rendering the rewards of good karma in a manner any viewer could understand.

What is missing at Sanchi and Karli is a depiction of the Buddha himself. Because no images of the Buddha were made in the first centuries, the early phase of Buddhist art is often called the *Aniconic period*. No prohibitions forbade his depiction, so we can assume it simply was considered illogical to show the Buddha in a physical form because his great accomplishment had been liberation from the physical world.

Figural Buddhist Sculpture

We turn now to the most famous images in Indian art, the actual depictions of the Buddha. Precisely when a representation of the Buddha as a person, rather than a symbol, was conceived is unknown, but the artform was firmly in place by the first century CE.

The Buddha may be represented in a standing or seated pose, but he is always presented in a frontal position. When standing, the weight of the body is evenly distributed through the legs. The Indian Buddha is stationary; he is always in a state of perfect rest. When seated, he assumes the meditative *lotus position* (*padmasana*), with his feet placed soles up on his thighs (see Fig. 26).

The position of the hands is especially important in Indian art because the *mudras,* or symbolic hand gestures, will indicate an activity or a state of spiritual consciousness. Hand gestures, rather than facial expressions, communicate information in Buddhist and Hindu art. In Figure 26 the Buddha performs the *teaching mudra* (*dharmachakra*) by joining the thumb and index finger, forming the Wheel of Law, which he turns with his other hand. Often the Buddha's palm or the soles of his feet will be imprinted with the Wheel of Law. Other mudras include the *reassurance mudra* (*abhaya*)—performed by the Buddha in Figure 24 with his right hand, palm out, raised to about shoulder level—and the *meditation mudra* (*dhyana*), recognized by both hands resting on the thighs, palms up, thumb tips touching. Positioning the left palm outward with fingers pointing down is the *gift-bestowing mudra* (*varada*).

Clothing, accessories, and marks on the body are also important in identifying the Buddha. His simple monastic garment may bare one shoulder or cover the entire torso. An Indian Buddha never wears jewelry, because he has renounced the illusion of the material world and discarded its trappings. Therefore, long ear lobes are a sign of the Buddha because, when he became a hermit, he removed the large earspools he had worn as a prince. Additional signs of Buddhahood include a carved or painted dot (*urna*) on the forehead and a protuberance (*ushnisha*) on top of the head, usually represented as a stylized knot of hair. Both the urna and the ushnisha indicate superior wisdom emanating from his person, as does the circular halo, the burst of illuminating buddha-wisdom.

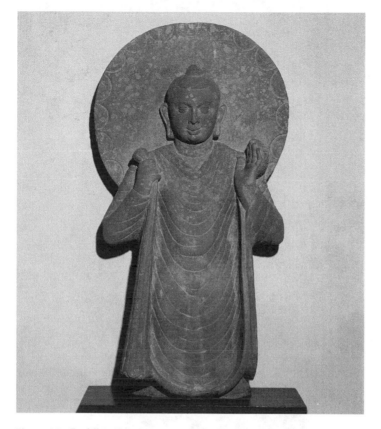

Figure 24 Buddhist (Mathuran; Kushan dynasty, ca. 50–320). Standing Buddha, second century; sandstone. Archaeological Museum, Mathura, Uttar Pradesh, India. Borromeo/Art Resource, NY

Other beings resembling the Buddha are nearly-buddhas called *bod-hisattvas*. They are enlightened beings who have delayed their own liberation to remain on earth and help weaker people achieve enlightenment. The Standing Bodhisattva in Figure 25 is possibly the Buddha-of-the-Future, *Maitreya*, who would carries his personal attribute, a flask with the elixir of life, in his left hand and would have raised his right hand in the reassurance mudra. The Buddha is frequently shown in the same standing pose with the reassurance and gift-bestowing mudras, but the earspools and princely garment show that the bodhisattva is still in the earthly realm.

While Buddhist symbolism remained consistent through the centuries, the manner in which the figure was presented changed rapidly in three stylistic phases. The *Mathuran* and *Gandharan* styles appeared simultaneously in the first century, flourished during the *Kushan dynasty* (50–320), and merged in the

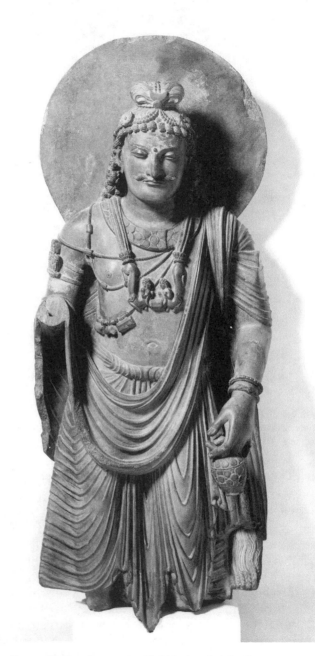

Figure 25 Buddhist (Gandharan; Kushan dynasty, ca. 50–320). Standing bodhisattva,
second century; schist, H. 41 in" x W. 16 1/2" X D. 9". Gandhara, India. Asian Art
Museum of San Francisco. The Avery Brundage Collection. Photo Copyright © 1992

54

fourth century to form the classic Indian style, the *Gupta*. The three Buddhist statues we have examined for their iconography represent these styles.

Artists in *Mathura*, a capital city of the Kushan empire, fashioned the Standing Buddha (see Fig. 24) in the brusque, comparatively abstract Mathuran style. The Buddha's engaging stare and frozen smile contribute to the commanding attitude. Although the authoritarian demeanor was short-lived in Indian art, the Mathuran treatment of the body—its muscles generalized into flat, smooth planes—persisted in later periods. The powerful Mathuran body—filled with an energizing spiritual breath that expands the broad chest like a balloon—is marked by thin, linear drapery folds. Mathuran sculpture is considered to be the indigenous Indian style, evident when we compare the Standing Buddha to the Karli mithuna.

Some seven hundred fifty miles north of Mathura, artists in *Gandhara*, a northern Kushan province in modern Afghanistan and Pakistan, explored a stylistic alternative for the Buddha image. The Gandharan style was inspired by Western art brought from the Roman Empire by way of the *Silk Route*, an international commercial roadway linking China with the Roman Empire. The Standing Bodhisattva (see Fig. 25) is an example of the Gandharan style, its naturalistic approach as brief in Indian art as the Mathuran curtness. The pronounced muscular definition, wavy hair, and heavy drapery folds—all Roman imports—are tempered by the Indian mood of contentment and introspection. Although the debt to Roman art is obvious, this bodhisattva would have been out of place in a forum. In Buddhist art, physical beauty reflects spiritual beauty, rather than being an end in itself. The deep undercutting in Gandharan sculpture creates dark shadows and detailed surfaces, compared to the generalized etched surfaces produced in the Mathuran workshops.

The two-hundred-year reign of the Gupta kings (319–500) is considered to be the Golden Age of Indian art. Artists fused the best of the Mathuran and Gandharan styles into the unique Gupta synthesis of physical and spiritual beauty. The statue entitled The Sermon in the Deer Park (Fig. 26) exemplifies the fully developed Gupta style. The anonymous Indian artist envisioned a mysterious being with a vaguely human presence. Gupta Buddhas are renowned for their otherworldly composure and inner peace; serenity distinguishes the style from its predecessors. The downcast lotus-petal eyelids and boneless body convey the divine wisdom and limitless strength that come from attaining enlightenment. His knowing expression is tender yet enigmatic.

Another characteristic of Gupta sculpture is its refined carving. The delicate transparent drapery drifts through smooth transitions, clinging like water-soaked fabric to his chest and arms. The edge of his monastic garment settles in a neat pleated fan, resembling both the lotus of purity, on which the Buddha often sits, and the Wheel of Law he preaches. The wheel motif unifies the composition, from the circular halo, through the teaching mudra, to

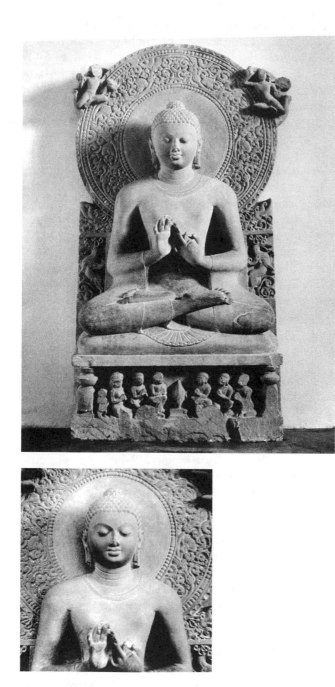

Figure 26 Buddhist (Gupta dynasty, 319–500). Seated Buddha (The Sermon in the Deer Park), ca. 475; sandstone; H. 5'3" (1.6 m). Museum of Archaeology, Sarnath. Photo, AKG London Ltd.

the garment, and finally the narrative on the base. The subject of the relief carving beneath the dais is the Buddha's first sermon after experiencing enlightenment. Five hermits, soon to be his disciples, join a woman and her child in adoring the Wheel of Law foreshortened in the center. The message is this: When the Buddha spoke in the Deer Park he set the Wheel of Law in motion for the benefit of all people.

As the Gupta Buddha was simplified, the setting became more elaborate. From the plain Gandharan disc to the scallop-edged Mathuran halo, we arrive at a foliated burst of buddha-wisdom in which the concentric rings of lotus petals, vines, and jewels reflect a rich universe. Two wisdom-bearers augment the halo, and winged lions flank the seat of enlightenment. In the center, the Buddha represents quiet repose in a busy world.

An anomaly of Gupta art is that its patrons, the Gupta kings, were not Buddhist but Hindu. In the centuries to follow, Buddhism was transformed into a religion of charms and incantations, squeezed into a smaller and smaller territory, until it ceased to be a motivating force in Indian art. The aesthetics refined in the Golden Age of Buddhist art lived on in Hindu art for the next thousand years.

HINDU ART

Hinduism is actually older than Buddhism, constructed squarely on the theological foundations of the ancient Vedic traditions. But historically, Hindu art appeared after Buddhist art. As a tool for focusing beliefs and galvanizing followers, Buddhist art had a certifiably high success rate, which probably inspired the pictorialization of Hindu deities and the construction of temples for their veneration in the Gupta period.

Several Hindu deities had been brought by the Aryans, and they are named in the *Vedas*. Others, such as Vishnu, grew out of the Vedic tradition but were altered so significantly that an ancient Aryan never would have recognized his original god. The worship of other deities, especially Shiva and the Great Goddess, have been traced back to the Harappan virility and fertility cults. Some, such as the sun god *Surya*, are manifestations of natural phenomena, and others are sociopolitical constructs, such as the rough and rude warrior-king of the Vedic gods, *Indra*. Most, however, are embodiments of abstract concepts such as cosmic order, righteous destruction, and good beginnings. Adding to the multiplicity of Hindu thought, the major deities exist in more than one form. Shiva, for example, has one thousand eight names with corresponding pictorial representations; he can combine his powers with those of other male or female deities to produce, in the visual arts, a split image such as *Harihara*, with one half Shiva and the other half Vishnu.

The Hindu world is anything but chaotic, however. Order pervades in immense diversity because all existence is subject to the Law. The number of gods and goddesses in Hinduism is potentially infinite because each is an

aspect of the ultimate reality, Brahman; people can come to appreciate bits of the magnitude of the World Soul through veneration of the deities emanating from it. From among the hosts, a Hindu selects one or more deities for personal veneration in a practice called *bhakti*.

Images of Hindu Deities

In the Hindu pantheon, one female and three male deities are supreme. The Great Goddess, *Devi*, is the major female deity, and from her arise all other goddesses and female nature spirits. The male triad is formed by *Brahma*, the Creator (not to be confused with *Brahman*, the World Soul, or *brahmin*, the highest, priestly caste), *Vishnu*, the Preserver, and *Shiva*, the Destroyer. We will select a few manifestations of Vishnu, Shiva, and the Great Goddess to explore the ways in which Indian artists structured images to communicate complex ideas. Using bronze, stone, and paint they materialized a world populated by beings of nearly impenetrable intricacy.

Vishnu remains the focus of intense devotion for hundreds of millions of Hindus around the world, and he has been the subject of innumerable works of art to aid in their venerations. As the agent of the Law, Vishnu maintains order in the universe, hence his name the Preserver. The brass statue of Vishnu (Fig. 27), costumed as a king with a regionally stylish trilobed crown, shows him in a stately frontal pose befitting the defender of the Law. Regardless of the activity in which he engages, Vishnu is always composed. Across his chest is the thin thread of a priestly brahmin, and wrapped around his arm, hanging down to his ankles, is the victor's garland.

Two animal heads emerging in profile from either side of his face represent Vishnu's third and fourth *avatars* (meaning "descent," or loosely, his "incarnations"). When evil threatened to disrupt cosmic harmony and destroy the universe, Vishnu assumed different physical forms. On the right, in his Boar avatar (*Varaha*) he became a gigantic boar—forty miles wide and forty thousand feet tall—to rescue the earth, personified as a goddess, from an evil serpent-king (a *naga*) who was pulling it down into the cosmic ocean. In his Lion-man avatar (*Narasimha*), Vishnu tore apart an evil king and rescued one of his own loyal followers. The image of Vishnu and the two animal heads is his "Penetrating" (*Viakuntha*) form.

Meaningful items, or *attributes*, help identify the gods and goddesses in Hindu art. Among Vishnu's attributes are his three weapons, the shell (*shankha*), the disc (*chakra*), and the club (*gada*), which often resembles a royal scepter. In our example, the club and disc take human form, with the personification of the club (*Gadanari*) on the left and the disc (*Chakrapurusha*) on the right. In his right hand Vishnu holds a lotus and in his left the shell. Each Hindu deity also has a vehicle to transport it; these animals may appear in works of art with their god or goddess, or they may be independent representations in sculpture or painting. Vishnu's vehicle (not included in this

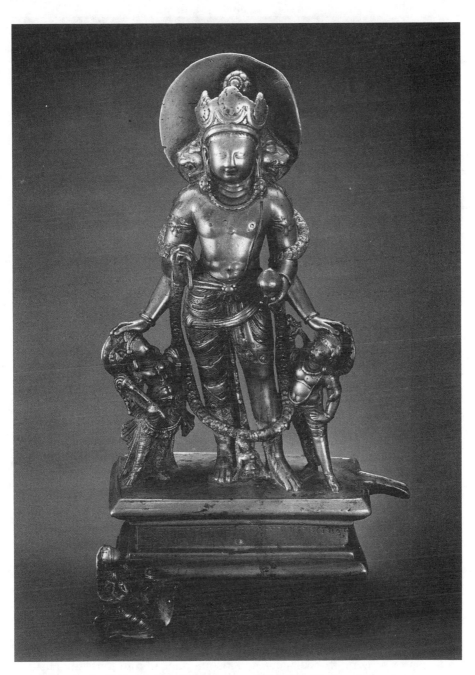

Figure 27 Hindu (Kashmir). The God Vishnu, ca. 850; brass with silver and copper inlay; 18 1/4" (46.4 cm) × 11" (28 cm) × 6 1/8" (15.6 cm). Los Angeles County Museum of Art. From the Nasli and Alice Heeramaneck Collection, Museum Associates Purchase (M.80.6.2). Photograph © 2000 Museum Associates/LACMA

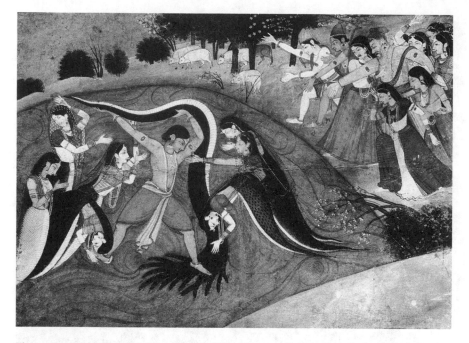

Figure 28 Hindu (Rajput, Punjab Hills). *Kaliya Damana: Krishna Overcoming the Naga Demon, Kaliya,* second half eighteenth century; paint on paper; H. 7 3/8" (18.7 cm), W. 10 3/8" (26.35 cm). The Metropolitan Museum of Art, Rogers Fund, 1927. (27.37)

statue) is the sunbird, *Garuda.* Every male deity also has a female complement represented as his wife. *Shri Lakshmi,* goddess of wealth and good fortune, is Vishnu's adoring companion. Usually shown massaging his feet in works of art, Shri Lakshmi is possibly the small figure between his legs in this statue; another possible attribution is an earth goddess named *Prithvi.* Outside the space of the majestic deity a devout follower gazes in adoration.

For his eighth avatar Vishnu assumed human form, incarnated as *Krishna,* the princely cowherd (a *gopa*). The adventures of young Krishna, proposed by some scholars to have been a real man who acquired deity status, are recounted in the *Bhagavad Gita,* a text that has inspired Indian painters from the sixteenth century to the present. The episodic format of manuscript painting suited the retelling of the Krishna epic, from charming childhood anecdotes to the supernatural triumphs of his adulthood. In an eighteenth-century manuscript painting (Fig. 28), Krishna destroys *Kaliya,* a despotic naga ruling an underwater kingdom beneath a pool near his village. Kaliya had been terrorizing the villagers, so Krishna danced him to death. Historians have interpreted the story as the symbolic triumph of Krishna over local nature spirits and the supremacy of the fledgling Krishna sect over the ancient Indian cults.

In the painting, serpent-queens (a *nagina*) join the men, women, and cattle of the village in praising Krishna's victory. All women found the fickle, blue-skinned Krishna irresistible. He was the trickster, stealing their clothes when they swam, and the seducer, teasing them with his provocative ways but always satisfying their every desire. Among all the women he truly loved *Radha*. When he was away she suffered miserably, but when he reappeared she would melt into joyful submission. The popular story of Krishna and Radha is a metaphor for the relationship between the devout Hindu and the deity. For those who have chosen Krishna as their personal deity, as have the villagers and naginas in the Kaliya narrative, he is the heart's sole desire and union with him is an ecstatic experience.

Shiva, the Destroyer of ignorance and illusion, is more difficult to embrace because he is the volatile god. He is lord of animals, god of the hermit, and the embodiment of virility. He can be recognized by a third eye on his forehead and a crescent moon in his hair; a tiger-skin garment and snake jewelry; his vehicle, the white bull, *Nandi*; and, his weapon, a trident (*trishula*). He lives in the cremation grounds or in the Himalayan Mountains with his wife, *Parvati* (also *Uma*) and his sons *Ganesha*, the elephant-headed god of good beginnings, and *Karttikeya* (also *Skanda*), the god of war.

In his form as Lord of the Dance (*Nataraja*) (Fig. 29), Shiva destroys ignorance, personified as the dwarf beneath his foot. Within the flaming circle of time he liberates the universe from the fallacy of permanence. In his upper left hand he holds the purifying flame, and in his upper right hand an hourglass-shaped drum (*damaru*) to keep the rhythm of destruction and creation. In the other meaningful pair of gestures he offers comfort to the audience; with the raised hand he performs the reassurance mudra and immediately below it, points down where refuge may be found beneath his upraised leg. The graceful movements of classical Indian dance inspire Shiva's dance of bliss (*ananda tandava*); absolute concentration and great physical strength make his fluid motions perfect. Many versions of Shiva, Lord of the Dance can be seen in museums around the world. Its fame derives from its artistic summation of the Indian worldview, stated in a composition of circles and lilting lines. Metal statues created in southern India between 1000 and 1100 (*Chola dynasty*, ca. 850–1279) capture the state of dynamic balance most eloquently.

Our final Hindu deity is a manifestation of the Great Goddess, *Devi*. As the embodiment of the earth's energies, Devi possesses the power to conceive and sustain life, so she often appears as an abundant, yakshi-type woman. But the earth is not only passive and cooperative; aspects of Devi have the capacity to destroy life, and as the final resting place for the dead, the earth consumes life. In this terrifying manifestation the Great Goddess is *Kali*, the "Black One," or *Chamunda* (Fig. 30), the destroyer of evil. No illusion disguises the unappealing reality of death, captured in her bulging eyes, frozen grimace, and deflated breasts. Often her ornaments include a garland of

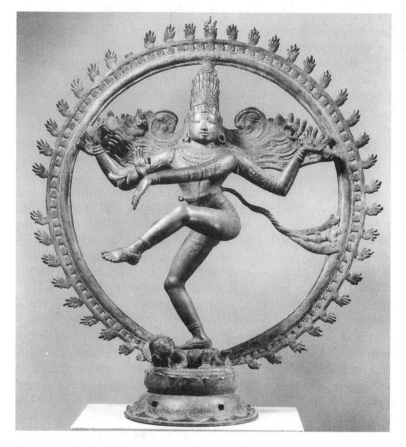

Figure 29 Hindu, Shiva as Lord of the Dance (Shiva Nataraja) India, Tamil Nadu;
Chola dynasty, twelfth century. Copper alloy. H. 29 1/4" (74.3 cm) 1979.29. Photography
by Susumu Wakisaka, Idemitsu Museum of Arts, Tokyo. The Asia Society, New York:
Mr. and Mrs. John D. Rockefeller 3rd Collection.

skulls and snakes. In this example, a scorpion, emblematic of death, crawls
up her torso. Created to destroy evil, eight-armed Chamunda brandishes the
weapons of the male gods, notably Shiva's trident, Vishnu's disc-topped
club, and Indra's thunderbolt. Also appropriated from the Destroyer are his
crescent moon and the tiger-skin garment carved on her thighs.

 When reviewing the four Hindu images it is apparent that certain fea-
tures are borrowed from Buddhist art. Figures, for example, are fluid and
boneless in the Gupta style. In sculpture they are centered in the composition,
presented in a frontal position, and possess meaningful mudras. However,
Hindu art is more interactive and animated than its Buddhist prototype.
Hindu artists took liberties with the figure, adding multiple heads and limbs,
combining animal and human parts to communicate the extraordinary pow-
ers of the deity. Hindu artists erased the lines between animate and inani-

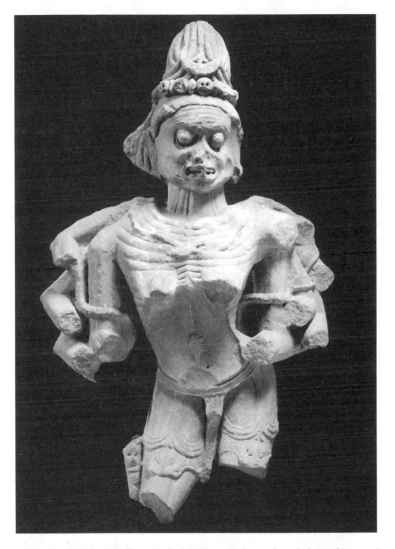

Figure 30 Hindu (Madhya Pradesh). Chamunda, tenth and eleventh centuries; sandstone; H. 44 1/2" (113 cm). The Metropolitan Museum of Art, New York. Purchase, Anonymous Gift and Rogers Fund, 1989 (1989.121)

mate, animal and human, to signal the divinity of the gods and goddesses; they are clearly not of this world.

Hindu statues were focuses for meditation and temporary receptacles for the deities, who came into people's presence through a statue. Images were created for domestic settings and for temples. More accurately, we should say the temples were created for the statues, to provide them with a suitably grand and mysterious surrounding.

The Hindu Temple

Hindu temples provide settings for the rituals and adoration offered to the deity enshrined in the statue. They can be elaborate complexes with many buildings and courtyards, but the essential element is the space housing the image. This most sacred place (the *garbhagriha*, meaning "womb chamber") is marked by a tower. The proportions, silhouette, and ornamentation of the tower is regionally specific, resulting in the identification of two main Hindu temple styles, the southern style (*dravida*) and the northern style (*nagara*).

In southern India, at the site of Mamallapuram (Fig. 31), stand four temples carved from a single granite protuberance along with a fifth temple, an elephant, a lion, and a bull each carved from separate granite boulders. The buildings are called *raths*, meaning "chariots," because they resemble the wooden wagons on which Hindu statues are transported in public processions. In comparison to later Hindu temples, those at Mamallapuram are exceptionally small. Possibly they were functional shrines, but the abnormal size and the linear arrangement of progressively more elaborate styles have led specialists to interpret the site as an "architecture school" for designers from other Indian cities who came to Mamallapuram to study the three-dimensional models. They document the evolution of the Hindu temple from an unpretentious hut to a conspicuous sanctuary.

The simplicity of the *Durga* shrine, dedicated to the warrior-goddess of that name (meaning, "difficult to go against"), identifies it as the oldest architectural form at the site. It replicates ancient wooden plank and thatched-roof forest shrines, which probably were as old as the Harappan civilization. The evenly spaced pilasters create the illusion of wooden poles supporting a thick thatched roof. Although its unadorned walls are unusual for a Hindu temple, the Durga shrine possesses several features common to all Hindu temples, including the union of a square plan and circular roof, doorkeeper statues flanking the entrance, and a basal platform carved with animals, creating the impression they are bearing the rath and its statue in procession.

The Arjuna rath in the foreground comes close to the mature southern temple style. The surface is more sculptural, with deep niches for the figural relief carvings, but the major change is evident in the roof, where the three-story stepped superstructure rises to a mushroom-shaped capstone. It conforms to the typical southern tower-type (*vimana*) in its stocky proportions and pyramidal shape. The Arjuna roof is a miniature city, with vaulted buildings and thatched-roof shrines on each of its three tiers. Decorative chaitya arches, the horseshoe-shaped architectural member we encountered at Karli, ornament the edges of the capstone and the tiers. As the southern-style temple changed through the centuries, the sacred precinct was enclosed by walls with monumental gateways (a *gopura*). The pyramidal tower achieved gargantuan size, culminating in one of the world's largest buildings at the time,

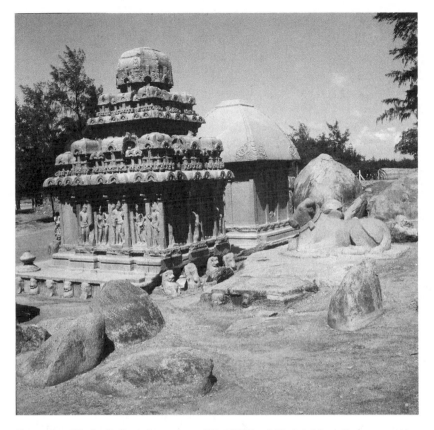

Figure 31 Hindu (Pallava dynasty, ca. 550–897; Tamil Nadu). Mamallapuram raths, ca. 630–70; granite; Durga shrine (distance) H. 12' (3.7 m); Arjuna rath (foreground) H. 36' (10.97 m). Scala/Art Resource

the *Rajarajesvara* temple (Chola, 1003–10) at Tanjore, dedicated to Shiva as The Great Lord (*Brhadeshvara*).

The temple style in northern India is more difficult to study because Islam's perseverance in the region resulted in a lower survival rate for Hindu buildings. Standing as a perfect example of the northern style is *Kandariya Mahadeva* (Fig. 32), one of the few temples remaining from the original eighty sponsored by kings of the *Chandella dynasty* (950–1203) at the site of Khajuraho in north central India. The Shaivite temple was designed in the fully developed northern temple style, recognized by a tall, prismatic tower (*shikhara*) with a flat, ribbed capstone. As it rises in diminishing but multiplying units from the telescoping platform, the building creates an illusion of rippling waves or—as it was in its original condition with white stuccoed surfaces—the snow-capped mountains of Shiva's residence in the

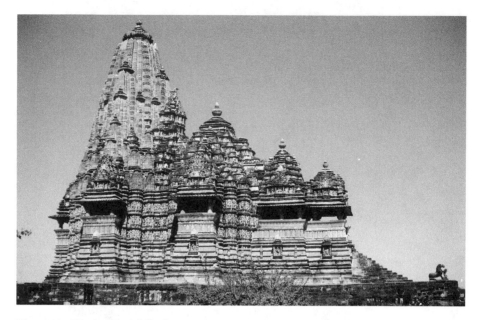

Figure 32 Hindu (Chandella dynasty, 950–1203; Madhya Pradesh). Kandariya
Mahadeva, Khajuraho, ca. 1025–50; sandstone; H. 102' (31.09 m). Photo, Charles Weckler

Himalayas. Northern-style temples also unify architectural spaces into an
organic whole. For example, the entrance porch and the assembly hall (*man-
dapa*) flow into the tower structure. Kandariya Mahadeva is exceptional for
its harmonious plan and its blend of sculpture and architecture. Carvings of
the Hindu deities, the beauties of nature, and the familiar mithuna (Fig. 33)
harmonize so well with moldings and buttresses that the lines between the
media dissolve. The building, like its individual sculptures, celebrates the
beauty and complexity of existence.

ISLAMIC INDIA

Hindu and Islamic art would seem to represent contrasting world-
views, one envisioning the divine to be infinitely divisible, the other founded
on the belief in an indivisible supreme being. Both contributed to the special
character of India's visual arts.

Islam was imported in several hesitant military campaigns beginning in
the eighth century, but major sections of the subcontinent were not secured
until the late twelfth century. Fighting between Muslims and Hindus raged
until one Muslim family of Mongol ancestry, the Mughal, unified the sub-
continent. Hindu princes were reduced to vassals, and temples in northern

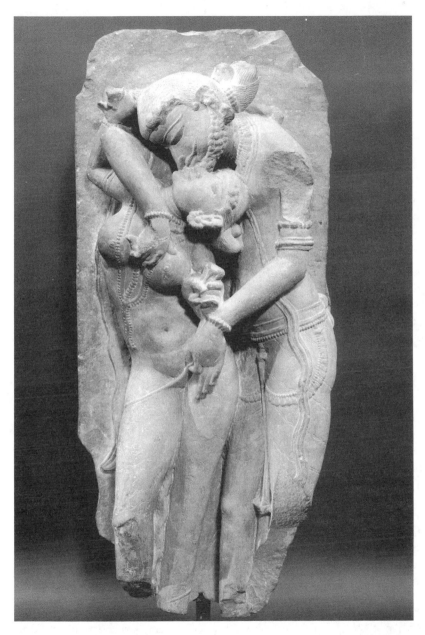

Figure 33 Hindu (Chandella dynasty, 950–1203; Madhya Pradesh). Mithuna (loving couple), architectural sculpture from Khajuraho, eleventh century; reddish sandstone; H. 29" (74 cm). ©The Cleveland Museum of Art, Leonard C. Hanna, Jr., Fund, 82.84

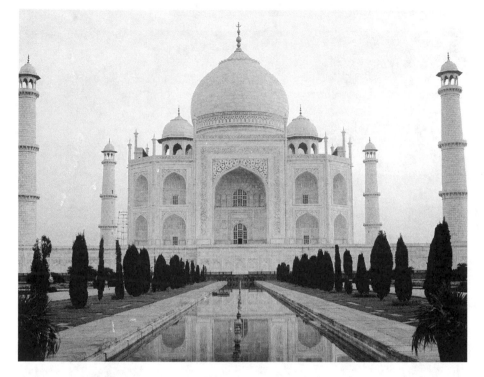

Figure 34 Islamic (Mughal dynasty, 1526–1857). Taj Mahal, Agra, 1630–48; marble, inlaid stones and gems; base each side, L. 186′ (56.7 m), dome H. 250′ (76.2 m).

India were systematically dismantled. Despite the unrest, Indian art flourished under the patronage of Islamic emperors during the first hundred years of the *Mughal dynasty* (1526–1857).

The Taj Mahal (Fig. 34) is an Islamic memorial commissioned by Mughal emperor *Shah Jahan* (reigned 1627–58, died 1666) in memory of his wife, *Mumtza Mahal,* who died in 1631 at age twenty-three, giving birth to her fourteenth child. The tomb and its setting epitomize the restrained opulence of Islamic design and, aesthetically, offer a chaste foil to the fleshy excitement of the Hindu temple. The domed mausoleum is raised on a rectangular platform with four kiosk-topped minarets anchoring the corners. Each is a clear, discrete unit, compared to the integrated platform and towers of Kandariya Mahadeva. The pointed arches, recalling those we saw in Islamic Africa, move the design upward to the swelling dome. The masonry core is faced with polished marble inlaid with gold, silver, jade, diamonds, and other precious stones. The intricate stone inlays of Qur'anic verse and floral arabesques around the entrance provide clues to the deeper meaning of the

Taj Mahal. Designed to replicate Paradise, it represents Mumtaz Mahal's reward for her steadfast defense of the faith against Christian infidels; she is with Allah in Heaven. The peaceful fragrant setting is as meaningful as the building because it recreates the celestial gardens. Symmetry governs the placement of every element in the walled garden, from the intersecting reflecting pools to the symbolic fruit trees of eternal life. In its reserved elegance the Taj Mahal testifies to the abiding love of the man for his wife, and the woman for her God.

The art of painting also flourished under the patronage of the Mughal emperors. Its eclectic blend of Persian, European, and indigenous Indian styles attests to the cultural impartiality of Islamic India when matters of religion were not involved. The preferred format for Mughal painting was the *manuscript illumination,* a painting in a bound book. The subjects chosen for illustration ranged from the legendary adventures of Alexander the Great to the avatars of Vishnu to the biographies of the Mughal emperors.

Shah Jahan's grandfather, *Akbar* (reigned 1556–1605), founded the dynasty and established the first Mughal painting workshop at his court. Producing one painting required the participation of many specialists working under the supervision of the court librarian. After the handmade paper had been prepared, the master artist laid out the composition. Portrait specialists created realistic images by layering colors directly on the painting, rather than by blending colors on a palette. The task of applying color to the clothing and the background was assigned to lesser artists.

The arrival of two Christian priests at Akbar's court (Fig. 35) is recorded in an *Akbarnama,* a book chronicling the emperor's reign. The manuscript illumination shows the Mughal blend of Persian and European painting styles. Persian features include flat patterns, minutely observed details, and an upward tilting space. The Persian predisposition to two-dimensional abstraction is offset by European artistic influences, brought to India by the Portuguese in 1498. Modeling in shades of light and dark, realistic portraiture, and vignettes of common people are features of contemporaneous Western art incorporated into the Mughal painting style.

Hindu manuscript illuminations (see Fig. 28), called *Rajput* (prince) painting, were sponsored by the Hindu warrior-kings who continued to rule small, independent kingdoms in northern India. Rajput painting assimilated many Mughal elements, but it is more poetic in tone and usually brighter in color. Rajput painters integrated figures and setting with flowing curves. In *Krishna Overcoming the Naga Demon, Kaliya,* a Rajput manuscript illumination created in the *Punjab,* the old Harappan heartland between the Indus and Jumna rivers, the curves of the bodies echo the rolling landscape. Both figure and setting restate the lyricism and the sensuous appeal of the earliest Indian art.

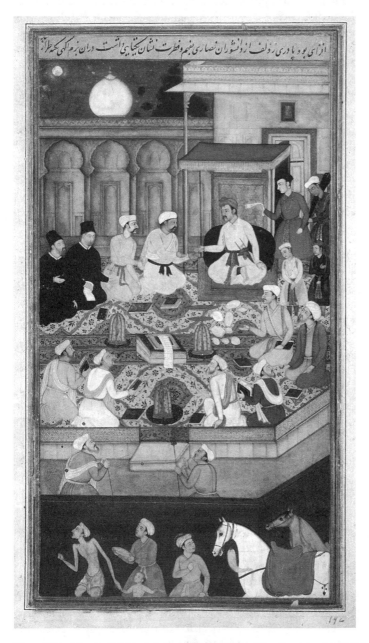

Figure 35 Islamic (Mughal dynasty, 1526–1857). *Akbar Receiving Jesuit Priests,* from an
Akbarnama, by Nar Singh, ca. 1605; opaque watercolor, gold, and ink on paper. Courtesy
of the Chester Beatty Library, Dublin, Ireland. Reproduced by kind permission of the
Trustees of the Chester Beatty Library, Dublin MS. 3 fol 263v

FOR DISCUSSION AND REVIEW

1. Begin with a comparison between the Dogon Seated Couple and the Hindu Mithuna. How is the tone changing as we move to the subcontinent?

2. Indian art is a synthesis of various cultures and ideas. How has geographic location contributed? Why may this be advantageous for art but problematic for politics? What comparisons with Africa can you make?

3. India was the birthplace of two major world religions, Buddhism and Hinduism. Discuss the highlights of each. What beliefs are shared? How are the two related to the Harappan civilization? The Vedic period?

4. Although "motivated by religion," was Indian art created to "access the divine"? Is it educational? Meditative? Magical? Inspirational? How can it benefit the spectator?

5. Summarize the achievements of the Harappan culture. What religious or social imperatives can be deduced using Mohenjo-daro, seals, and the bronze female as evidence?

6. Chronicle the treatment of the female body in Indian art, from the Harappan figure to the Hindu architectural sculpture. Is the change more or less conservative? Radical? Account for the inclusion of the figure in the Indian religious context. In the Western religious context, both Greek and Christian.

7. Use the following terms to compose a paragraph on the Indian worldview in the Vedic period: Brahman, brahmin, Dharma, karma, samsara, and nirvana or moksha.

8. Who was the historical Buddha? Summarize the reasons for the spread of Buddhist ideas.

9. What are the symbolic and religious significances of the Great Stupa at Sanchi? Include architectural terms. How is it incorporated into the chaitya hall?

10. What constitutes "usefulness" in architecture? Is a building always "built"? Consider the stupa, chaitya hall, and Hindu temple. Comparisons with any Western buildings? In what ways does each of these three Indian structures relate to earlier, less permanent building types?

11. List the ways in which the Buddha presence was represented before figural depictions. What is the meaning of each symbol? Propose explanations for the absence of figural representations in the early centuries.

12. How is a buddha distinguished from a bodhisattva? What are the marks of a buddha? Any thoughts on why we usually think of him as fat and

happy? Who is the fat, happy figure, really? Occasionally you may see a person place a coin in the hands of a Buddha displayed in a Western museum. Is that an appropriate use of the statue in the museum context? Should it require a reprimand?

13. Discuss the differences among the following Indian styles: Mathuran, Gandharan, Gupta. Identify at least three distinctive visual features (not symbols) for each. What features (not symbols) do they have in common? Which style expresses the nature of buddhahood most clearly, do you feel? Why?

14. Mathuran and Gandharan appeared at the same time, but is the order in which we study them important? Why or why not? Would the Gandharan bodhisattva be "out of place" in a Roman forum? What about the Mathuran Buddha? The Gupta Buddha?

15. Indian art was described as "limitless diversity in changeless design." For "limitless diversity," identify the following Hindu deities: Brahma, Brahman, Chamunda, Devi, Durga, Ganesha, Garuda, Harihara, Indra, Kali, Karttikeya, Krishna, Nandi, Parvati, Shiva, Shri Lakshmi, Surya, Vishnu.

16. For "changeless design," note that one entity in question 15 is not really a "deity." How does it relate to all the others?

17. Returning to question 15, list features to identify each deity in the visual arts.

18. Discuss the Krishna painting and the statue of Vishnu using the following terms: bhakti, darshan, Dharma, avatar, attribute, Gupta, chakra, Radha, Shri Lakshmi, nagina, Rajput, Kaliya.

19. Discuss the concept of the circle, the Wheel in Indian art. Select examples in sculpture and in architecture. How does that relate to the Indian worldview?

20. Artistically, the Shiva Nataraja may be said to be a summation of the Indian worldview. Agree or disagree with the statement and explain your position. For "summation" include both the ideas of "artistic" and "worldview." Account for all the symbolic gestures and components.

21. Devi, the Great Goddess, embodies life and death. How is this dual nature possible in one deity?

22. Identify the parts of the Hindu temple. Differentiate the northern and the southern styles.

23. Mughal painting is a hybrid style. What does it borrow? How successful is the synthesis? Compare with Rajput painting.

24. What is the Taj Mahal and its meaning? Compare it with the Cairo mosque for the continuity of Islamic architectural design.

25. How have Indian architects designed buildings to symbolize the world-views of Buddhism, Hinduism, and Islam?

26. One theme in Buddhist and Hindu art—cyclic time—is based on continuity, repetition, and the interrelatedness of activities and events. Choose works that support this observation.

27. How have Buddhist and Hindu sculptors used the human body as a vehicle for spiritual concepts?

28. Hindu art draws heavily on Buddhist art for its style and ideas, yet it looks quite different. What did Hindu artists borrow from Buddhist art? How did they modify it to fit their own needs?

FOR FURTHER READING

Asher, Catherine B., *The Cambridge History of India: Architecture of Mughal India*. Cambridge: Cambridge University Press, 1992.

Beach, Milo Cleveland, *The New Cambridge History of India: Mughal and Rajput Painting*. Cambridge: Cambridge University Press, 1992.

Begley, W. E. and Z. A. Desai, *Taj Mahal: The Illuminated Tomb: An Anthology of 17th Century Mughal and European Documentary Sources*. Seattle and London: University of Washington Press, 1989.

Bhagavad Gita, trans. Franklin Edgerton. Cambridge: Harvard University Press, 1972.

Blurton, T. Richard, *Hindu Art*. Cambridge: Harvard University Press, 1993.

Bussagli, Mario, *Oriental Architecture I: India, Indonesia, Indochina*, trans. John Shepley. New York: Electra/Rizzoli, 1981.

Carroll, David, *The Taj Mahal*. New York: Newsweek, 1977.

Craven, Roy C., *Indian Art: A Concise History*. London: Thames and Hudson, 1991.

Davis, Richard H., *Lives of Indian Images*. Princeton: Princeton University Press, 1997.

Dehejia, Vidya, *Indian Art*. London: Phaidon Press, 1997.

Desai, Vishakha N. and Darielle Mason, eds., *Gods, Guardians, and Lovers: Temple Sculptures from North India A.D. 700–1200*. New York and Ahmedabah: The Asia Society Galleries and Mpin Publishing Pvt. Ltd., 1993.

Fisher, Robert E., *Buddhist Art and Architecture*. London: Thames and Hudson, 1993.

Guy, John and Deborah Swallow, *Arts of India: 1550–1900*. London: Victoria and Albert Museum, 1990.

Harle, J. C., *The Art and Architecture of the Indian Subcontinent*. New Haven: Yale University Press, 1994.

Huntington, Susan L., *The Art of Ancient India: Buddhist, Hindu, Jain*. New York: Weatherhill, 1985.

Kramrisch, Stella, *The Hindu Temple*. Vols. I and II. Delhi: Motilala Banarsidass, 1980.

Lampert, Catherine, George Michell, and Tristram Holland, *In the Image of Man: The Indian perception of the universe through 2000 years of painting and sculpture.* New York: Alpine Fine Arts Collection, 1982.

Lee, Sherman E., *A History of Far Eastern Art.* Englewood Cliffs, NJ: Prentice Hall, 1982.

Ross, Nancy Wilson, *Three Ways of Asian Wisdom: Hinduism, Buddhism and Zen and Their Significance for the West.* New York: Simon and Schuster, 1966.

Seckel, Dietrich, *The Art of Buddhism.* New York: Crown Publishers, 1964.

Stierlin, Henri, ed., *Architecture of the World: India.* Benedikt Taschen Verlag, n.d.

Zimmer, Heinrich, *Myths and Symbols in Indian Art and Civilization,* Bollingen Series VI. Princeton: Princeton University Press, 1974.

See also Chapter 1, Africa, For Further Reading.

3

The Indian Surround

Commerce and colonization brought about the amicable Indianization of lands adjacent to the subcontinent. People were receptive to Buddhist and Hindu ideas because they found value in the Indian concepts of social order and moral responsibility. Indian transplants were often reconstituted in fantastic theological and visual aberrations. In some areas the differences between Buddhism and Hinduism were virtually undetectable. Contributing to the unique mutations were the frequent political realignments in ethnically volatile regions and the deeply held beliefs in local, pre-Indian nature spirits. As each culture came in contact with India, it absorbed the imported traditions and adapted them to its own regional needs.

Our attentions will focus on Tibet, a bridge between India and China, and Southeast Asia, a geographic unit consisting of mainland Indochina and the Indonesian islands. In Southeast Asia, the first Buddhist images were created in the eighth century, about a hundred years after the religion had become established in the region. They imitated the Indian examples that monks and merchants had been transporting, possibly as early as the fifth century. In Tibet, Buddhism was in place by the tenth century. The monastic community nurtured Tibetan Buddhist art; most was spiritually motivated. In Southeast Asia, on the other hand, art was usually initiated in palaces and political in intent. Religion was an administrative tool, a means by which kings proclaimed their right to rule.

TIBET

Buddhism underwent its greatest transformation along India's Himalayan border in Tibet, where ancient shamanic practices, associated with

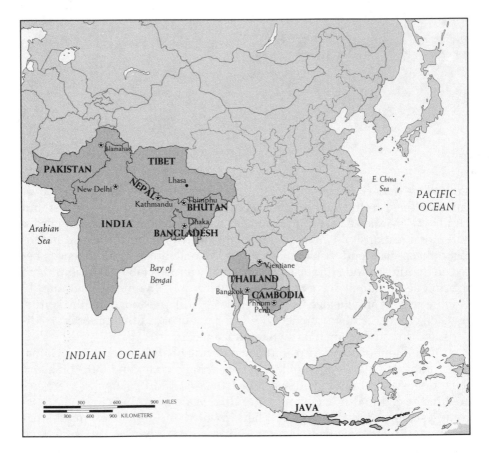

The following labels appear on the map:

PAKISTAN
Islamabad

TIBET

NEPAL
Lhasa
New Delhi
Kathmandu
Thimphu
BHUTAN

INDIA
Dhaka
BANGLADESH

E. China
Sea

PACIFIC
OCEAN

Arabian
Sea

Bay of
Bengal

Vientiane

THAILAND
Bangkok
CAMBODIA
Phnom
Penh

INDIAN OCEAN

300 600 900 MILES
0
0 300 600 900 KILOMETERS

JAVA

The Indian Surround

the native *Bon* religion, affected the theology and visual arts. Encouraged, perhaps, by the bleak physical environment, the Tibetan worldview envisioned spirits and demons roaming in a psychic world quite alien to the ordered Indian mental universe. This dangerous realm was negotiated by *shamans*, gifted individuals who possessed special powers that enabled them to interact directly with the spirit world, especially through trances. When allied with Buddhism, the attitude produced fantastic costumes for religious theatrical performances and ritual implements of gold and human bones. Tibetan Buddhism is an esoteric religion, its mysteries virtually impenetrable to those outside the monastic communities. Called *Vajrayana* (*vajra* meaning, "diamond" or "thunderbolt"; *yana*, meaning "path" or "vehicle"), Tibetan Buddhists attain the awesome power of enlightenment suddenly by means of sacred ritual and intense devotion, which cuts like a diamond or strikes like a thunderbolt through ignorance and illusion.

A Tibetan *tanka* is a painting that functions both as a magical charm with concentrated energy and as a meditative aid for accessing those energies. Something of that mystical power resonates through the *Vajrapani* tanka (Fig. 36), with patterns repeating in visual incantations like the intonations of a chant. The blunt style, with its shrill palette of intense green, red, and yellow, seems to concentrate psychic forces. It is agitating in its color, yet soothing in its repetitions. Tankas created with opaque paint on cloth survive for our enjoyment, but those created with colored sand—consuming countless hours of a monk's patient skill—would be destroyed after the meditations had been concluded. The concentrated act of creating the piece was the act of meditation.

The tanka has the linear clarity of a map or a blueprint because that is exactly what it is, a cosmic diagram called a *mandala*. The four mandalas in this tanka chart the spiritual universe; each is a circle, inscribed in a square with projecting T-shapes, circumscribed by a larger circle. The T-shaped projections are the entrances to the square earth, and the inner circle—symbolizing the World Mountain—is the goal of each spiritual traveler. Enshrined cosmic buddhas and goddesses complete the points of meditation on the metaphysical journey through a tanka.

JAVA

Sometime around the year 800 the stone monument, Borobudur (Fig. 37), was built on a low hill on the island of Java. The gigantic structure is a testament to the magnitude of imperial vision, the erudition of island scholars, and the tenacity of Javanese artists. Reminiscent of the Tibetan tanka, Borobudur is an architectural mandala, a huge stone replica of the earth and the World Mountain. Javanese Buddhists literally walked the mystic path that Tibetans followed only mentally in the painted picture.

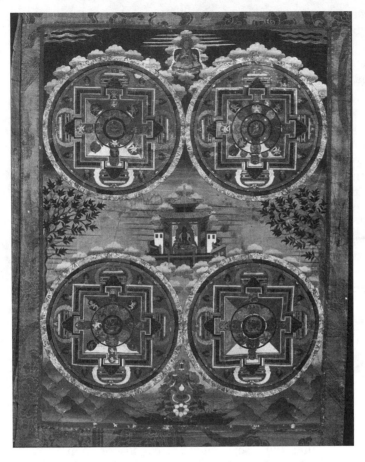

Figure 36 Tibet. Vajrapani tanka, probably eighteenth century; opaque watercolor on cloth. Courtesy Department of Library Services, American Museum of Natural History, New York (336753). Photo by Jim Coxe

The nine levels of Borobudur represent three cosmic zones, changing from five square terraces to three circular levels and a top circular platform. Because the structure is so enormous, the undecorated basal platform was added later to buttress the walls. Ten miles of stone carvings cover the surfaces. The bottom levels represent the mundane zone of human existence. In a practice seen elsewhere in Buddhist art, the carvings at this level were deliberately hidden behind stone slabs, the implication, perhaps, that the participant was aware of invisible dangers lurking along the path to enlightenment but chose to ignore them. The celestial zone is represented in the four middle terraces, where miles of relief carvings illustrate the life of the Buddha and his quest for enlightenment through his former lives. The Buddha's journey was an inspiration to the person traveling through the cosmos of Borobudur. Over

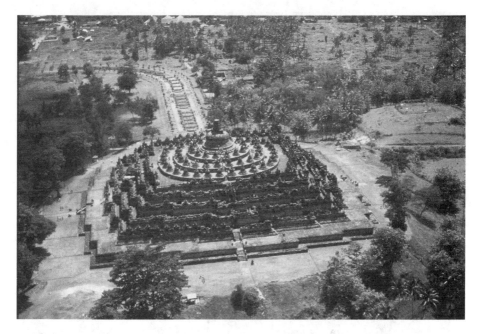

Figure 37 Java. Great Stupa, Borobudur, ca. 800; stone; L. 408' (124.36 m) each side, H. 105' (32.04 m). Tettoni, Cassio and Assoc.

four hundred freestanding Buddha statues mark the path on these levels. On the top three circular levels, seventy-two statues of the Buddha sit in hollow, bell-shaped stupas. An empty stupa, representing the world of the formless, crowns the summit. The sculptural program takes the pilgrim from ordinary subjects—the world of people and things—to the sphere of pure idea—the attainment of enlightenment.

CAMBODIA

Traces of inspiration from Borobudur are evident in the monuments built for the *Khmer* god-kings (a *devaraja*) of Cambodia. King Jayavarman II (died 850) had lived on Java before founding the five-hundred-year Khmer dynasty in the early ninth century. By the early thirteenth century, stone monuments had become self-serving statements of imperial vanity.

Jayavarman VII (reigned 1181–1219), a dedicated patron of Cambodian architecture, sponsored the rebuilding of the royal capital, *Angkor*. His own walled temple-city at Angkor, called *Angkor Thom*, was a worthy addition to the existing extravagant projects that had aggrandized the god-kings for centuries. In the center of Angkor Thom stands the Bayon (Fig. 38), the finest in a long line of Cambodian temple-mountains. Like the mandala, it is square in plan with a central Mount Meru tower and four shorter corner towers. The

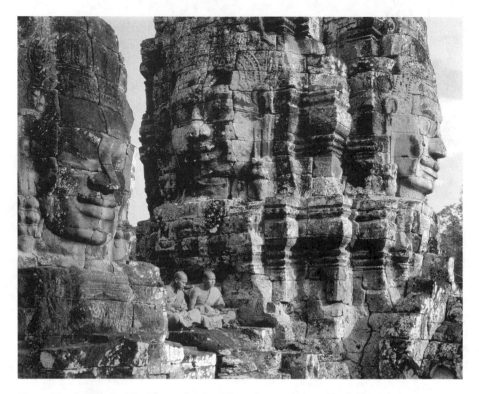

Figure 38 Cambodia. The Bayon, Angkor Thom, late twelfth and early thirteenth centuries; H. 140′ (42.7 m).

cosmic ocean is actualized by a surrounding moat and four canals representing the World Rivers. Huge statues of kneeling gods line both sides of the north and south roads leading to the Bayon. They pull on a stone serpent wrapped around the central Bayon tower. The stone assemblage recounts a Hindu creation myth, the *Churning of the Milk Ocean.* Using the serpent of eternity (*Ananta*) as the rope and Mount Meru as the churning stick, the gods churn the world out of watery chaos, like butter from milk. When the mountain began to sink into the cosmic ocean, Vishnu appeared in his second avatar as a turtle (*Kurma*) to support it on his shell.

The gigantic face-towers rising from the tiered roofs of the Bayon are Buddhist in inspiration. They combine portraits of the king and the royal bodhisattva, *Lokeshvara,* the Lord of the Worlds. From the earliest times Khmer kings had claimed descent from a divinity, either a Hindu god or Lokeshvara. The broad, serene smile and closed eyes are distinctive features of the Cambodian expression; poised between physical and spiritual worlds, it unites the self-confidence of a god-king with the inner peace of an enlightened being.

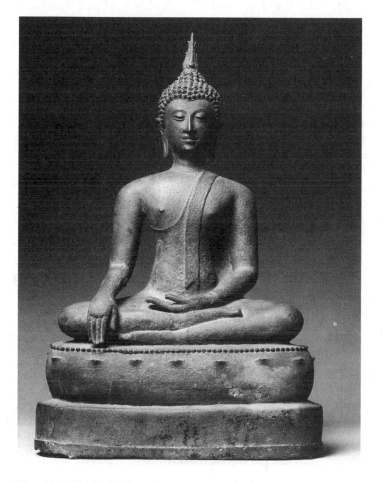

Figure 39 Thailand (Chien Sen style). Seated Buddha, late fifteenth and early sixteenth centuries; bronze; H. 19 1/2″ (49.5 cm). The Metropolitan Museum of Art, New York. Gift of Mr. and Mrs. Richard A. Benedek, 1981 (1981.463)

THAILAND

The art of Thailand carried the imprint of classical Indian aesthetics throughout its history, from the earliest fifth-century Buddhist works made by indigenous *Mon* people, through the tenth century Cambodian Khmer invasions and subsequent occupation, to the arrival of the Thai-speakers and the eventual formulation of the Thai style in the thirteenth century.

Our example of Thai sculpture (Fig. 39) shows the Buddha performing the *earth-touching,* or *calling-the-earth-to-witness mudra* (*bhumisparsha*). The pose illustrates a specific episode in the life of the Buddha, when demons and luscious ladies, both representing earthly desires, attempted to divert his

thoughts and disrupt his meditations while he sat under the bodhi tree seeking enlightenment. He ignored the temptations and once the desires left him completely, he summoned all creation to witness his victory. The subject is depicted frequently in countries where the older version of Buddhism, *Theravada Buddhism* (Way of the Elders, also *Hinayana*, meaning "the Lesser Vehicle") is practiced. Because Theravada Buddhists recognize only the historical Buddha, Shakyamuni, their art does not include the bodhisattvas and multiple celestial buddhas of the more popular form of Buddhism, *Mahayana Buddhism* (the Greater Vehicle).

Among all the national Buddhist styles, Thai and Cambodian are perhaps most distinctive. The elegant stylization of Thai sculpture is evident in the elongated, boneless limbs, the smooth surfaces, and the flame-shaped ushnisha. Literal representations of poetic descriptions of the Buddha in sacred texts (*sutras*)—his eyelids like lotus petals, fingertips curling like lotus buds, and arms like an elephant's trunk—inspired the more unusual visual passages. The Thai artist's approach to the sculptural form is volumetric and curvilinear, while the Cambodian's approach, by comparison, is geometric. Both national styles conceived unique sophisticated anatomical formulas for rendering a divine being. As they capture the tranquillity of spiritual peace, both are the logical culminations of Indian Gupta abstraction.

FOR DISCUSSION AND REVIEW

1. What is the *geographic* sequence of Buddhism's move outside India? What made Buddhism so attractive that it required no "forcible conversion"? What reasons are there for no forcible conversion to Hinduism? What effect did commerce and colonization have on the spread of Indian ideas?

2. What are the main differences in function for Buddhist art in Southeast Asia and in Tibet? Give examples and suggest reasons.

3. Indian art and belief was modified by local practices. Discuss the tanka as a Tibetan blend of Buddhism and Bon. Incorporate the religious significance of the mandala into the discussion, referencing architectural versions from India and Java.

4. Summarize the following types of Buddhism: Theravada, Hinayana, Vajrayana. After reviewing the steps of *The Eightfold Path* enumerated in the Glossary, give your thoughts on how the ideas of a single man, the historical Buddha, could become so complicated. Is this unique in the history of religions? Is theological variety a positive or a negative force in art?

5. Describe the stylistic features of Cambodian and Thai Buddhist sculpture, noting new points and those borrowed from India. Review all the mudras and the lakshana for Buddhist art.

6. Beginning with the Churning of the Milk Ocean, list all the avatars of Vishnu and discuss his role as "the Preserver."

FOR FURTHER READING

Fisher, Robert E., *Art of Tibet*. London: Thames and Hudson, 1997.

Rawson, Philip, *The Art of Tantra*. London: Thames and Hudson, 1978.

_____ , *The Art of Southeast Asia: Cambodia, Vietnam, Thailand, Laos, Burma, Java, Bali*. London: Thames and Hudson, 1990.

See also Chapter 2, India, For Further Reading.

4

China

If multiplicity shaped the character of Indian and Southeast Asian art, then duality was the compelling force in Chinese art. The paradigm of Chinese duality is yin and yang. *Yin* is the female principle, the earth. Yin is flexible, cold, low, wet, dark, and passive. Its male complement, *yang,* is sky. Yang is rigid, hot, high, dry, bright, and active. Yin and yang are interactive; neither is superior. Life's dynamic energy, as well as its harmony, arises from the symbiotic mix of these two forces. The possibility that life was activated by mutually supportive opposites—complementary rather than antagonistic polarities—was explored by Chinese philosophers. Two philosophies in particular, *Confucianism* and *Daoism,* provide the underpinnings of Chinese thought, society, and art.

Confucius (551–479 BCE) was the spokesman for the ethical code bearing his name. Confucianism, a set of moral standards governing proper conduct, upholds the importance of decorum in a well-ordered society. Artists were expected to be morally responsible individuals and present only ethically instructional subjects. Leading the list of rules and expectations regulating social and familial relations is *filial piety,* or respect for one's parents. Chinese art reflects the importance of filial piety in many ways, including the number of tombs with abundant grave goods, paintings and sculptures with themes of deference, and specialized ritual items such as the bronze vessels used in sacrifices to the ancestors.

The complement to Confucian order is the freedom of Daoism, a philosophy traditionally credited to the elusive Chinese sage, *Lao Zi* (ca. 604–531 BCE). Daoism envisions a dynamic, life-sustaining energy flowing through the universe, a vitality that can fill artists if they are open, flexible, and yielding. In the Daoist worldview, the vital force moves through a

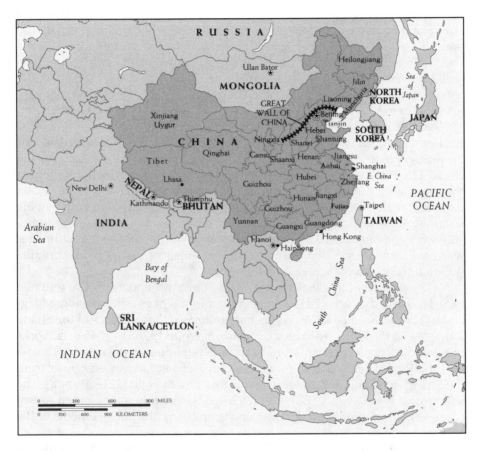

China

great void, apparent in art in the meaningful negative spaces that structure a work and provide its center of interest. Though Chinese art swirls with abstract lines animated by the energy of the Dao, Chinese artists also discovered the power of empty areas. They understood that a pause in visual silence can be more arresting than a commotion of shapes.

As fantastic as the images in Chinese art may appear to be at times, the natural world was its ultimate source of inspiration. Inventive combinations of animal parts produce a dragon; a mountain of the Immortals may be vaporous, but it is anchored by a cardinal direction. Reflecting a respect for the power and variety of nature, artists rendered vegetables and insects with the same detail accorded emperors and gods. Landscape painting provided a special domain for the Daoist spirit, while portraiture and genre scenes provided the social setting for Confucian order. Styles varied over time and, depending on the historical context and the purpose of the object, fluctuated between extremes of decorative abstraction and convincing naturalism.

Art served several purposes in China, functioning as magical objects, emblems of authority, signs of superior cultural refinement, mechanisms for the preservation of information, and vehicles for self-expression. As the world's first art historian, Zhang Yan Yuan (847), stated succinctly, art helped human relations and explored the mysteries of the universe. Art, he wrote, completes culture. Patrons included members of the imperial court, noble families, high-ranking bureaucrats, and Buddhist and Daoist monasteries. However, the percentage of the population having access to visual images was small, not to mention the minuscule number of people who commissioned or owned works of art.

The imperial families lent their names to most epochs in Chinese history. The early dynasties of the third millennium BCE are still considered legendary, but archaeological evidence has confirmed the existence of the Shang dynasty and the kings who ruled China from around 1766 to 1045 BCE. Works of art and written documents add to an understanding of the ensuing dynasties of ancient China. The Zhou family (1045–256 BCE) wrested power from the Shang, and they in turn were overthrown by the Qin (221–206 BCE). The subsequent Han dynasty (202 BCE–220) is considered the first Golden Age of Chinese culture, both summarizing and amplifying the achievements of the ancient world.

Buddhism took hold following the collapse of the Han dynasty, during the politically muddled period of the Northern and Southern Dynasties (265–581). Once order had been restored, a second artistic renaissance began in the Tang dynasty (618–906), only to be arrested by another era of political upheaval and realignment, the Five Dynasties period (906–960). The Song dynasty (960–1279), which experienced the fluorescence of Chinese painting, was terminated by invading Mongols, who inaugurated the Yuan dynasty (1279–1368). Soon the foreigners were driven out, and the emperors of the Ming (1368–1644) and the Qing (1644–1912) dynasties, the latter founded by

foreigners from Manchuria, led China into the twentieth century. Through every political cycle of stability, erosion, and chaos, Chinese art expressed the abiding principles of order and energy.

The material in this chapter is organized in two parts. The first highlights sculptural achievements, the second is a chronological overview of Chinese painting. Although references will be made to the dynasties, our attention will focus on artistic attitudes, materials, and subjects.

THREE-DIMENSIONAL MEDIA

Many examples of monumental stone sculpture can be seen in China, including colossal Buddhist images carved into the mountains at Yungang and Lungmen, and freestanding marble animals lining Spirit Ways, the processional roadways leading to the tombs of Tang and Ming emperors. Although never as imposing as the stone statues, the small-scale works in clay, bronze, wood, and jade reveal the technical mastery and artistic inventiveness for which the three-dimensional arts of China have been appreciated.

Clay

Clay provided artists with a versatile material suited to the production of vessels and figural sculpture. The readily available substance lent itself to abstract vessel designs concerned primarily with proportion and placement. Utilitarian and ritual wares were made first in unglazed earthenware and later in glazed porcelain. By the eighteenth century "china," as Westerners called fine porcelains, was a major Chinese export and a status symbol in Europe and in the American colonies. Clay was also an avenue for realistic sculpture. Figurines and life-size statues were included, along with ceramic vessels, in the inventories of Chinese grave goods.

Ceramists were among China's first artists. Their products are associated with one of the oldest cultures in the world, the neolithic *Yangshao culture* (5000–2000 BCE). Excavations at *Banpo*, a neolithic town near Xian on the Wei River, have unearthed semisubterranean pithouses, a cemetery with adult burials, and, in addition to innumerable artifacts, six pottery kilns located outside the twenty-foot-deep protective trench encircling the town.

Among the burial goods from Yangshao sites are distinctive mortuary vessels (a *guan*) (Fig. 40) with globular bodies, narrow orifices, and vertical rims. In the ceramic process called *coiling*, vessels were handbuilt with layered ropes of clay spiraled into the desired shape. The surface was smoothed to erase ridges and seal the coils, painted in earth tones of red and brown, burnished with a stone to produce the dull sheen, and fired in a hillside kiln. Even in this early example we can sense the dualism in Chinese design beginning to emerge, with the pictorial field divided into a large void and an energy-filled compartment. Pairing the swirling lines with cowrie shells, a form of ancient Chinese currency, also anticipates later combinations of real and fanciful motifs.

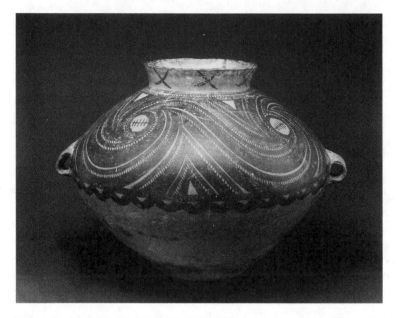

Figure 40 Neolithic (Yangshao, ca. 5000–2000 BCE). Jar (guan), ca. 2200 BCE; painted earthenware; H. 14 1/8" (35.9 cm), D. 7 7/8" (20 cm). The Seattle Art Museum. Eugene Fuller Memorial Collection. Photo, Paul Macapia. © Seattle Art Museum

Four thousand years separate the Yangshao mortuary vessel from the wine jar (Fig. 41) created by potters in the *Yuan dynasty* (1279–1368). Typical motifs on Yuan *blue-and-white ware* include concentric bands of peony-scrolls, large *cloud collars*, and the Islamic-inspired panels at the base.

Millennia of innovations in ceramic technology preceded the blue-and-white glazed porcelain of the fourteenth century. Glazed porcelain is a shiny, translucent ceramic ware made of fine soft clay fired at a high temperature. In the *underglaze painting* process, new in the Yuan period, cobalt-blue pigment was painted on an unfired porcelain surface. A thick clear glaze was applied over the painting before the object was fired. The jar was constructed by pressing clay into a section mold; patterns carved on the outer mold left raised designs on the exterior of the vessel. The process facilitated mass production, necessary because a significant portion of all blue-and-white ware was exported to Islamic markets. Though technology had changed considerably since the Neolithic period, the shape of the Yuan wine jar and the arrangement of its patterns bear a more-than-coincidental resemblance to its Yangshao ancestor. Chinese artists invigorated ancient forms with new motifs and processes, preserving their visual heritage even in the culturally debilitating atmosphere of the Yuan dynasty.

The world's most ambitious project in clay was undertaken at the command of the founder of the *Qin dynasty* (221–206 BCE) and the first emperor

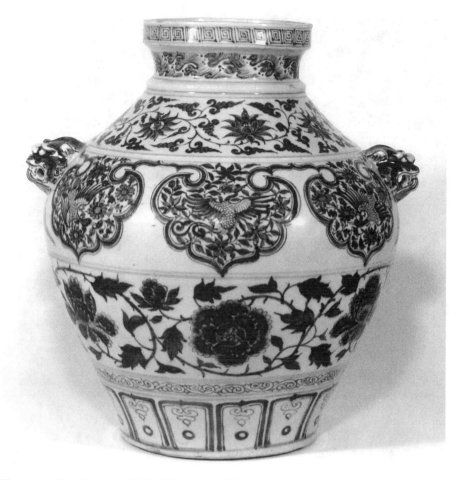

Figure 41 Yuan Dynasty (1279–1368). Jar, ca. 1375; porcelain with underglaze blue decoration; H. 15 3/4" (40.3 cm). The Cleveland Museum of Art, John L. Severance Fund, 62.154

of China, *Qin Shih Huang Di* (259–210 BCE). Although he was a merciless despot, some of his strategies to consolidate political power, such as uniform currency, weights, and measures, and completing the Great Wall to a length of about twelve hundred miles, had long-term benefits for China. Evidently he assumed his political policies of conquest, confiscation, and containment could be extended beyond the grave in his burial complex, the most spectacular archaeological find in Chinese history.

While Qin Shih Huang Di's grass-covered mortuary mound remains undisturbed, the surrounding subterranean pits have been under excavation since the complex was discovered by a farmer near Xian in 1974. Thousands of life-size statues duplicating members of the emperor's army have been

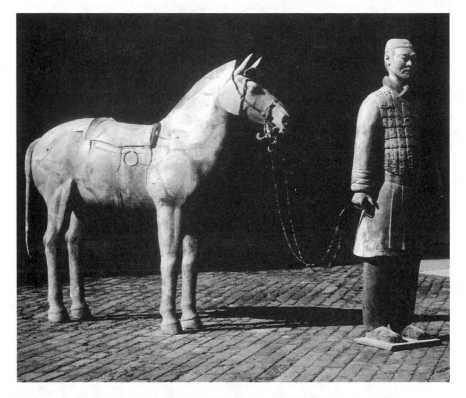

Figure 42 Qin Dynasty (221–206 BCE). Warrior and horse from the tomb of Emperor
Qin Shih Huang Di, ca. 206 BCE; terra cotta with traces of paint; H. 5′ 10 1/2″ (1.79 m).
Shaanxi Province. Courtesy of the Cultural Relics Bureau, Beijing, and the Metropolitan
Museum of Art, New York

recovered, standing in rows by rank, alert and ready to fight. No doubt the
talents of the nation were enlisted for the project, with pottery workshops
across northern China geared up for production. If we include labor con-
sumption as a feature of Chinese art, this clay assemblage would top the list.
Each soldier and horse (Fig. 42) is a freestanding, fired, coarse clay statue con-
structed with a combination of techniques, including coiling, piece-mold,
and direct manipulation of the clay. The heads and hands were created sepa-
rately in two-part molds, with the realistic details worked by hand in a wet
clay coating; every face is a unique portrait. Traces of pigment indicate they
were originally painted in vivid colors, with a pinkish tone reserved for the
hands and faces. The horse, weighing in at about five hundred pounds, is an
almost unimaginable feat of ceramic technology.

Despite his insensitive orders to burn all Confucian books and bury
nearly five hundred Confucian scholars alive, Qin Shih Huang Di's decision
to commission a clay army represented a humanitarian leap over his prede-

cessors' custom of taking real soldiers and horses into the imperial graves. Soon aristocrats were including clay replicas of people, animals, and buildings in their own tombs. Although never as large as the Qin originals, later ceramic mortuary figurines from the Han and Tang dynasties present us with a miniature, three-dimensional view of daily life in ancient China.

Bronze

The feature distinguishing neolithic art from subsequent dynastic art is the conspicuous use of bronze. Possessing bronze was an indication of wealth and authority because procuring and processing bronze required a labor force only a king could muster. Many abandoned ancient cities, notably the late Shang dynasty capital, *Anyang*, have tombs with large deposits of bronze grave goods.

In ancient China, bronze was cast in two categories of objects: ritual vessels, used in sacrifices to the ancestors, and weapons. Aristocrats performed sacrifices in the spirit of filial piety, but it was especially important for the king to maintain contact with the imperial ancestors because they were his source of power. He offered sacrifices on behalf of all the people. With ancestor sacrifices people honored the dead, sought their guidance in earthly matters, and reaffirmed family bonds.

Bronze ritual vessels are classified into two groups, those used for sacrifices of wine and those for sacrifices of meat and grain. They were cooking, pouring, serving, drinking, and storage utensils. The offerings were received by the half of the person's soul that stayed on earth (*hu*); the other half of the soul (*hun*) joined the ancestors. The wine-mixing bucket called a *you* (Fig. 43) is recognized by its bail handle. Our elaborate example was cast during the *Shang dynasty* (1766–1045 BCE), a period of technological, compositional, and iconographic innovation in the arts. It was cast in the *piece-mold* process with a sectional clay mold lashed around a clay core.

As to artistic content, imaginative associations lent themselves to intriguing pairs such as the tiger, a beneficent emblem of the earth, and the man, who stands on the animal's paws with his head in its mouth. The tiger's heart-shaped ears are stylized cicadas, an insect that, because it spends part of its life-cycle in the earth, is a burial motif in Chinese art. Associating the tiger and cicada with the deceased, who will receive the contents of the vessel, underscores the object's function and helps explain why the man allows himself to be devoured by the earth-agent. The tiger's body is modified into an ancient tripod vessel form (*li*), with the curling tail positioned as the third "leg." Visual ambiguities in ancient Chinese design result from such metamorphosing shapes, as well as the absence of blank spaces. Covering the surface are squared spirals, named the *thunder pattern*, and *C-scrolls*, which often coalesce into imaginary animal shapes such as the proto-dragon (*taotie*) along the lower edge between the tiger's paw and tail. Like the dragon, with its symbolic associations of clouds, moisture, springtime, life, and good luck, the

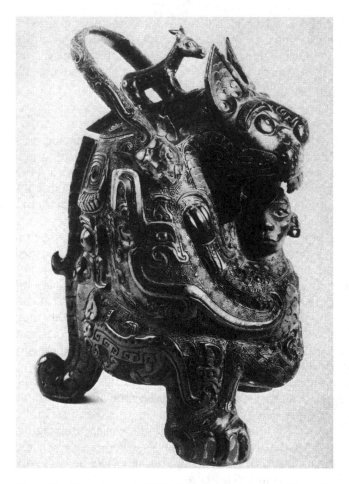

Figure 43 Shang Dynasty (1766–1045 BCE). You; bronze. Musee Cernuschi, Ville de Paris

thunder pattern remained a decorative motif through the history of Chinese art, and we can find it along the rim of the Yuan jar created three thousand years after the Shang you was cast and buried.

In the dynastic periods immediately following the Shang, casting innovations produced bronze vessels with contrasting colors by inlaying gold, silver, and copper in the *cold-casting* method (attaching solid pieces of precious metals to the inside surface of the mold) or by incising directly into the hard surface of the bronze object. Both processes resulted in a more curvilinear, decorative, and two-dimensional treatment with broadly spaced, meandering swirls replacing the tight-knit, geometric thunder pattern. *Han dynasty* (202 BCE–220) artists were particularly adept at forming bronze into fluid shapes, which resemble painted images as much as cast statues.

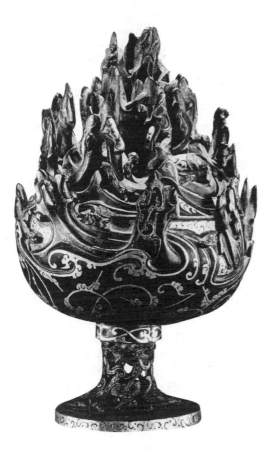

Figure 44 Han Dynasty (202 BCE–220). Incense burner from the tomb of Prince Liu Sheng (died 113 BCE); bronze with gold and silver inlay; H. 10 1/4" (26 cm), 7 lb. 8 oz. Hebei Provincial Museum, Shijiazhuang

Following the collapse of the Shang dynasty, bronze was used for secular objects such as mirrors, musical instruments, and architectural fittings. New forms appeared, notably the mountain-shaped incense burner (*boshan xianglu*) in Figure 44. A unique invention of the Han dynasty, it illustrates one belief in the mystical Chinese religion called *popular*, or *religious Daoism*, so named to differentiate it from *philosophical Daoism* mentioned at the beginning of this chapter. Among the more appealing aspects of religious Daoism, accounting for its large following, was the promise of immortality through the consumption of magic potions.

The imaginative world of religious Daoism was populated with creatures, spirits, and immortal beings whose courts were located on ever-receding mountains enveloped in clouds. The Han incense burner represents a residence of the Immortals, a magic mountain rising from the Eastern Sea.

The linear energy of the old thunder pattern has been recast in expanding and contracting inlaid swirls, which reappear as a design motif on the rim of the Yuan jar. Rushing puffs with trailing wisps are "cloud vapors" to carry the spirits. Immortals materialize in the cliffs, and spirits peek from waves cresting in solid foam on the shore. Smoke emitted from holes in the vessel once mingled with the metallic cloud vapors. The elusive boundaries between substances reflect the Chinese penchant for transformation and energized design, yet Han art is visually more vigorous and thematically more varied than the efforts of preceding periods.

Devotion to the Daoist Immortals was overshadowed temporarily by the arrival of a new "supernatural," the Buddha. Buddhism entered China along the Silk Route during the Han dynasty, but because the beliefs were so foreign, centuries passed before it was assimilated into Chinese culture. How, for example, could a good Confucian conceive of his revered grandfather returning in another life as a goat? When immortality was the goal of a religious Daoist, why would extinction be appealing? Many Indian customs, essential to Buddhist art, were abhorrent in Chinese culture. Pierced ears, bare torsos, and shaven heads were outright barbaric.

It seems logical, then, that the first people in China to embrace Buddhism were foreigners. The *Toba Wei*, a group of Turkish ancestry, founded a Buddhist kingdom (the *Northern Wei*, 386–535) in China during a period of political upheaval, the *Northern and Southern Dynasties* period (265–581). The Toba Wei excavated monastic complexes in the mountains near the Great Wall, but their colossal stone buddhas, with bulging eyes and frozen smiles, were ill-proportioned misinterpretations of Indian models.

Toba Wei artists were more comfortable in the old Chinese medium, bronze, and later statues show a growing artistic refinement. Although the gold-covered bronze Standing Buddha (Fig. 45) incorporates a lotus pedestal and a circular halo with lotus tendrils, the image is definitely not Indian. The mudras—a raised reassurance gesture and a downward gift-bestowing gesture—are too emphatic. Both derive from Indian Gupta sculpture, but the close placement suggests a yin and yang pair. Flaring, pointy *waterfall-drapery* conceals the slender body. In the history of Chinese art, fabric can convey energy and suggest a spiritual essence, but rarely is the body itself an expressive element. Recalling the inlaid gold swirls on the Han incense burner, the full-length laurel-leaf-shaped halo (*mandorla*) is treated as a linear pattern on a two-dimensional surface.

Wood

Five hundred years after the fall of the Northern Wei kingdom, another group of foreigners, a semi-nomadic people of Mongolian descent, established the small *Liao kingdom* (907–1125) beyond the Great Wall in northeastern China. During this second major episode of political chaos, the *Five*

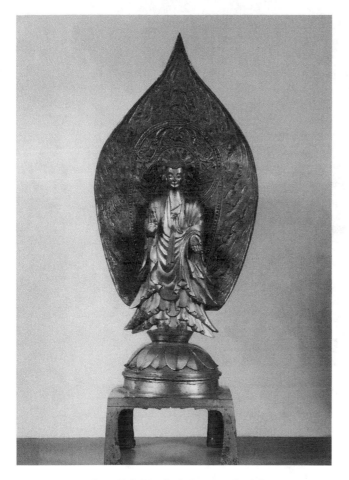

Figure 45 Northern Wei (386–535). Standing Buddha or Maitreya, 535; gilded bronze; with pedestal and halo H. 4'6" (1.37 m). The University Museum, University of Pennsylvania Museum. Object: C355, Neg # S5-2308

Dynasties period (906–960), Buddhist images acquired a grace and physical splendor to rival the beauty of their Indian prototypes.

The magnificent gessoed and painted wooden statue of the Bodhisattva of Compassion, *Guanyin* (Fig. 46), is attributed to Liao artists. In the history of Buddhist art this example ranks among the more compelling renditions of Guanyin, "The Regarder of the Cries of the World." As the beloved Bodhisattva of Mercy, whose name was evoked in times of danger and despair, Guanyin became the focus of independent worship, especially among the lay population during times of political uncertainty in China.

Having transcended the physical limitations of gender, Guanyin is shown as an elegant androgynous being. In its form as the Water and Moon

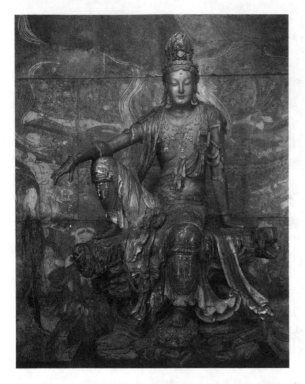

Figure 46 Liao (907–1125) or Northern Song (960–1127). The Water and Moon Guanyin
(Kuan-yin) Bodhisattva, eleventh to twelfth centuries; painted wood; H. 95" (241.3 cm),
W. 65" (165.1 cm). The Nelson-Atkins Museum of Art, Kansas City, Missouri. (Purchase:
Nelson Trust) 34-10. © The Nelson Gallery Foundation. (Photograph by Robert
Newcombe.) All reproduction rights reserved

Guanyin—referring to the Buddhist idea that all reality is as unreal as moon-
light on water—the bodhisattva sits on a rocky ledge, at one with nature. The
drapery, dripping like water over the ledge, and the knotted streamers are
tactile reinterpretations of the stiff peaks of Northern Wei garments. The ear-
lier verticality is softened by a languid ease. Guanyin is dignified yet gra-
cious, while the bronze Standing Buddha is hieratic and remote. Dynamic
symmetry characterizes the composition, from the pedestal to the position of
the limbs. The silhouette is irregular, and the form is open. In contrast, the de-
sign of the Standing Buddha is compact, balanced, and predictable. As we
will discover shortly, both Buddhist statues were three-dimensional rendi-
tions of contemporaneous Chinese painting.

Jade

From our brief survey of the three-dimensional arts, it should have be-
come apparent that Chinese artists excelled in time-consuming processes and

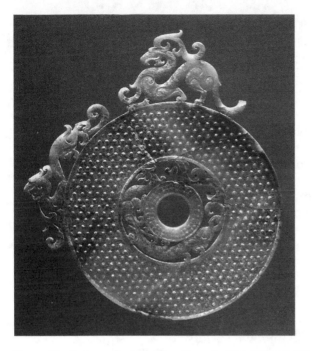

Figure 47 Eastern, also Late Zhou Dynasty (770–256 BCE). Ritual disc (bi) with dragon motif, fourth–third centuries BCE; jade (nephrite); D. 6 1/2″ (16.5 cm). The Nelson-Atkins Museum of Art, Kansas City, Missouri. (Purchase: Nelson Trust) 33-81. © 2000 The Nelson Gallery Foundation. All reproduction rights reserved

technically difficult materials. Exceptionally challenging was jade, a mineral so hard it must be shaped by drilling and abrasion. Prized for its resistance to conventional carving methods, jade was seen as unyielding and full of yang. Jade was also appreciated for its streaked colors, described by ancient Chinese writers as vital spirit surging through the stone; it was flexible and full of yin. To Confucius, jade symbolized the highest moral order.

The technical virtuosity of an anonymous *Late Zhou* (also the *Warring States period*, 770–256 BCE) lapidary is preserved in the delicately pierced, openwork version of a ceremonial jade object called a *bi* (Fig. 47), a flat disc with a hole in the center. With its companion, a prismatic tube called a *cong*, they are believed to represent heaven and earth, respectively. In this daring interpretation of an ordinarily simple shape, the artist disposed a trio of dragons in concentric zones of increasing spatial complexity. In the asymmetric grouping, two dragons, augmented with flourishes of curling *Zhou hooks*, hunch along the perimeter while one stretches around the center. The bi breathes with expanding, contracting shapes and open spaces, created by connecting series of drill holes. The tiny bosses, made by grinding down the background, form the *grain pattern*, which identifies the object as a gentleman's bi.

Bis have been recovered, along with ritual jade axes, daggers, hoes, and pendants, from tombs dating back to the Neolithic period.

PAINTING

Chinese painting is one of the few art forms in our study created expressly to appeal to the artistic temperament. Paintings could function in ritual and didactic contexts, but above all, an acquaintance with painting indicated superior cultural refinement. An aristocrat was distinguished by mastery of calligraphy, painting, and poetry, the genteel activities linked as The Three Perfections. Professional painters, however, were not held in high regard because they, like ceramists and sculptors, were skilled laborers, not cultured gentlemen like those who so avidly collected and critiqued their works. Because of the social polarization of the people who made paintings—the painters—from the people who appreciated paintings—the connoisseurs—those artists who were held in the highest regard were aristocrats who created pictures for their own enjoyment. Eventually, being an amateur painter in China was immeasurably preferable to being a professional; avocational painting appeared near the top of a professional gentleman's resume.

Early Painting, Through the Tang Dynasty

To begin our chronological study of Chinese painting, we should acknowledge its origins in the neolithic Yangshao culture. The frayed bamboo reed used to create the fluid X-marks on the funerary vessel anticipates the finely crafted brushes in later Chinese painting. Clay would always offer an attractive surface for Chinese painters, but it was superseded by silk, the painting support of choice.

The oldest intact Chinese painting on silk is a T-shaped funerary item listed in the inventory of items in the grave as a *fei-i*, which translates to "fly-away garment." In 1971 the perfectly preserved fei-i (Fig. 48) was found atop the wooden coffin of a perfectly preserved Han aristocrat, Lady Dai, who died around 186 BCE. The banner shape foreshadows the popular vertical hanging scroll in later Chinese art. It was painted with brush and opaque mineral colors in earth tones of red and tan. While color is handled as flat paint laid inside firm black outlines, several other elements are rendered with amazing realism. For example, textural variety, a feature of early Chinese painting, is evident in the grain pattern on the circular bi and the scaly dragons threaded through its center. Symmetry prevails in this surface-oriented work, but each motif in the numerous pairs is slightly different from its mate.

The purpose of the fei-i was to assist the hun half of Lady Dai's soul on its flight to the immortal ancestors, so it is replete with symbols mapping the Daoist cosmos. In the vertical section, two horizontal lines anchor earthly scenes. Above the bi, a scene of filial piety includes old, bent Lady Dai receiving respectful attendants, most likely her children. Some distance below

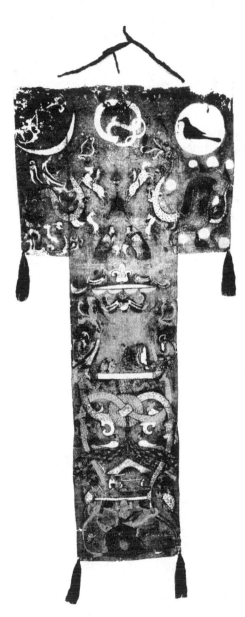

Figure 48 Han Dynasty (202 BCE–220). Fei-i, from the tomb of Lady Dai Hou Fu-Ren, ca. 193–186 BCE; line drawing after original painted silk banner; L. 80 3/4" (2.05 m). Hunan Provincial Museum, Changsha. Cultural Relics Publisher House, People's Republic of China. Computer generated and enhanced image, Charles Boone

the bi is a funeral sacrifice with several bronze ritual vessels. Beyond this or-
dinary world is a mythical space filled with Daoist symbols. Most are famous
in Chinese culture, and the following short list is helpful in understanding as-
pects of many images in Chinese art. The important emblems for our concern
are the animals associated with the cardinal directions and their symbolic col-
ors. Beginning at the top of the vertical section are two phoenixes indicating
the south (red). Dragons of the east (green) frame lady Dai, and beneath the
filial group is the tiger of the west (white). Two turtles and a snake near the
funeral vessels are emblems of the north (black).

It is unlikely we will ever know the name of the individual who painted
Lady Dai's fei-i because in ancient China painters were viewed as common la-
borers. An appreciation for artistic genius and individual personality appeared
in the Northern and Southern Dynasties period (265–581) when analyzing art
became an avocation among the nobility. We would not find these connois-
seurs among the Toba Wei buddha-makers in the north but in the refined
southern courts where individuals devoted time to evaluating artistic quality.

In the closing years of the fifth century, writer Xie He outlined six points
that have endured as the standards for excellence in Chinese painting.
Known as *The Six Principles of Painting,* they have provided the foundation for
art criticism and artistic creativity in China. The first principle says a paint-
ing must have vital energy, or "spirit resonance." The artist must capture the
essence of the subject because the spirit animating the image is more impor-
tant than its exterior appearance. This vital energy, according to the second
principle, resides in the "bones" of the painting, a metaphorical reference to
brushstrokes. The strength of the brushwork, as the visible record of energy,
also reveals the strength of the painter's character. The third and fourth prin-
ciples state that the painting must be faithful to the subject's appearance and
color, respectively; in the Confucian vein, capricious distortions would be
discourteous and show a lack of deference. The fifth principle addresses
proper composition—arrangements must support the theme, and placement
should be both dynamic and meaningful. The sixth principle is also Confu-
cian because it says the experiences of the past are transmitted into the pres-
ent by copying the old paintings. While the idea of copying another artist's
work line-for-line may imply a lack of inventiveness from a Western per-
spective, it is a desirable artistic expression in Chinese and many other Non-
Western cultures. More than merely seeking inspiration from the past, the
Chinese painter cultivated an understanding and a respect for the past by re-
living the strokes of the masters.

From the southern courts, where these attitudes were fostered, came the
first important Chinese painter, **Gu Kaizhi** (ca. 344–ca. 406). Because no
paintings from his hand survive, his work is known through old copies, such
as the Tang dynasty copy of the handscroll *Admonitions of the Instructress to
the Ladies of the Court.* Characteristic of early Chinese painting, its purpose
was educational, in this case to provide models of proper conduct for young

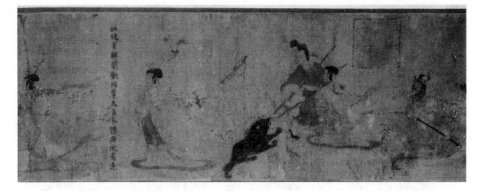

Figure 49 Southern Dynasties (265–581). *Admonitions of the Instructress to the Ladies of the Court,* detail Lady Feng and the Bear, Tang dynasty copy after original by Gu Kaizhi (ca. 344–406); handscroll, ink, slight color on silk; H. 9 3/4" (24.8 cm), L. 11'6" (3.5 m). British Museum, London, Great Britain. Art Resource, NY

women at court. One episode in the handscroll (Fig. 49) shows the virtuous Lady Feng protecting the emperor from a raging bear.

Gu Kaizhi's reputation rests on his economy of means and on his tight, wiry brushstrokes. The lines impart dignity to the most willowy characters. Little movement is conveyed through the figures, but Lady Feng's fluttering ribbons carry her vital energy, her spirit resonance, as she stands shoulder-to-shoulder with the armed guards. The Northern Wei sculptors had cast the curling drapery on the bronze Standing Buddha in imitation of these ink swirls. Lady Feng's placement with the armed guards is an example of the meaningful composition mandated by the fifth principle of Chinese painting. Absent in this painting and the Han fei-i is a setting or framing device. With each component isolated against a flat ground, the actions transcend a specific place and moment to carry meaning in all situations.

Under the patronage of the *Tang dynasty* (618–906) emperors in their magnificent capital, *Chang'an,* painting expanded spatially and thematically. Prevailing taste favored realism with subjects ranging from portraits of people and animals to buddhas and bodhisattvas. Great events, both heroic and tragic, competed with the everyday activities of aristocrats and farmers for the Tang artists' attentions.

An episode from the life of the famous but controversial Tang emperor, *Ming Huang* (also Xuan Zong, reigned 712–56), is presented in a Song dynasty copy after an original Tang horizontal hanging scroll entitled *Ming Huang's Journey to Shu* (Fig. 50). An avid patron of poetry, music, and painting, the emperor also had a special affection for fleshy horses and women. Resenting his obsession with the courtesan Yang Guifei, the army rebelled in 755, driving Ming Huang, his sweetheart, and court loyalists from the capital to the province of Shu (Sichuan). On the way south, Yang Guifei was

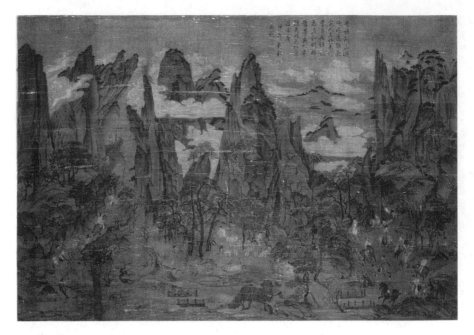

Figure 50 Tang Dynasty (618–906). *Ming Huang's Journey to Shu,* Song dynasty copy after a Tang original, ca. 800; horizontal hanging scroll; ink, color on silk; H. 21 3/4" (54 cm). National Palace Museum, Taipei, The People's Republic of China © W Werner Forman Archive/Art Resource, NY

captured and strangled. The tale of passion and ruin inspired painters and poets for centuries.

The Tang painter divided the narrative into three sections, beginning with the arrival in the valley on the right, pausing with a respite in the center, and concluding with the departure on the left. Presented in the colorful, detailed *blue-and-green style* (also called the *decorative style*) favored in the Tang court, the procession has the flair of a pageant rather than the desperation of flight and pursuit. The panoramic scenery overwhelms the figures while sharp details draw attention to the surface. Overlap establishes an illusion of depth, but the landscape lacks both atmosphere and transitions between colors, due primarily to the black ink contour lines and flat bright colors. Malachite greens and azurite blues touched with gold create a sumptuous metallic surface. The jagged mountains and linear clouds in the Tang painting share qualities with the Han incense burner. In the centuries to follow, the Tang blue-and-green style would fall out of fashion, condemned as a shallow, naive form of art. It was replaced by ink landscape painting and revived periodically as an intentionally archaic artistic expression.

Ink Painting, Song Through Qing Dynasties

Chinese painting matured in the Song dynasty courts and in the Buddhist monasteries outside the capitals. The Song army routed the invaders who had toppled their Tang predecessors, but they were forced to flee their capital city, *Kaifeng,* when a new group of insurgents drove the Song court south of the Yangzi River to the new capital at *Hangzhou.* Therefore, an important distinction is made between the first phase, the *Northern Song* (960–1127), and the subsequent *Southern Song* (1127–1279).

Portraits, still lifes, and genre scenes were painted by Song artists, but it was landscape painting, which had played a minor role in earlier Chinese art, that became the supreme expression. New attitudes toward old materials made the stylistic changes possible. Tonal applications of ink washes, replacing flat colors with black edges, revolutionized the appearance and the artistic potential of painting. Therefore, we must consider the materials and formats available to the Song painters before continuing with the chronology of Chinese painting.

Silk and paper were the two supports preferred by Chinese painters. Because the textures of fine silk and rough paper were critical aspects of a complete aesthetic experience, a Song painter never concealed the support in the way earlier Han and Tang painters had done. Classic Chinese painting from the tenth century onward lacks strong color because it was worked primarily in tones of black ink. For this reason, Chinese landscape painting is called *monochrome painting,* even when slight touches of color are added. To create the ink, a solid *inkstick* of compressed soot and glue was abraded on an *inkstone* and the ground particles mixed with water. The "slight color" in monochrome ink paintings was a solution of mineral crystals mixed with water and glue. Fresh inks and colors were processed for each painting session.

Brushes were specially designed for different tasks, with some reaching the size of brooms. A typical brush had a center core of stiff bristles with soft animal hair on the outside; between the two was an air pocket where the ink was held before the brush was touched to the surface. Wet and dry brushes, referring to the amount of ink the brush held, were created by varying the size of the air pocket. Line quality and tonal range were controlled by the pressure on the brush, the angle of the brush on the support, the density of the ink, and the absorbency of the support. Brushwork, the key factor in evaluating the quality of an ink painting, defined form, carried energy, and revealed the artist's personality. Brushwork interpreted the subject and provided the vehicle for self-expression.

Four basic formats were available. The *vertical hanging scroll* was ordinarily displayed on a wall for the enjoyment of a large audience. The *horizontal handscroll,* by comparison, was designed for an intimate audience, usually a solitary spectator who unrolled the work in short sections, studying individual segments from right to left. The fan was a painting format

uniquely suited to the life of a leisured connoisseur. The basic fan forms, the round *stiff-leaf fan* and the *pleated fan*, presented painters with special design challenges. Finally, sets of paintings on a single theme, called *album leaves*, were assembled in portfolios, often with fans and scraps of old handscrolls.

Northern Song. The justly famous hanging scroll *Travelers Among Mountains and Streams* (Fig. 51) by **Fan Kuan** (active 990–1030) summarizes the style and mood of the Northern Song approach to landscape painting. A technically perfect ink painting, it is rich in the variety of brushstrokes, ranging from short, quick dabs on the hairy mountaintops to the long, sustained stroke for the waterfall on the right. Subtly graduated tonal washes, by contrast, introduce a misty atmosphere to envelope the mountains, shroud the crevices, and glaze the planes.

Chinese landscape paintings do not reproduce the appearance of actual locations, although they were often inspired by an experience of a real place. A painter's goal was to capture the spirit of a place, which was both unique and universal. By contemplating such a rational vision of nature, the viewer would come to respect the order of the universe. Often referred to as *monumental style painting*, Northern Song landscapes communicate the grandeur of nature through majestic mountain ranges. Underscoring the order in a Confucian world, people and their accomplishments are always small in relation to nature; Fan Kuan shows two men with their donkeys in the lower right and a monastery partially concealed in the forest above them. Appropriately, he signed his name in the leaves near one of the men.

Fan Kuan's painting represents the distinctive Northern Song approach to landscape composition, notably in the prominent mountain range with one dominant and two auxiliary peaks. It participates, as well, in the larger tradition of Chinese landscape painting. Reinforcing the close ties between ink painting and calligraphy, Chinese landscape paintings required two motifs—mountain and water—which are the pictorial counterparts to the two characters forming the word "landscape." Water and mountain also correspond to yin and yang principles, things low and high, flexible and rigid. In addition, human qualities are frequently projected onto plant life in Chinese painting. Pine trees are symbolic of longevity, character, and steadfastness. In Fan Kuan's painting, the scrappy pines stand along the edge of the cliff as a fraternity of adventurous, faithful friends. Toward the bottom of the composition, gnarled, leafless trees stoop as wise old men.

Southern Song. The last emperor of the Northern Song dynasty, *Hui Zong* (reigned 1102–25), was an accomplished painter but an inept administrator who lost northern China to invaders. He was captured, and his son fled south with remnants of the Song court. Although Chinese court life resumed its former splendor, the humiliating defeat hung in memories. Southern Song painting matured in a precarious political situation, and we can expect a current of uncertainty to run through the landscapes. Nature became

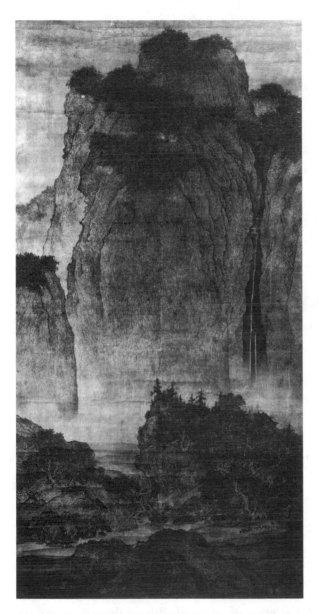

Figure 51 Northern Song Dynasty (960–1127). Fan Kuan (active 990–1030). *Travelers Among Mountains and Streams,* ca. 1000; hanging scroll; ink, slight color on silk; H. 6' 9 1/4" (2.06 m), W. 3' 4 3/4" (1.03 m). National Palace Museum, Taipei, Taiwan

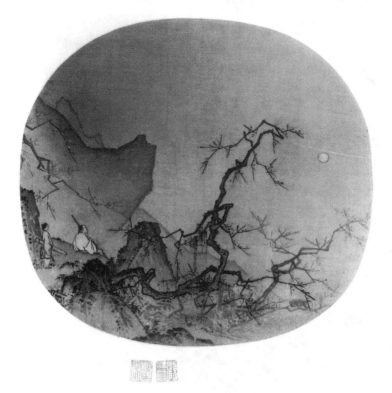

Figure 52 Southern Song Dynasty (1127–1279). Ma Yuan (active 1190–1225). *Viewing Plum Blossoms by Moonlight*; round fan mounted as an album leaf; ink, slight color on silk; H. 11 1/4″ (28.5 cm) × 10 13/8″ (27 cm). The Metropolitan Museum of Art, New York, Gift of John M. Crawford, Jr., in honor of Alfreda Murck, 1986 (1986.493.2)

a gentleman's refuge in the unsettled age, but it was a world where the perfect Confucian order of the monumental style had been disrupted.

Ma Yuan (active 1190–1225) was a premier exponent of *lyrical style* Southern Song landscape painting. *Viewing Plum Blossoms by Moonlight* (Fig. 52), an oval stiff-leaf fan later mounted as an album leaf, is infused with lonely reflection. Fan Kuan's pines have been replaced by the blossoming plum, its early spring flowers symbolic of beauty and purity that perseveres, its thorns metaphors for life's fleeting pleasures and inevitable pain. While sitting immobile in the hostile thicket, the man gazes into the night sky, engaged in the ancient Chinese activity of moonviewing. For centuries, buildings and gardens had been designed to facilitate advantageous views of the moon; traditionally a group activity for the gentry, it is now a solitary act. The illusion of the moon's reflection on the water echoes the message of the plum tree, both as transitory as life itself. The gentleman is oblivious to the attendant who stands respectfully behind his master. The young man, who always

accompanies the scholar in lyrical style Southern Song paintings, holds a musical instrument for the scholar's melancholic response to nature.

Ma Yuan's paintings are narrow-focus visions where individual brushstrokes are readily apparent. His is an art of placement and framing, with near and far linked by repeating elements. Southern Song compositions push the center of interest to one side, hence the phrase *one-corner Ma* often used for these designs. Where solid mountains command the Northern Song composition, over one half of Ma Yuan's painting is empty. On the surface, a diagonal line slices through the composition, dividing the lower left into a congested corner opening abruptly to the vista. Reinforced by the two large plum branches, the Southern Song gentleman's gaze establishes a diagonal movement in depth, compared to the measured, vertically ascending spatial steps in the Northern Song. In this new world, trees are large, mountains are small, and the man dominates the space with his presence. Two protuberances, edged in rich black, nearly close the gentleman's view of the moon. While undeniably refined and excruciatingly sensitive, by Confucian standards this gentleman's world is not quite right.

Suppose we abandon all Confucian order and take a step over the edge of the gentleman's cliff. Then we would be in the minimalist landscapes of **Liang Kai** (died after 1246), a professional artist who had earned the highest painting awards in the Southern Song court before disappearing from the academic setting around 1204. What happened to Liang Kai after he left the court is not known with certainty, but the change in lifestyle allowed him to paint Chan Buddhist subjects in his finest works. In *Chan,* called Zen Buddhism in Japan, Daoism is united with Buddhism. The buddha-spirit, identical to the Daoist vital energy, exists in everything. Enlightenment comes suddenly and happens in the void. Studying the past or reciting the sutras would be useless because a person grasps the buddha-spirit intuitively, almost accidentally. Sudden revelations, unsought and unplanned, ousted book-learning in the Chan worldview. This new unstructured approach to attaining enlightenment is credited to the illiterate Sixth Patriarch of Chan, *Hui Neng* (638–713), who never apologized for his inability to write the poem that won him the leadership of the Chan Buddhist monastic community.

The freedom nurtured by Chan is responsible for Liang Kai's paper hanging scroll *The Sixth Patriarch, Chopping Bamboo at the Moment of Enlightenment* (Fig. 53). Hui Neng performs a menial task because in Chan, ordinary work provides the perfect opportunity for enlightenment. Wisdom and, carrying the principle into the arts, creativity come through "not-trying" (*wu wei*). Alone in the space with fallen trees and nondescript twigs, Chan's leader busily performs the remarkable act of slashing a stalk of bamboo, the symbol of Confucian order. Bamboo was the quintessential emblem of the virtuous Chinese gentleman. It remained green through the winter, a symbol of endurance. It stood straight and rigid, but it survived because it was flexible; its hollow center—the void through which vital energy flowed—gave it

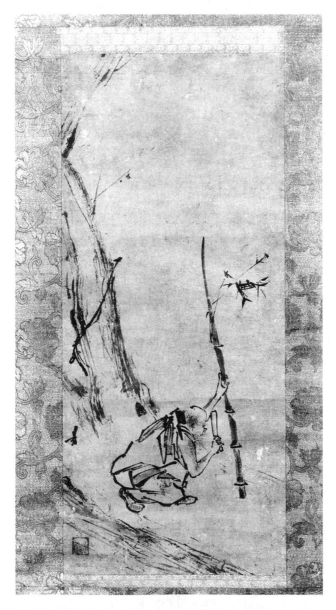

Figure 53 Chan (during the Southern Song Dynasty, 1127–1279). Liang Kai (d. after 1246). *The Sixth Patriarch, Chopping Bamboo at the Moment of Enlightenment;* after 1204; hanging scroll; ink on paper; H. 29 1/4″ (74.3 cm). Tokyo National Museum

strength. Bamboo was segmented, like an ordered Confucian society. Bamboo branches grow closely together, like a solid Chinese family. But the monk hacks away at the venerable symbol, and by abandoning decorum and reason in this non-thought act, he achieves enlightenment.

We could calculate the amount of time Liang Kai spent painting this picture in minutes, which is the point of Chan. The creative urge is unpredictable and the creative act swift. Compared to Ma Yuan's saturated brushstrokes on silk, the thrusts and blobs in Liang Kai's dry-brush painting seem undisciplined and his choice of paper deliberately crude. The brushwork suggests the work of a rank amateur because it does not adhere to the rules of craftsmanship learned by a professional painter. "Amateurness" or personal honesty has been highly esteemed in Chinese painting from the Northern Song dynasty to the present. Amateur painting, called *literati painting* (*wen ren*), was the work of gentleman-scholars, educated court officials who adopted painting as a mode of personal expression. Literati painters and Chan monks broke all the rules with deliberately awkward, anti-craft brushwork; blank paper was their void, their free zone for sudden self-actualization.

Yuan. In the thirteenth century Genghis Khan (ca. 1162–1227) had led his armies across the continent, cutting a path of misery and destruction from India to the shores of Japan. One of Genghis Khan's sons, *Kublai Khan* (reigned 1260–94), defeated the Southern Song, proclaimed himself emperor of China, and adopted the dynastic name *Yuan* (1279–1368), which means "Great Beginning." To his court in Beijing the Mongol emperor welcomed Muslim merchants, Franciscan monks, and Venetian adventurer Marco Polo, who served in his employ from 1271 to 1292, but the Khan's alien presence disgusted the Chinese. Although they had been spared the atrocities endured by other conquered peoples, the Chinese intelligentsia was psychologically decimated by the takeover. The Great Beginning seemed to be the Great Conclusion. Bamboo painting became a rally cry among the dissenting nobility because, like bamboo, they would endure.

An esteemed master of Yuan dynasty bamboo painting is China's leading woman artist, **Guan Daosheng** (1262–1319). The deliberate, sword-stroke brushwork on her short handscroll (Fig. 54) makes it an excellent interpretation of a subject laden with masculine overtones. On another bamboo scroll she wrote, "Wouldn't someone say that I have transgressed?" Bamboo is still considered the most difficult subject to master because the ability to dispose the repetitious shapes is a test of the artist's inventive spirit. Without the aid of detail or narrative, the brushwork must carry the entire weight of the composition. The technical challenges posed by bamboo, coupled with its symbolic associations noted above, made it a popular subject during one of China's most difficult historical periods. With the plum blossom and the pine, it completes the "Three Friends" theme in Chinese painting, symbolizing beauty, steadfastness, and integrity.

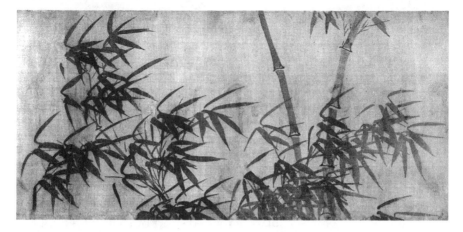

Figure 54 Yuan Dynasty (1279–1368). Guan Daosheng (Taosheng Kuan; 1262–1319). *Bamboo,* 1309; handscroll; ink on silk; H. 11" (27.9 cm), W. 53.1" (135 cm). Julia Bradford Hunntington, James Fund, Courtesy, Museum of Fine Arts, Boston (08.133)

Qing. In the fourteenth century the Mongols were finally expelled and the *Ming dynasty* (1368–1644) was established, to be followed by the last dynasty, the Manchurian *Qing* (1644–1912). Artistic tastes were conservative during the "Brilliant" dynasty and the "Pure" dynasty, as the names translate, respectively. The walled *Forbidden City* in Beijing, with its imposing halls, vast ceremonial plazas, and rectilinear alignment, encapsulates the petrified attitudes of the Chinese court.

Individualists fled the stifling atmosphere at court for the freedom of the countryside. Referred to as the *Eccentrics,* these recluse painters went beyond the literati style in search of artistic freedom. Among the Eccentrics was **Dao Ji** (also Shitao, 1641–1707). A twelfth-generation descendent of the founder of the Ming dynasty and the recipient of commissions from the Qing court, Dao Ji felt like an outsider in the new Chinese high society and left for a Buddhist monastery. In 1697 he renounced his monastic vows and lived out his years as a painter and landscape designer.

Dao Ji's novel album leaf entitled *Wilderness Cottage* (Fig. 55) is a fitting conclusion to our study of Chinese art. Although he never expressed an interest in knowing the past, his composition strays through past styles—bright Tang colors in loose random shapes, a Southern Song asymmetric composition with the weight to the top, Northern Song mist breaking the mountains with sharp white bands. Lines are nervous scratches for trees touched with washes of vivid color. The scholar works quietly in self-imposed isolation, seeking the silence that nurtures wisdom. In a brilliant comment on sudden revelation, Dao Ji places the cottage in midstream; perhaps he shows us that when the man least expects it, a rush will sweep him into the void. As a painter and writer, Dao Ji was an articulate spokesman for artistic freedom.

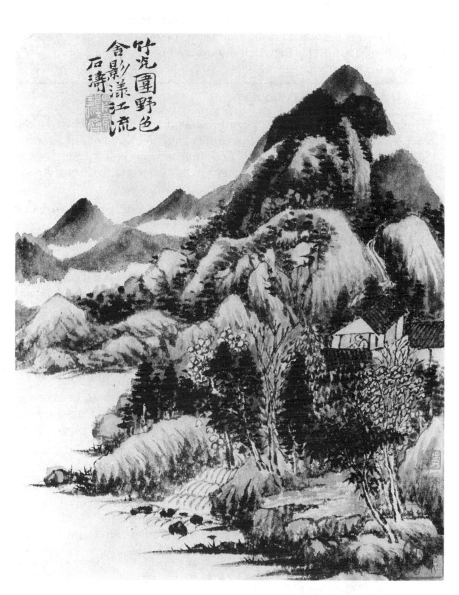

Figure 55 Qing Dynasty (1644–1912). Dao Ji (also known as Shitao; 1641–1707). *Wilderness Cottage*, leaf (g) in the album of twelve leaves, *Wilderness Colors*; ca. 1697–1700; ink, color on paper; H. 15 1/2″ (39.37 cm), W. 11 1/2″ (29.21 cm). The Metropolitan Museum of Art, New York. The Sackler Fund, 1972. (1972.122)

He cared nothing for correctness or traditional standards of excellence, entitling one of his paintings *Ten Thousand Ugly Ink Dots,* the number indicative of a multitude or eternity. His most famous statement translates "I am as I am; I exist; I cannot stick the whiskers of the ancients on my face, nor put their entrails in my belly . . . I prefer to twitch my own whiskers."

FOR DISCUSSION AND REVIEW

1. Summarize the basic points of Confucianism and Daoism. How would each relate to the principles of yin and yang? Review each illustration for the principles of "filial piety" and "meaningful void." Using examples, test the hypothesis that symmetry is associated with Confucianism and asymmetry with Daoism.

2. Compare the outlook of an artist motivated by Confucianism with one motivated by Daoism. Pairing the bi with the cong and the landscape paintings by Fan Kuan with Guan Daosheng, illustrate the points with works of art.

3. Review the purposes for art in China. Which examples in the text best illustrate each? Reviewing the Introduction for comments on "art and relations," discuss Zhang Yan Yuan's observation that "art helps human relations." Give examples from China. India? Africa?

4. How did mastering the clay medium contribute to the development of intricate art objects? Compare the Yangshao vessel with the Yuan jar for 1) construction process, 2) painting process, and 3) decorative motifs.

5. Who was Qin Shih Huang Di? Describe his clay army and discuss it as a "technological marvel" and as a "humanitarian gesture." Was he a humanitarian? What does the burial complex reveal about his personality?

6. How were bronze ritual vessels used in China? Why were these activities important?

7. Bronze ritual vessels constitute a major artistic and cultural expression in China, yet their popularity off the mainland is negligible, compared to the popularity of "china." What may account for the popularity of "china" around the world and through the centuries? In Islamic households? The American colonies? Dining room tables today? Is bronze a better "prestige material" than clay?

8. How can one recognize a guan? A you? A li? Describe the casting process used for all three.

9. Find the following lifeforms and decorative motifs on works of art: tiger, cicada, cowrie shells, dragon, pines, bamboo, plum blossoms, turtle, snake, thunder pattern, grain pattern, C-scrolls, taotie, Zhou hook.

In what media are they found? Which historical periods? Which has symbolic implications?

10. Identify the different contexts in which mountains appear in Chinese art. What is the meaning of the mountain in each? Find the different contexts for water. What is the meaning in each example? How is water represented? Mist?

11. What are the differences between religious (popular) Daoism and philosophical Daoism?

12. Compare the Shang and Han bronzes for purpose, process, and symbols.

13. Usually we think of the body as the energy agent in art, but in China "fabric can convey energy." Analyze the role of fabric in the Guanyin, the Northern Wei Buddha, and the painting of Lady Feng. Compare the Northern Wei Buddha with an Indian or Southeast Asia Buddha.

14. Who is Guanyin? Why might Guanyin be more popular among the lay population than Maitreya? Has the artist captured its true character?

15. Compare/contrast the form and meaning of Shiva Nataraja and Guanyin.

16. What are the processual and symbolic aspects of jade?

17. Discuss the place of the artist in Chinese society. Why were artists "menials" and collectors "connoisseurs"? Who was Hui Zong? Develop the idea of wen ren. Why could amateurs be "more genuine" than professionals?

18. What are The Three Perfections? Which works unite the three?

19. What was the function of the fei-i? Discuss the symbolism, especially the spatial zones. Compare the jade bi with the painted version on the fei-i. What "realities," if any, interested the artist?

20. Brushwork is the "bones" of Chinese painting. Describe the changes in line quality beginning with the fei-i through Dao Ji.

21. Review the Six Principles of Chinese Painting. Select a work to illustrate each point. Which single example do you feel contains all six? Why? Select any Western painting and critique it according to the Six Principles.

22. Consider 1) line quality, 2) composition (placement and focus), 3) subject, 4) mood, and 5) artist for each of the following: Han, Northern and Southern Dynasties, Tang, Northern Song, Southern Song, Chan, Yuan, and Qing. Include two distinctive formal features for each.

23. Choose three examples to illustrate the approaches to setting and space in painting. How is each different?

24. Review the materials, methods, and formats for ink painting.

25. What is wu wei? Your thoughts about this creative avenue? How would concepts such as education and craftsmanship fit in when evaluating works created with the wu wei approach? How can wu wei be reconciled with the sixth principle of Chinese painting? Using the same Western painting used in question 21, critique it according to wu wei.

26. Describe the political climate in China when the following artists painted: Ma Yuan; Liang Kai; Guan Daosheng; Dao Ji.

FOR FURTHER READING

Barnhart, Richard M., et al., *Three Thousand Years of Chinese Painting*. New Haven: Yale University Press, 1997.

Cahill, James, *Chinese Painting*. Skira, 1960.

Capon, Edmund, *Qin Shihuang: Terracotta Warriors and Horses*. Australia: International Cultural Corporation of Australia, Ltd., 1983.

Chase, W. Thomas and K. C. Chang, *Ancient Chinese Bronze Art: Casting the Precious Sacral Vessel*. New York: China Institute in America, 1991.

The Cleveland Museum of Art, *Eight Dynasties of Chinese Painting: The Collections of the Nelson Gallery-Atkins Museum, Kansas City, and The Cleveland Museum of Art*. Cleveland: The Cleveland Museum of Art and Indiana University Press, 1980.

Clunas, Craig, *Art in China*. Oxford: Oxford University Press, 1997.

Fong, Wen C., *Beyond Representation: Chinese Painting and Calligraphy, Eighth Through Fourteenth Centuries*. New York: Metropolitan Museum of Art, 1992.

Lao Tsu, *Tao Te Ching*, trans. Gia-Fu Feng and Jane English. New York: Vintage Books, 1989.

Lee, Sherman, ed., *China, 5000 Years: Innovations and Transformations in the Arts*. New York: Solomon R. Guggenheim Museum, 1998.

Li Zenhou, *The Path of Beauty: A Study of Chinese Aesthetics*, trans. Gong Lizeng. Beijing: Morning Glory Publishing, 1988.

Loehr, Max, *The Great Painters of China*. New York: Harper and Row, n.d.

Medley, Margaret, *The Chinese Potter: A Practical History of Chinese Ceramics*. New York: Charles Scribner's Sons, 1976.

Rawson, Jessica, ed., *The British Museum Book of Chinese Art*. London: Thames and Hudson, 1992.

Rowley, George, *Principles of Chinese Painting*. Princeton: Princeton University Press, 1974.

Sickman, Laurence and Alexander Soper, *The Art and Architecture of China*. New Haven: Yale University Press, 1968.

Silbergeld, Jerome, *Chinese Painting Style: Media, Methods and Principles of Form*. Seattle: University of Washington Press, 1988.

So Kam Ng, *Brushstrokes: Styles and Techniques of Chinese Painting*. San Francisco: Asian Art Museum of San Francisco, 1993.

Sullivan, Michael, *The Three Perfections: Chinese Painting, Poetry and Calligraphy*. New York: George Braziller, 1980.

_____ , *The Arts of China*. Berkeley: University of California Press, 1984.

Tregear, Mary, *Chinese Art*. London: Thames and Hudson, 1987.

Watson, William, *The Arts of China to A.D. 900*. New Haven: Yale University Press, 1995.

Weidner, Marsha, et al., *Views from the Jade Terrace: Chinese Women Artists 1300–1912*. Indianapolis: Indianapolis Museum of Art and Rizzoli, 1988.

Willkinson, Jane and Nick Pearce, *Harmony and Contrast: A Journey Through East Asian Art*. Edinburgh: National Museums of Scotland, 1996.

See also Chapter 3, India, For Further Reading.

5

Japan

Japanese art reflects a reverence for nature, and many of its special features can be linked to the physical setting. Japan is an arc of islands embracing the Asian coast. Covering an area about the size of California, it is a country fractured into a thousand shards of land, each with a uniquely irregular coastline. Only one-fifth of the forested mountain terrain is suitable for human habitation, and even there, volcanoes, earthquakes, and tidal waves disrupt the peace. A feeling of vulnerability and an acute sensitivity to space matured.

Japan was close enough to mainland Asia to receive continental influences but far enough away to cultivate a unique vision. It always looked to China as its primary source of artistic and cultural inspiration, receiving Buddhism, Confucianism, bureaucracy, writing, and most artistic techniques and motifs from its parent culture. However, Chinese artists sought perfection while Japanese artists celebrated the accidental.

ANCIENT JAPAN

Japan maintained a neolithic culture thousands of years longer than China. While the Shang, Zhou, Qin, and Han dynasties rose and fell in China, Japanese lifeways remained village-based. From approximately 11,000 to 300 BCE, during the *Jomon period,* people lived in pithouses and shaped utilitarian and fancy special-use vessels, the oldest ceramic wares in the world. Contact with China, by way of Korea, brought Japan into the age of metal, cities, and kingship.

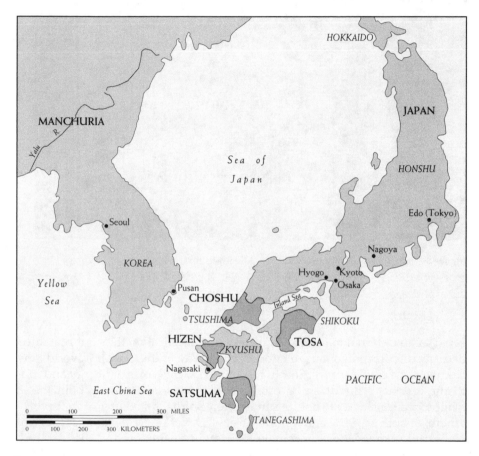

Japan

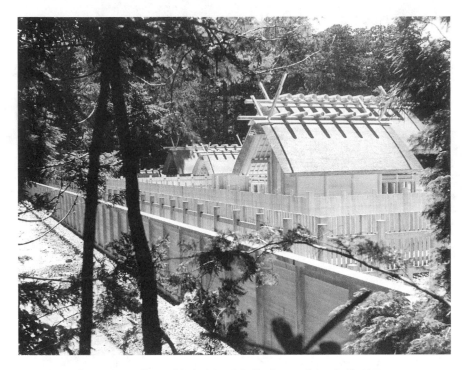

Figure 56 Shinto. Inner Shrine (Naiku), Ise, Mie Prefecture, last rebuilt 1993; cypress wood and cypress bark. Courtesy of Japan National Tourist Organization

Shinto

Japan deferred to China on cultural and political matters but remained dedicated to its indigenous religion, *Shinto* (Way of the Gods). A worldview from Japan's earliest times, Shinto has had no sacred texts or liturgy and, until the arrival of Buddhism, no images. Shinto is an attitude about life, a heightened sensitivity to nature's mysteries. Spirits, called *kami,* dwell everywhere, in both artificial and natural objects. Devotion to the kami consists of respectful acknowledgment conveyed through cleanliness and silence.

A Shinto complex in the woods at Ise marks the sacred site of the high kami and divine ancestor of the imperial family, kami of the sun *Amaterasu Omikami* (Heaven Illuminating Great Spirit). The austere Inner Shrine (Fig. 56) is the centerpiece of a natural site approached down pebbly paths, across streams, and through three fences with wooden *torii* gates. Dated by tradition to 29 BCE, the Inner Shrine has been rebuilt every twenty years since the late seventh century, with the sixty-first renewal performed by Shinto craftsmen in 1993. The projecting ridgepost and the soaring crossed rafters (*chigi*) on the gable ends break from the structure's compact silhouette. Using stilts to ele-

vate the building, an architectural feature borrowed from ancient Japanese granaries, also contributes to the feeling of buoyancy. The weighty cypress bark roof, which conveys feelings of protection and enclosure, is a counterpoint to the building's lightness. These design features, as well as undecorated natural materials and revealed structure, continued to be fundamental qualities of Japanese architecture.

Kofun Period

During the *Kofun period* (300–600/710) Japan began shedding its provincial status as political power was consolidated in one ruling family, the *Yamato*. The growing wealth of the Yamato and other aristocratic families is evident in the size of their earthen burial mounds, especially the distinctive *keyhole-shaped mounds* for individuals of the highest rank. Near Osaka the largest keyhole mound, built for Emperor Nintoku (reigned 395–427), rises ninety feet and with its three surrounding moats covers thirty-six acres.

The grassy surface of a Kofun period burial mound was covered with representational drainage tiles called *haniwa* (clay circle). Haniwa houses and horses, farmers shouldering hoes (Fig. 57), ladies dressed in fashionable Korean-style court costumes, and soldiers in leather armor were fashioned in slabs and rolls of clay. Minimal but meaningful details were appliquéd or etched in the surface. The clean, direct sculptural style correlates with the architectural aesthetic of Shinto.

BUDDHIST ART

The arrival of Buddhism in 538 marked a turning point in Japanese art and society. Initially perceived as a threat to the native kami, it was scarcely tolerated until Japan's champion of Buddhism, *Prince Shotoku* (574–622), stressed its moral benefits. When the political tide turned in favor of the new faith, Buddhism was adopted as the state religion and hundreds of temples were built across the country.

The first Japanese Buddhist images were bronze statues imitating the Northern Wei (386–535) style. Soon the ramrod symmetry and schematic waterfall drapery of the Chinese style were abandoned for a lyrical spiritual style. In the wooden statue of *Kannon* (Fig. 58), the Japanese bodhisattva of compassion, Chinese formality is replaced by a gentle vulnerability. The tip of the metal laurel leaf-shaped halo tilts over the head, initiating an S-curve that carries through the drapery to the base. The winsome Kannon, dematerialized in the manner of jamb statues on a European cathedral, is poetic, in comparison to its didactic Chinese Buddhist counterpart.

Japanese Buddhist architecture, on the other hand, shows no deviation from its Chinese model. Unfortunately, invasions and cultural purges have destroyed almost all old buildings in China, forcing historians to look to the

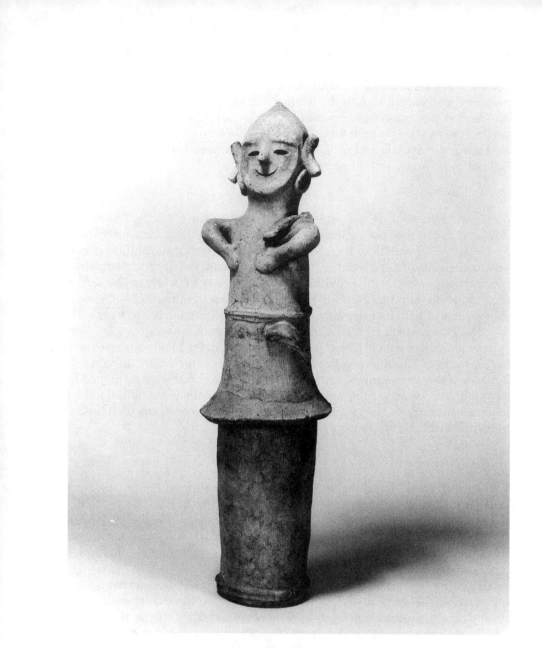

Figure 57 Kofun Period (300–600/710). Haniwa, man carrying a hoe, from Akabori-mura, Gunma; clay; H. 36 3/8″ (92.5 cm). Tokyo National Museum

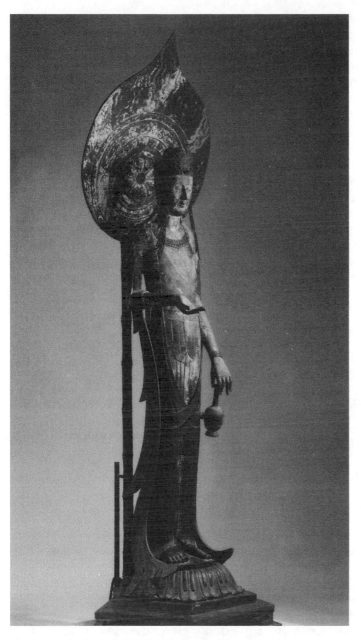

Figure 58 Asuka Period (552–710). Kudara Kannon, early seventh century; painted wood, metal; H. 6'11" (2.1 m). Horyuji Treasure House, Nara

islands for a picture of continental architecture. The Five-Story Pagoda (Fig. 59) at the venerable monastic complex, *Horyuji* in Nara, is an exemplary Tang-style (618–906) building that just happens to stand in Japan. Its purpose and basic form derive from the Indian stupa, modified by the multiple roofs of a Chinese watchtower. When comparing the Five-Story Pagoda to the Inner Shrine at Ise, the differences between Chinese and Japanese design begin to emerge. For example, the Chinese-style pagoda stands on a masonry base, while the Shinto shrine is raised on stilts. Elaborate brackets, a hallmark of Chinese architecture, project from the walls of the pagoda to support the flaring eaves. The bracketing system adds an ornate flavor to the structure, which would be out of place on the spartan Shinto shrine. Paint and goldleaf enhance the decorative appeal of the Chinese transplant, as do the heavy clay roof tiles. Where Japanese design seeks simplicity, the Chinese style delights in complexity. Another difference between the two Asian styles is the placement of the architectural elements. Four equidistant stairways lead to four identical doors on the pagoda, whereas a single stairway rises to one entrance on a long side of the Ise shrine. The asymmetric placement of the main buildings at both Ise and Horyuji is distinctly Japanese, in contrast to the symmetric placement preferred in space planning on the mainland.

HEIAN PERIOD PAINTING

In 898 Japan severed diplomatic ties with China. With the atmosphere cleared of persistent Chinese influences, the national Japanese painting style came into focus. By the year 1000 a unique pictorial vision, soon called *Yamato-e* (Japanese-picture), had crystallized.

Yamato-e Handscrolls

Like its Chinese Song contemporary, Japanese painting was a courtly style. It flourished in the *Late Heian period* (897–1185), named for the capital city, *Heiankyo,* now modern *Kyoto.* Times were peaceful and prosperity afforded leisure time to cultivate artistic sensibilities. Music, poetry, and painting were the forms of communication among Heian aristocrats. They lived splendidly, but isolated from the realities of life. With only themselves to think about, the Heian elites became self-absorbed and preoccupied with manners. Strict etiquette suppressed normal human emotions while the arts oozed sensitivity. Beneath the gorgeous but stiff exterior grew an acute awareness of the nuances of feelings. In their artificially perfect world, the only reality was the fear that an existence so wonderfully beautiful could never last. Prolonged reflection nurtured a preoccupation with life's frailties, which in turn found an artistic outlet in visual and literary metaphor. A melancholic attitude, similar to the Southern Song, entered Japanese painting.

This decorative art, with its air of resignation, was the product of the woman's world. A Heian lady spent her life indoors, moving through the

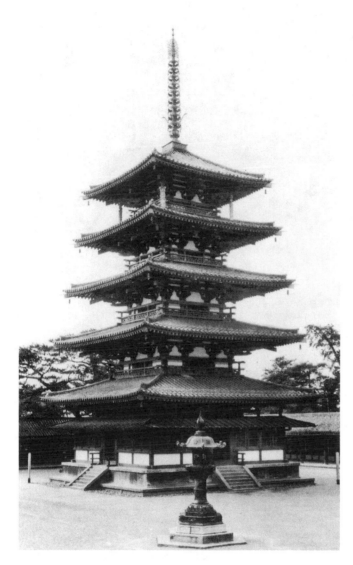

Figure 59 Five-Story Pagoda, Horyuji, after 670; H. 122' (32.45 m)

covered walkways and corridors that linked the numerous chambers in a Heian villa. Because the only men who could see her were her father and husband, portable screens and hanging blinds were set in place when a male guest was received. Yet despite her cloistered existence a Heian lady was given every opportunity to express her feelings in writing, painting, and music. Her most private thoughts found outlets in the stories and pictures she composed.

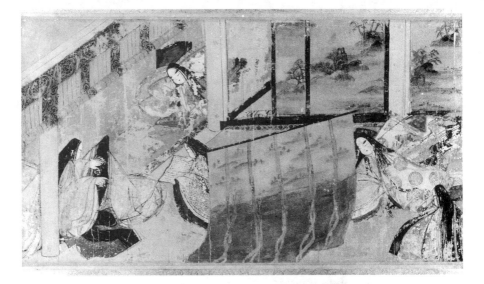

Figure 60 Late Heian Period (897–1185). *Azumaya I*, from *The Tale of Genji*, ca. 1120–40;
handscroll; ink, color on paper; H. 8 1/2" (21.59 cm). Permission: The Tokugawa
Reimeikai Foundation, Tokyo. The Tokugawa Art Museum, Nagoya

Our example of Yamato-e painting is from a classic of Japanese litera-
ture, *The Tale of Genji*, a romantic novel set in Heian high society. Written
around 1000, *The Genji* is attributed to *Lady Murasaki Shikibu* (ca. 970–1015), a
lady-in-waiting to the empress. Figure 60 shows one of the twenty paintings
surviving from the oldest known Genji handscroll. It records a nonevent from
Chapter 50 (*Azumaya*, "The Eastern Cottage"), Lady Nakanokimi having her
hair combed. The incidental episode is singled out because it is a prelude to
doom. Sitting across from her at the toilette is her half-sister, the beautiful Uk-
ifune, who, through circumstances of birth, was an outcast in Heian society.
Lady Nakanokimi agreed to befriend the young woman, not anticipating that
Prince Niou, an irresistible man with a cavalier attitude toward women,
would be attracted to her. Undetected by the women, he spied Ukifune at the
toilette and soon put her in a compromising position. In grief and humilia-
tion, Ukifune eventually drowns herself in a river.

Although Niou is not shown in the painting, having returned by this
time to the Imperial Palace, we can sense his lingering presence in the open
sliding screen. The vertical slice of emptiness in the center, extending from
the open door through the hanging screen, is the tension-filled section. The
landscape painted on the sliding screen, the cascading ribbons on the hang-
ing screen, and the black river of her hair prefigure Ukifune's watery death.
The great tragedy of the painting is that she will die because someone forgot
to close the door.

On first consideration the poignant narrative may seem neutralized by the distinctive Yamato-e painting style. It is highly decorative and two-dimensional, created with thick opaque paint layered over a preliminary ink drawing. A shorthand stroke for nose and brow (*hikime kagibana,* meaning "a line for the eye, a hook for the nose") marks each stylized face. As bodies implode in heaps of angular fabric, we might pause to consider the psychological weight of all the fabric. A disorienting space results from the elevated, voyeuristic viewing angle, with interior–exterior views created by removing the roofs (*fukinuki yatai,* meaning "blown-off roof"). Diagonal lines fragment the space, contributing to the claustrophobic feeling. The design is partly a function of the horizontal handscroll (*e-maki*) format, with only sections of the picture visible as the scroll was unrolled. Nothing is ever revealed completely.

A complete set of scrolls, with text and illustrations for all fifty-four chapters, would have required considerable time to produce. It is not known who painted *The Genji* pictures, although the Yamato-e style was often referred to as the "woman-picture" (*onna-e*). References are made in *The Genji* to the emperor and the empress enjoying the act of painting and to Prince Genji winning a painting competition. If the paintings were not executed by the Heian aristocrats themselves, other evidence points to a team of professional painters, with a master ink painter and subordinate color painters.

Monochrome Ink Painting

A second type of Late Heian painting, using monochrome ink on paper, was closer in appearance to contemporary Chinese painting than was the hard-edged, polychrome Yamato-e style, which drew its inspiration from the archaic Tang blue-and-green style. But Japanese ink painters explored physical and psychological interactions, while in China the theme was the solitary experience in nature. The irreverent attitude of many Late Heian ink painters separates their work from continental or courtly Japanese counterparts.

Few artists were as cynical as the abbot of Kozanji monastery, **Toba Sojo** (1053–1140), traditionally credited with the first two handscrolls in a four-scroll set entitled *Choju jinbutsu giga,* or *Frolicking Animals* as it is popularly called. Unlike *The Genji* handscrolls, these have no text, and the most cursory glance shows why a written narrative was unnecessary. In the last scene in the first scroll (Fig. 61), animals parody the Buddhist clergy and its perceived sham devotions. The dower-faced frog-buddha performs the mudra of reassurance for the monkey-monk chanting before the lotus throne. In the upper right, a compassionate monkey-monk is overcome with ecstasy and, slightly outside our detail, an aristocratic fox-lay-Buddhist sits demurely behind its fan while an ascetic cat intones the rosary. Only the wise owl in the Tree of Enlightenment looks out knowingly. To the painter, human foibles were silly, not the great tragedies envisioned by the Heian aristocrats. Contributing to the painting's satirical bite, the ink lines are witty marks interpreting the

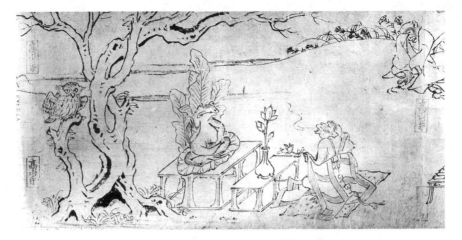

Figure 61 Late Heian Period (897–1185). *Frolicking Animals,* detail from the *Choju jinbutsu giga* (Caricatures of animals and humans), possibly by Toba Sojo (1053–1140), twelfth century; handscroll; ink on paper; H. 12 1/2″ (31.8 cm). Kozanji, Kyoto

main points. The emphatic tree, for example, is painted in black ink, while the insubstantial frog-buddha is rendered in transparent washes.

KAMAKURA PERIOD SCULPTURE

While Late Heian painters explored psychological realism, artists of the *Kamakura period* (1185–1333) excelled in depicting physical realism. The statue of Shunjobo Chogen (Fig. 62) is a nearly photorealist presentation of the old Buddhist monk. With ruthless honesty, the artists carved the sunken eyes and sagging, paper-thin flesh of a man nearly ninety years old. Spirit, conveyed in his determined expression and strong hands clicking the rosary beads, invigorates his frail body. This presentation of a devout Buddhist is worlds apart from the caricature of Buddhists in the Late Heian handscroll.

Kamakura statues were often made of several pieces of wood (*multiple-block sculpture*) in an attempt to avoid the warping and cracking that resulted when a single wooden block was used. In this production method, separate blocks—with specialists carving faces, hands, or elbows—were assembled into a final statue.

Heroes of church and state were memorialized in Kamakura portraits. Shunjobo Chogen was revered for his efforts to restore monasteries destroyed during the civil war that had ended the Heian period and begun the Kamakura. The individual who benefited most from the civil war was *Minamoto Yoritomo* (1147–99), who built his fortress at *Kamakura,* near an inconsequential area that would later grow into modern Tokyo. When his troops seized control of the country, the emperor appointed him military dictator, the *shogun.* For the next seven hundred years (1192–1868) Japan was ruled by a

Figure 62 Kamakura Period (1185–1333). Portrait of Shunjobo Chogen, early thirteenth century; painted wood; H. 32 3/8" (82.2 cm). Todaiji Temple, Nara. National Treasure

shogun, and the emperor was a figurehead. *Samurai* soldiers pledged their allegiance to the shogun, and their no-frills warrior attitude encouraged Kamakura realism. Despite the military dictatorship, Japanese society was convulsed by constant warfare for hundreds of years.

ZEN AND THE WAY OF TEA

Zen Buddhism, which we have encountered as Chan Buddhism in the discussion of Chinese painting, offered an avenue to spiritual peace in the politically tumultuous times. Since the twelfth century Japanese monks had traveled to China to study with Chan masters, but with the diaspora of Chinese monks fleeing the Mongol invasions of the thirteenth century, Zen became a spiritual and cultural force in Japan. Chinese monks were given refuge in Japanese military strongholds because the samurai found the attitudes of Zen to be compatible with their own stringent lifeways; Zen flashes of insight were as swift sword slashes, and prolonged meditation complemented physical self-discipline. Samurai warriors and Zen monks became the arbiters of taste in the *Ashikaga* (also *Muromachi,* 1338–1573) and subsequent *Momoyama* (1573–1615) periods. From their cultural alliance arose Zen ink painting, the meditation garden, and the distinctive architecture and ceramics for the Way of Tea.

Zen Painting

Paintings and poems by Zen monks and samurai warriors tend toward simplicity because understatement is a key feature of Zen-inspired arts. This aesthetic is apparent in paintings by Zen monk **Sesshu Toyo** (1420–1506), the undisputed master of Japanese monochrome ink painting and the country's most esteemed artist. He studied with Zen abbot and painter *Shubun* (ca. 1390–1464) before choosing the life of a recluse. Samurai sought his company in his mountain retreat, a lonely refuge which probably resembled Dao Ji's wilderness cottage.

Sesshu mastered many painting styles, creating landscapes in a dry brush, scratchy style and in the difficult drenched ink technique called *haboku,* which translates as "splashed" or "broken" ink. The hanging scroll in Figure 63 is his finest effort in the minimalist haboku method. All necessary landscape motifs are present, but the painting must be scrutinized before the mountains and water coalesce. With the briefest gestures Sesshu included a village, two figures, and a boat. Tonal ranges are extreme, from deep blacks to barely perceptible veils of gray. Apparently, Sesshu considered this soft brush painting one of his major achievements. Above the landscape he wrote a synopsis of his life leading up to its creation, mentioning his visits to Chan monasteries in China and the names of his teachers. Other Zen monks added inscriptions praising the painting. Sesshu created the painting for one of his students, a graduation gift to a young monk-painter.

Garden Design

Many types of special-use gardens were constructed in Japan. A pleasure garden, for example, was enjoyed by strolling along paths of irregularly

Figure 63 Ashikaga (also Muromachi) Period (1338–1573). Sesshu Toyo (1420–1506). *Landscape,* dated 1495; lower two-thirds of a vertical hanging scroll; ink on paper; entire scroll H. 58 1/4" (147.9 cm), W. 12 7/8" (32.7 cm). Tokyo National Museum

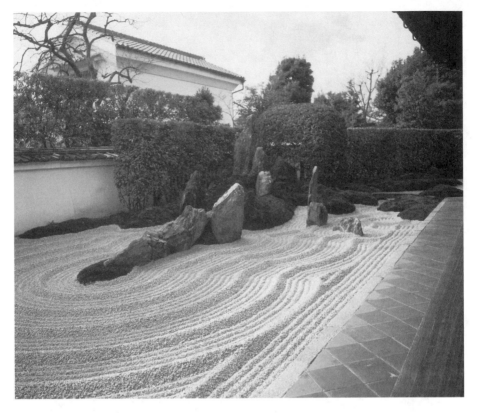

Figure 64 Ashikaga (also Muromachi) Period (1338–1573). Garden of the Daisenin, Daitokuji, Kyoto, possibly by Kogaku Soko (1464–1548); early sixteenth century; L. 47′ (14.3 m), W. 12′ (3.65 m). Photo © Judy Bellah / Photo 20–20, Inc.

placed stepping stones in a cinematic experience where pace and framing were carefully controlled. Many vistas were gigantic replicas of famous paintings or miniature versions of famous scenic locations. To achieve the desired "natural" effect, pines were trained, their limbs anchored with ropes to simulate ancient trees, and the countryside was scoured for boulders with evocative shapes.

Meditation gardens, associated with Zen, would be experienced from the perimeter of the garden, like a viewer contemplating Sesshu's ink painting from outside the paper's space. The plan for the meditation garden of the Daisenin (The Great Hermit Temple) (Fig. 64) at the Daitokuji temple complex in Kyoto is attributed to **Kogaku Soko** (1464–1548), the founder of the Zen monastery where it is located. Collaborating with Zen artist *Soami* (1455–1525), whose ink paintings hang inside the temple, the abbot composed the elements against a white wall simulating the paper background of an ink painting. Within the tiny twelve- by forty-seven-foot space, he orches-

trated stones to rise like mountain ranges and sand to flow in a river rippling near imaginary shores. One horizontal stone suggests a boat, another a bridge no one can cross. Small stones conjure images of fish and turtles in the raked sand water. Pines and moss add the only greenery. Meditation gardens, also called *dry gardens* (*kare-sansui*), are distinctly Japanese because they intensify Zen ideas with Shinto awareness of the evocative potential of natural materials.

The Arts of Tea

For centuries Chan monks had used tea to stay alert during meditations. When the activity of consuming tea passed to Japan it was elevated to a fine art, formalized in the secular Way of Tea (*chanoyu*), or the tea ceremony as it is popularly called. Practitioners of the Way of Tea are quick to point out it is not a "ceremony" but a way of savoring the company of friends while respecting a code of etiquette. To properly prepare and present the thick, green, special-use tea (*matcha*) requires years of training.

By the sixteenth century specially designed buildings were being constructed specifically for the consumption of tea. Rough hewn timbers were exposed inside and outside the rustic *teahouses;* the lowliness of the teahouse was a poverty by choice. Short doors required participants to stoop as they entered the tiny building; the act of deference was a humility by choice. The space was intimate, every action subdued. One hanging scroll or a single blossom displayed in the alcove (*tokonoma*) focused attentions for the evening. The intention was to make participants acutely aware of beauty in the smallest things. As outlined by the great tea master, *Sen Rikyu* (1522–91), the four principles of the Way of Tea are harmony, purity, respect, and tranquillity.

The first tea wares were elegant continental imports, but Sen Rikyu preferred decrepit-looking pottery such as *Shino ware* with its thick, white glaze and desirable pocked surface. The unassuming water jar entitled *Kogan* (Fig. 65), meaning "Bank of an Ancient Stream," summarizes the Zen-based tea aesthetic. Enduring beauty was found in the rough, irregular shapes ordinarily associated with plain utilitarian wares and natural objects such as rocks. Prized were the sad, lonely-looking objects that seemed to hold an eternity of experiences in their beat-up surfaces. The element of chance—which always exists in the creative process whether it be firing a pot or painting a picture—is evident in Kogan's irregular rim, lopsided contour, and crunched base. Cracks and sags were celebrated because mishaps made the object unique and irreproducible; they were as unpredictable as the moment of enlightenment. In comparison with the perfect Chinese jar (see Fig. 41), humble Kogan looks as though it happened naturally. Even the few blades of painted grass, visual complements to the tea's grassy flavor, sustain the harmony of senses and spirit sought in the Way of Tea.

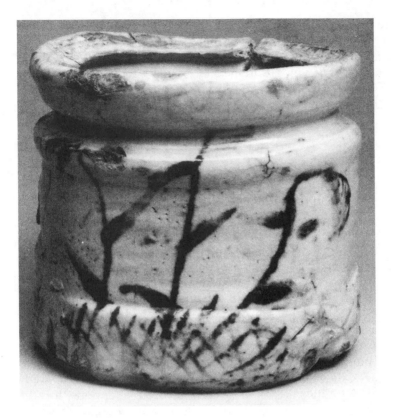

Figure 65 Momoyama Period (1573–1615). Shino water jar, called *Kogan*, late sixteenth century; glazed, painted stoneware; H. 7" (17.8 cm), D. 7.3" (18.5 cm). Hatakeyama Memorial Museum, Tokyo

SCREEN PAINTING

Alongside the austere Zen visions were the opulent expressions of the *decorative style* screen painters. Both aesthetics had their proper places in Japanese life. The decorative style screens were at home in the samurai's castle, never in his teahouse.

A notable change in the new painting is its monumental size. The architectural-scale pictures rivaled but never ousted the smaller hanging scrolls and handscrolls in popularity. Two popular formats were the sliding screen (*fusuma*), a structurally fixed room partition created for a specific location, and the portable folding screen (*byobu*). (The upper section of *The Genji* painting shows a fusuma with a polychrome ink painting.) Both screen formats had a support made of small sheets of paper pasted on a wooden lattice, with a final paper or silk layer for the actual painting surface. Frequently, thin sheets of beaten gold or silver glued to the prepared support provided

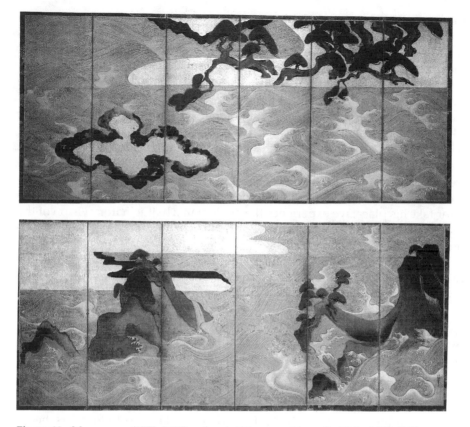

Figure 66 Momoyama (1573–1615) and early Tokugawa (also called Edo, 1615–1868) Periods. Sotatsu (active 1600–40). *Waves at Matsushima*, pair of six-panel folding screens (top, left screen), seventeenth century; ink, color, goldleaf on paper; each screen H. 59 7/8" (151 cm), W. 140 1/2" (356 cm). Courtesy of the Freer Gallery of Art, Smithsonian Institution, Washington, DC (06.231 and 06.232)

the ground for the artist's brightly colored opaque paints, silver and gold paints, and ink.

A pair of six-fold screens (Fig. 66) by **Sotatsu** (active 1600–40) exemplifies the decorative style screen tradition. As any screen painter would, he faced the task of designing several compositions in one work, twelve vertical compositions, two horizontal compositions, and a final long picture incorporating all the parts; each was to be interesting and complete in itself. Inherent in designing either a sliding or folding screen was the understanding that when it was used, parts would be obscured and combined in unpredictable ways.

Characteristic of all decorative style screen painters, Sotatsu's work represents a return to the Late Heian Yamato-e style. Aspects of *The Genji* handscroll have been purified by the Zen temperament. Colors are bolder,

the disposition of shapes and spaces more emphatic. Yamato-e outlines disappear in favor of color-against-color, an approach to painting called the *boneless style,* then in vogue in Ming dynasty China. The foaming waves, on the other hand, unite fluid ink brushwork with silver paint.

Sotatsu drew inspiration from Heian period literature. Besides *The Genji,* he painted passages from the mid-tenth-century classic the *Tales of Ise,* a collection of poems about a Heian nobleman. The title of Sotatsu's screens, *Matsushima,* is the name of a bay located north of Kyoto, one of the three most beautiful landscapes in Japan (the *sankai*). The subject, however, has been traced to an episode in the *Tales of Ise* in which a man, who has been banished from Kyoto, ponders the distance between himself and his home. But the nobleman is nowhere to be found in the painting because Sotatsu has the spectator take his place; we experience the nobleman's hallucinatory vision of the sea, catching a glimpse of a surreal world where clouds become islands without warning or explanation.

Decorative style screens helped illuminate the dark interiors of fortified castles built in the Momoyama period. It was a brief but tempestuous era when neither the emperor nor the shogun could maintain peace, and rivalries between feudal lords (a *daimyo*) erupted in civil war. One personality, the cultivated but ruthless samurai *Toyotomi Hideyoshi* (1536–98), dominated the transitional age. Although an avid practitioner of the Way of Tea, Hideyoshi compelled tea master Sen Rikyu to take his own life.

WOODBLOCK PRINTS

When *Tokugawa Ieyasu* (1542–1616) defeated Hideyoshi loyalists, he inaugurated an era of internal stability, the *Tokugawa,* or *Edo period* (1615–1868). Around his administrative center, the castle he had built at the old Kamakura stronghold, grew the boomtown of *Edo,* now modern Tokyo. In a political move designed to prevent the feudal lords and their samurai from opposing him, Shogun Ieyasu enacted the *alternate residence requirement* (*sankin kotai*), which impelled the lords to live six months each year in Edo while their families stayed on the estates. In Edo, feudal lords spent fortunes on mansions, while still maintaining their estates at home; alone with nothing to do, they spent what remained of their fortunes on entertainment.

A new class of art patrons, the urban merchants, replaced the daimyos and their samurai, whose services were unnecessary in the peaceful, urban climate. Merchants and artisans, traditionally the lowest members of Japanese society, became affluent, influential middle-class citizens. Their tastes in art and entertainment ensured the success of the woodblock print and the activities inspiring it.

The samurai were forbidden to enter the licensed pleasure quarter of Edo, the *Yoshiwara* district, a walled neighborhood set aside for merchant-type entertainments. But they could be seen, disguised in broad-brimmed

hats, mingling with businessmen at the theaters and brothels. For the tourists, artists created inexpensive souvenirs, pictures of the famous actors and courtesans. The pleasure district was a place of insubstantial sensations, an arena for momentary physical stimulation. It lacked tradition, permanence, and purpose, but it was, nevertheless, immensely interesting. For these reasons, the pleasure district was a "floating world" (ukiyo), and the pictures it inspired are called ukiyo-e.

Our selection from among the myriad images to come out of the floating world was inspired by the popular theater, Kabuki. Men, who specialized in male or female roles, performed in the bawdy melodramas and bombastic brawls. Pictures of leading actors, especially members of the Ichikawa clan, were avidly collected by their fans. For decades artists of the Torri family monopolized the production of Kabuki prints because their studio, founded by a Kabuki actor in the 1680s, had acquired exclusive rights to printing theater programs. The Torii studio also printed many illustrated books and single-sheet prints, such as the hand-colored woodblock print by **Torri Kyotada** (active 1720–50). The image (Fig. 67) captures the violent gestures and contorted expressions of the Ichikawa actors, who specialized in "rough stuff" Kabuki. Against a neutral background, typical of eighteenth-century theatrical prints, the actor holds the distinctive "sustained pose" (mie), its unrealistic mannerisms heightened by the angular folds of the "large sleeve" costume. As though imitating the actor, the artist used exaggeration for dramatic effect.

By tradition woodblock printing, traced to fourth-century China, had been reserved for Buddhist texts until the first black-and-white ukiyo-e prints were made in 1658. When color was used on the early prints, such as Torii Kyotada's, it was applied by hand. Multicolor woodblock technology, introduced in the 1760s, required a separate woodblock for each color in the print. Regardless of the process employed, woodblock printing mass produced inexpensive pictures by transferring an image from a wooden matrix to a piece of paper. It was a corporate effort requiring the expertise of publisher, designer, carver, printer, and retailer. Once the publisher had surveyed the market for a popular theme, he commissioned a design from an artist, whose ink drawing was transferred to thin paper and glued to a block of wood. A specialist carved away the wood around the ink lines to create the key block, which aided in the difficult task of aligning the blocks for printing the multicolor prints (nishiki-e, meaning "brocade pictures"). The printer brushed color on the raised areas of the block and covered it with a sheet of strong, absorbent paper. Rubbing the back of the paper transferred the color to the print. The final printing was the key block, which overlaid the black outlines.

The public never tired of provocative ukiyo-e subjects, but in the nineteenth century an old painting theme, the evocative landscape, entered the world of prints. In 1823 master printmaker **Katsushika Hokusai** (1760–1849) began a series of prints, Thirty-six Views of Mount Fuji, with the auspicious kami site as the backdrop for human activities. Reflecting the influence of

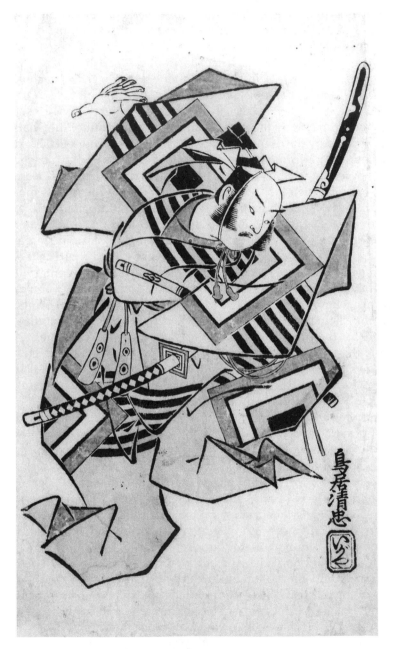

Figure 67 Tokugawa Period (1615–1868). Torii Kyotada (active 1720–50). *An Actor of the Ichikawa Clan*, hand-colored woodblock print on paper; H. 11 1/4" (28.48 cm), W. 6" (15.24 cm). The Metropolitan Museum of Art, New York. Harris Brisbane Dick Fund. 1949 (JP 3075)

Figure 68 Tokugawa Period (1615–1868). Katsushika Hokusai (1760–1849). *Great Wave at Kanagawa,* from *Thirty-six Views of Mount Fuji,* 1823–31; multicolor woodblock print on paper; H. 10 1/8" (25.7 cm), W. 14 3/4" (37.5 cm). Spaudling Collection Fund. Courtesy, Museum of Fine Arts, Boston

European painting, he juxtaposed large foreground and small background shapes in *The Great Wave at Kanagawa* (Fig. 68). In addition to the novel spatial treatment, he restricted the color to shades of Prussian blue, a recent import to Japan; even the overlaid outlines are blue. Despite the foreign influences the theme is wholly Japanese. In a union of yin and yang, the surging arc of the ocean rises to embrace the mountain. The men are tossed about by the gigantic claw, but they seem at peace with its power; safety exists in respect for nature.

FOR DISCUSSION AND REVIEW

1. Japan was influenced by China in many ways, but often their approaches to art-making were different. Discuss this statement, referencing specific works of art.

2. Review the principles of Shinto and the character of kami. Compare to other cultures with spirit beings, such as early India and Africa.

3. Summarize the design features of the Inner Shrine at Ise. How does the design complement the attitudes of Shinto? Do the haniwa and the keyhole-shaped mound share Shinto aesthetics?

4. What is a haniwa? Where would it be found? Compare with the Qin soldier. Which is more "modern" in style? Why?

5. Buddhism was viewed as a threat when it first arrived in Japan. Discuss possible reasons for the hesitant response on the islands. Compare with the reception of Buddhism in China. In Tibet.

6. Who is Kannon? Can a Shinto aesthetic be detected in the wooden statue? Compare with Guanyin for style and mood. Compare with the Northern Wei Buddha for the early Chinese influence on Japanese art.

7. Identify Chinese design elements in the pagoda at Horyuji. Compare with Ise.

8. Describe life during the Late Heian period. It has been estimated that only about fifteen hundred people experienced that "life," yet it shaped the cultural character of Japan to the present day. Your thoughts on how any nation's culture is shaped. Compare an aristocrat's life in the Late Heian period (897–1185) with one in Song dynasty (960–1179) China, especially the Southern Song (1127–79).

9. How did the arts relate to the cloistered existence of a Heian lady? Compare "woman-painting" and *The Tale of Genji* with Guan Daosheng and the literati tradition in China.

10. List all the features of the Yamato-e style. Does the style obscure the true feelings of the characters in the narrative? The painter? If so, why do you suppose Japan did not produce more emotional renderings? Also, restate the story told in the illustration. What other "non-events" have we seen in Non-Western art? What are the strengths and weaknesses of the handscroll format for storytelling?

11. Compare/contrast Yamato-e and Japanese monochrome ink painting for style. For subjects. For mood. As "woman-painting" and "man-painting." Reconsider question 6, in Chapter 1, Africa.

12. Toba Sojo's paintings approach the modern notion of "caricature." Discuss this idea in the Frolicking Animals detail. Compare with Liang Kai's Sixth Patriarch.

13. Describe the political climate during the Kamakura period. Why would realism be the dominant art style? Two classics of Japanese culture appeared in the period, the shogun and the samurai. Who were they? Why are they important in art? Why would Zen appeal to them?

14. Zen is the last form of Buddhism we will study in this text. Briefly recount the movement of the religion from its inception in India, and its different manifestations. Consider, especially, "sudden enlightenment."

Relate this Buddhist concept to the "spontaneous creative act." Why was Zen so successful in Japan?

15. Who was Sesshu Toyo? What are the Zen-inspired elements in his work? Analyze his brushwork and composition. Compare his with the work of Liang Kai and Dao Ji, asking what modifications the Japanese painter made to the Chinese heritage. Consider Daoist and Confucian components.

16. Describe the materials and meanings of the Japanese dry garden. What connections exist between Zen painting and meditation gardens?

17. Japan's ceramic tradition, the oldest in the world, culminates in Shino ware. Discuss the relation between technological progress and artistic process. Ancient values in a modern world. Discuss Shino ware and the principle of wu wei. Compare Shino ware with Yuan blue-and-white ware.

18. Using Sen Rikyu's Four Principles of the Way of Tea, evaluate the Shino water jar. The teahouse. The Inner Shrine at Ise. The pagoda at Horyuji.

19. The British are also famous for "the consumption of tea." How is the Japanese Way of Tea different?

20. Describe the Japanese screen formats. Compare with the Late Heian period horizontal handscroll for viewing experiences. Compositional challenges. Compare Sotatsu's painting style with Late Heian. With Tang dynasty China. All three narratives use the decorative style. Why was the decorative style suited to this format? How does Sotatsu's elimination of the main character affect the painting's mood and a viewer's reaction?

21. Describe the political and social climates during the Edo period. What was the policy of "alternate residence"? What influence did it have on the arts? Artists? Patrons?

22. What was the Yoshiwara? Was it accurately called "a floating world"? Which of its activities were popular in art? Why?

23. Describe the woodblock printing process. Include the two methods for applying color.

24. Discuss the Great Wave as the summation of the landscape tradition in Asian art.

FOR FURTHER READING

Faulkner, Rupert, *Masterpieces of Japanese Prints: The European Collections, Ukiyo-e from the Victoria and Albert Museum.* Tokyo: Kodansha International, 1991.

Guth, Christine, *Art of Edo Japan: The Artist and the City, 1615–1868.* New York: Harry N. Abrams, 1996.

Itoh, Teiji, *The Gardens of Japan*. Tokyo, London, New York: Kodansha International, 1998.

Link, Howard A., *The Theatrical Prints of the Torri Masters: A Selection of Seventeenth and Eighteenth-century Ukiyo-e*. Honolulu: Honolulu Academy of Arts and Riccar Art Museum, 1977.

Mason, Penelope, *History of Japanese Art*. New York: Harry N. Abrams, 1993.

Munsterberg, Hugo, *The Japanese Print: A Historical Guide*. New York and Tokyo: Weatherhill, Inc., 1982/1991.

Murasaki Shikibu, *The Tale of Genji*, trans. Edward G. Seidensticker. New York: Alfred A. Knopf, 1977.

Newland, Amy and Chris Uhlenbeck, eds., *Ukiyo-e to Shinhanga: The Art of Japanese Woodblock Prints*. The Mallard Press, 1990.

Noma, Seiroku, *The Arts of Japan*. Vols. I and II., trans. John Rosenfield. Tokyo and New York: Kodansha International, 1966/1978.

Okudaira, Hideo, *Narrative Picture Scrolls*, trans. Elizabeth ten Grotenkuis. New York and Tokyo: Weatherhill and Shibundo, 1973.

Paine, Robert Treat and Alexander Soper, *The Art and Architecture of Japan*. New Haven: Yale University Press, 1981.

Stanley-Baker, Joan, *Japanese Art*. London: Thames and Hudson, 1984.

Suzuki, Daisetz T., *Zen and Japanese Culture*, Bollingen Series LXIV. Princeton: Princeton University Press, 1970.

See also Chapter 3, India and Chapter 4, China, For Further Reading.

6

Oceania

Oceania is a term for the islands sprinkling the seas around Asia. Most are little chips of land, like the Japanese archipelago, but one is a landmass of continental proportions. Tahiti, Fiji, and the Hawaiian Islands are a few of the better-known exotic locales for Oceanic art. Our selections from New Zealand, New Guinea, and Australia will represent the artistic achievements of the diverse, individualized Oceanic cultures. All share artistic similarities such as preferences for portable objects, body ornamentation, and wooden sculpture. Shared subjects include clan affiliation, ancestor veneration, fertility, and warfare.

Unlike the nearby island civilizations of Japan and Java, the Oceanic communities on the Pacific Rim existed outside the sphere of Indian and Chinese influence. In some regions, a neolithic lifeway is still maintained. While the mechanics of their everyday lives were and, in some cases remain, rudimentary by the standards of industrialized nations, the arts and worldviews of Oceanic peoples are highly sophisticated expressions with traditions reaching back to remote antiquity.

NEW ZEALAND

New Zealand, a Polynesian island off the southeastern coast of Australia, is home to the *Maori* people. They had been living on the island for at least seven hundred years by the time Europeans arrived in 1768. The Maori were militaristic village-dwelling fishermen with chiefs governing the socially stratified communities. Dozens of clans aggressively defended their territorial boundaries in intertribal conflicts.

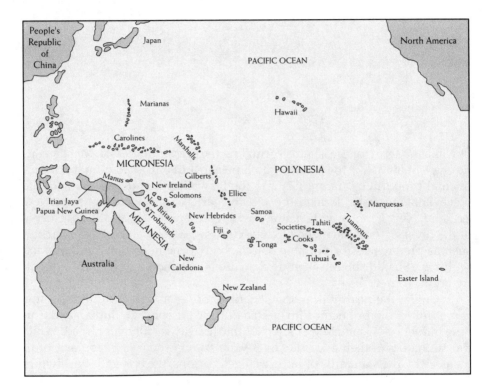

Oceania

Figure 69 New Zealand (Maori). War canoe prow, eighteenth century; wood; L. 45 1/4" (114 cm). WE 1202. Photographer: Jan Nauta. Photograph copyright © Museum of New Zealand Te Papa Tongarewa, Wellington

Maori war canoes were launched from the fortified coastal villages. The monumental transports, capable of holding forty to eighty warriors, were also vehicles for artistic expression. The dugout canoe was protected by symbolic carvings on the prow (Fig. 69) and stern. Our example highlights a fearsome head with lolling tongue and two large spirals whirling with the ocean energy of Hokusai's *Great Wave* (see Fig. 68). Two protective ancestors (a *Kaitiaki*), one on the bottom and another facing the warriors, unite life and death symbolism. Tiny curved-beak bird heads (*Manaia*), also symbolic of life and death, peck at the spirals and connecting bars that stabilize the openwork carvings. In the manner of Islamic ornamentation and Early Medieval European manuscript paintings, Maori designs are intricate patterns with symbolic and decorative functions. The pierced wood gives the frightening imagery a fragile appearance.

NEW GUINEA

The island of New Guinea is divided into two political regions: Irian Jaya, a province of the Republic of Indonesia, occupies the western half, while the independent nation of Papua New Guinea populates the east. Although the Asmat people of Irian Jaya and the Sulka people of Papua New Guinea are separated by the geography of modern politics, they share the same language group, and their lifeways and ceremonialism have much in common.

Irian Jaya

The *Asmat* people are village-dwelling hunter-gatherers. Before they made sustained contact with the West, which did not occur until after World War II, the Asmat were a warlike people. Today they struggle to preserve vestiges of one of the world's last surviving neolithic cultures.

The brackish, muddy waters and thick jungle foliage of the lowland coastal swamps where the Asmat live probably encouraged the eerie quality of Asmat art. Two related themes, ancestor veneration and headhunting, supplied the subjects and motivations for art. Many symbols appearing in connection with these themes derive from the Asmat creation story. The Asmat culture hero, *Fumeripits,* carved the first humans from trees and, reflecting their arboreal ancestry, the Asmat call themselves *Asmat-ow,* meaning "We, the Tree People." In the tree metaphor, fruit symbolizes the human head. Fruit-eating animals, including birds and fruit bats, are symbols for headhunting activities, along with the female praying mantis, which consumes the head of the male after mating. The tree does not appear as a visual motif because the works of art themselves are carved from wood.

Headhunting was associated with male initiation rites. Blood of the decapitated head was mingled with the blood of the newly circumcised boy, energizing the ancestral spirits and the young warrior with the life force tapped from the dead enemy. When a clan member fell to an enemy's knife the family avenged his spirit with a head taken from the offending clan. Large, carved wooden spirit poles (*mbis*) were also set up as receptacles for the wandering spirit; carved with small canoes at the base, they ferried the spirit to the open sea.

During the special shield feasts, held before headhunting raids, men shaped war shields (*jamasji*) from planks of mangrove tree root and embellished them with painted relief carvings of military and virility motifs. The mystical protection provided by the images was as important to the warriors' well-being as the physical protection provided by the slab of wood. The contour of the left shield in Figure 70 has phallic overtones, and the stylized fruit bats along the central axis supply the headhunter symbolism. The middle shield is surmounted by an ancestor head carved in-the-round; other male and female ancestors are carved in relief on the top and bottom. Characteristic of the Asmat rendering of the human body, their diminutive heads, articulated genitals, and dangling limbs imitate the praying mantis. The splayed position, also seen with the male ancestor on the right shield, is considered to be a protective pose. Bird-like C-shapes (a nose ornament associated with headhunting) and S-shapes (identified as the stomach incision on a headhunting victim) add potent symbols to unite the main elements in the composition. Because headhunting is outlawed now, the Asmat create war shields for art collectors.

Papua New Guinea

Sometime around the first decade of the twentieth century a *Sulka* artist of East New Britain Province devoted about one year to plaiting, carving, and painting a gigantic *umbrella mask* representing the outstretched wings of the praying mantis (Fig. 71). The circular superstructure was constructed by lash-

Figure 70 Irian Jaya (Asmat). War shields, twentieth century; painted wood. The
Metropolitan Museum of Art, New York. The Michael C. Rockefeller Memorial
Collection, Gift of Nelson A. Rockefeller and Mrs. Mary C. Rockefeller, 1965
(1978.412.918, .925, .929)

ing plant fibers on a frame of lightweight sticks, adding concentric hoops of
branches, and finally plaiting fibers on the grid. Patterns on the wings were
created with black soot and red and green dyes. The insect's body is a carved
and woven three-dimensional figure attached to the underside of the um-
brella. In its pincers it holds a potato, the food staple of the Sulka people.
Grasses hanging from the conical tuber conceal the body of the dancer; more
than a mask, it seems to recreate the entire forest setting.

 When the masker performed, during a funeral or initiation ceremony,
he jumped up and down in place while holding the umbrella parallel to the
ground; then he tilted the umbrella backward to display its underside. The
artist's virtuosity was augmented by the performer's strength. Everyone
would be permitted to watch the performance, but the masker's identity was
withheld from women and children.

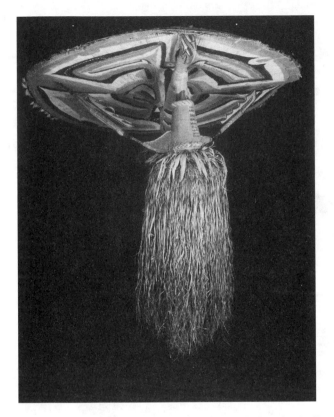

Figure 71 Papua New Guinea (Sulka). Praying mantis umbrella mask, collected 1910; plant fibers, feathers. The Field Museum, Chicago 138910. Photo, J. Weinstein and D. Alexander White 111293 © The Field Museum, Chicago, IL

AUSTRALIA

On the continent called "the empty land" by eighteenth-century European explorers, Aboriginal Australians have been creating works of art since remote antiquity. Examples of their rock art are tens of thousands of years old; other important art forms, such as body painting and bark painting, last less than a lifetime.

Aboriginal Australian artists create paintings on behalf of their local community; they are custodians of vital communal traditions. In particular, they assume responsibility for preserving a collection of stories called *the Dreaming,* which recounts the adventures of supernatural beings in *dream time,* the mythical past before people. The Dreaming stories were given to people by *mimi*—thin spirits whose appearance in pictorial form is similar to the Asmat praying-mantis-type humans—and passed on through oral and visual traditions. The Dreaming episodes are always tied to specific places on

the landscape; they tell the creation stories of the people who live in that area and, by retelling the stories, the group asserts its claim to the territory. The land belongs to them because the spirits tailor-made them for the place. The supernaturals of the Dreaming travel from named-place to named-place, leaving traces of their spiritual presence on the landscape; often they changed themselves into geographic features. Most paintings are, therefore, a form of landscape painting showing familiar places in a fantastic way, as they existed in dream time.

Regional styles identify the geographic origins of particular Dreaming paintings. *The Rainbow Serpent, Yingarna* (Fig. 72) by **Bruce Nabekeyo** (ca. 1949–89) represents the *northern style.* In the traditional Aboriginal Australian metaphor for birth, the supernatural snake swallows humans, whom she will transform into landscape features by regurgitation. Vomiting is the primary creation and renewal motif; drawing on the concepts of transformation and emergence it addresses ideas of cyclic change in nature, especially the life-renewing monsoon season, and human renewal through past and future generations. The x-ray view, characteristic of northern Aboriginal art, exposes the events taking place inside her body. The waterhole where Yingarna lives is indicated by the waterlilies on her back; this, and all other vital information, is recorded with firmly outlined shapes. Crosshatched patterns (*rarrk*), also pointing to the painting's northern Australian origin, are the personal property of individual clans.

Nabekeyo's process—painting with earth tones on prepared sheets of bark—is another northern Australian feature. When painting the picture he rotated the bark as he held it on his lap; by designing the work with no fixed viewing angle, Nabekeyo produced an overall composition to fill the picture plane from edge to edge. Because the process is more important than the finished product, bark paintings are ordinarily discarded after use. The earliest collected examples are from the 1830s, but the antiquity of bark painting is presumed to be much older.

Paintings by **Clifford Possum Tjapaltjarri** (born around 1932) represent the regional style practiced in the deserts of the Northern Territory, particularly around the city of Papunya. Combining a highly abstract with a nonrepresentational style, paintings such as *Bush Dreaming* (Fig. 73), are filled with veiled symbols that only an audience initiated into the Dreaming sequence could decipher. The purpose of this Dreaming episode was to state codes of correct social conduct by illustrating the consequences of antisocial behavior. The subject of *Bush Dreaming* is the death of two brothers trapped in a fire their father had set to punish them for greed and lack of filial piety. The luminous, patchy background represents the path of destruction; red indicates flames, gray is the smoke-filled atmosphere, and the wavy lines represent smoke carried by the desert winds. Having established the setting, Possum Tjapaltjarri introduces the narrative motifs—the skeletal remains, the abandoned weapons, and the bundles of bush used by the young men to

Figure 72 Aboriginal Australian. Bruce Nabekeyo (ca. 1949–89). *The Rainbow Serpent, Yingarna;* 1989; natural pigments on eucalyptus bark; H. 59 1/8" (150.1 cm), W. 15 7/8" (40.4 cm). National Gallery of Australia, Canberra. Photo © National Gallery of Australia

Figure 73 Aboriginal Australian. Clifford Possum Tjapaltjarri (b. ca. 1932). *Bushfire Dreaming,* 1982, Papunya Northern Territory. Synthetic polymer paint on canvas, 81.0 × 100.8 cm. Art Gallery of South Australia, Adelaide. Elder Bequest Fund 1984. 846P12

fight the fire. The interplay of curved and straight lines with light and dark textural reversals is as compelling as the Dreaming episode that inspired the painting. A lustrous field of dots, invigorating the surface with sparkling patterns, has become a hallmark of the artist's style, as have the pair of skeletons and the horizontal division of the picture plane.

Possum Tjapaltjarri is one of a growing number of Aboriginal Australian artists who have, since 1971, chosen synthetic paints and commercial fabrics for their paintings. Acrylic paints enabled him to achieve the brilliant color characteristic of the *desert style,* but the European easel held no appeal, and he continues to compose with the linen laid on the ground. Possum Tjapaltjarri was introduced to watercolor and acrylic paints by Geoffrey Bardon, a European school teacher in Papunya. Bardon encouraged the adults to paint murals in the school and soon supplied them with acrylics. During his tenure, the *Papunya Tula Artists' Cooperative,* for which Possum Tjapaltjarri continues to produce many works, was founded to safeguard the interests of the painters and to bring their works to an international audience.

FOR DISCUSSION AND REVIEW

1. Review the Oceanic cultures, isolating at least three artistic/cultural features held in common. Include examples of each.

2. Geographically speaking, Japan is a cluster of islands, like Oceania. What reasons can you suggest for the profoundly different lifeways? Are the artistic traditions also "profoundly different"?

3. Review the role of ancestor spirits in Oceanic art. Any relevant comparisons with Africa? With China? With Japan?

4. Discuss the functional and aesthetic aspects of the Maori war canoe.

5. Patterns can be symbolic and decorative. Identify specific patterns and their meanings in this chapter. In Islamic art. In Benin art. In Chinese art. How does the idea of "meaningful patterns" affect an audience's ability to respond to a work of art?

6. Review the function of Asmat shields, focusing on the meanings of shape, figure, and design to enhance the function. Does the art echo the people's lives?

7. Asmat shields are now created only for art collectors. Why has this happened? Debate the question of whether recent works are valid cultural objects, offering arguments from both perspectives. Include Aboriginal Australian painters, who also work for a global market, as well as examples from previous chapters. Have these people "sold out"? Considering its original meaning and function, why would a Western collector want to own an Asmat shield? Discuss concepts of art changing with its context. From the purposes for art listed in the Introduction, choose which best fits the original function and the current function of the shields.

8. What are the Dreaming stories? How are they represented in pictorial form? How is transformation, an essential component of the Aboriginal Australian worldview, represented in the stories?

9. The landscape is an important source of inspiration for Aboriginal Australian artists. Discuss their perception of the land, as reflected in the art. Tie your answer with question 8 by considering people "transformed into landscape features." Discuss the notion of "landscape" by comparing with a Chinese painting. With the Senufo wooden door.

10. List the animals and plants in Oceanic art. What is the meaning of each? Any parallels with question 5 from Chapter 1, Africa? Question 9 from Chapter 4, China?

11. Review the Aboriginal Australian painting processes. List all features distinguishing the northern style and the desert style.

12. The arts of Africa and the Pacific Islands are often treated as a single topic in art history. What characteristics are held in common? Your thoughts, pro and con, about such an organization. What implications, if any, exist in the organization of material for any topic of study? The selection of the material?

FOR FURTHER READING

Berndt, Ronald M. and Catherine H. Berndt, *The Speaking Land: Myth and Story in Aboriginal Australia*. Rochester: Inner Traditions, 1994.

Campbell, Julie, *Irian Jaya: The Timeless Domain*. Scotland: Tynron Press, 1991.

Caruana, Wally, *Aboriginal Art*. London: Thames and Hudson, 1993.

Greub, S., *The Art of the Sepik River: Papua New Guinea: Authority and Ornament*. Basel: Tribal Arts Center, 1985.

Hanson, A. and L. Hanson, *Art and Identity in Oceania*. Honolulu: University of Hawaii Press, 1990.

Kernot, B. and S. Mead, *Art and Artists of Oceania*. Mill Valley: Ethnographic Arts Publications, 1983.

Mowalkarlai, David and Jutta Malnie, *Yorror Yorro: Aboriginal Creation and the Renewal of Nature: Rock Paintings and Stories from the Australian Kimberley*. Rochester: Inner Traditions, 1993.

Smidt, Dirk, ed., *Asmat Art: Woodcarvings of Southwest New Guinea*. New York: George Braziller, 1993.

Thomas, Nicholas, *Oceanic Art*. London: Thames and Hudson, 1995.

See also Chapter 1, Africa, For Further Reading.

7

South America

For thousands of years before Europeans arrived on their continents, ancient Americans were building thriving cities and sprawling ceremonial complexes. They traded textiles, precious metals and stones, and ceramics across long-distance trade routes through the mountains, deserts, highlands, and rainforests of the New World. Therefore, the ancient arts of South America, Mesoamerica, and North America share similar themes and styles, such as mound building, animal imagery, and transformation.

The term *Andean* applies to the civilizations in the culture hearth of South America, a long, narrow terrain of abrupt ecological extremes in the modern countries of Colombia, Bolivia, Chile, and especially, Peru. The Andean heartland is defined by the Pacific Ocean on the west and the Andes Mountains on the east. The Andes (about 4,660 miles long) separate the coastal desert from the Amazonian rainforest and once divided the western urban agriculturists from the eastern forest peoples. The major Andean cultures flourished on the strip of coastal desert (on average forty miles wide) between the ocean and the mountains, and in the Andean highlands. Oasis towns with irrigated fields of corn, beans, cotton, and peanuts were characteristic of the desert communities, while in the mountains people herded llama on the high plateaus and cultivated potatoes in terraced fields. The desert peoples also harvested the ocean's abundant resources, and the highland people imported exotic goods from the eastern jungles. Interaction across the highly diverse ecozones produced a homogenous Andean artistic expression that synthesized special qualities of each lifeway into a flexible, consistent style. Eras of cultural unification are referred to as *Horizons* and those of regional variation as *Intermediate periods.*

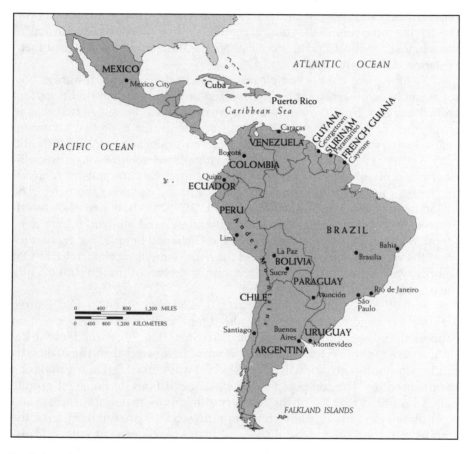

South America

EARLY HORIZON

Chavín

Early Andean achievements in art and architecture from the *Preceramic period* (3500/3000–2000/1800 BCE) and the *Initial period* (2000/1800–800/ 500 BCE) were consolidated during the *Early Horizon period* (1200–200 BCE), the first of three periods of cultural unification in the history of ancient Andean art and society. *Chavín culture* (850–200 BCE), named for the ninety-nine-acre northern highland ceremonial and residential complex, *Chavín de Huantar*, was the driving force behind the cultural coalition. Often called the Chavín "cult," the religious, political, and economic phenomenon found its permanent manifestation in the visual arts.

For the great temple complexes at Chavín de Huantar, designers borrowed architectural features from the desert and the highland traditions and animal imagery from the rainforest to create a visual language that was to shape the character of ancient Andean aesthetics for over two thousand years. Many structures at Chavín de Huantar are granite-faced, earth and rubble platform mounds perforated by stone-lined corridors. Neither efficient nor economical, mound building consumed vast amounts of material and human resources to express the extraordinary nature of the place. The major temple, the *Old Temple* (L. 330', H. 36'–52'), combined the desert-derived *U-shaped pyramid* with the highland-derived *sunken circular court* (depth 8'), located between the arms of the U-shaped temple. Facing east toward the water-giving mountains and the rising sun, the approach to the Old Temple was indirect, across courtyards, up stairs, and through tunnels into the oracular labyrinth of the building.

From the later phase of Chavín art (500–250 BCE), when the Old Temple was being enlarged and new plazas added for the city's growing population of about three thousand, comes the *Raimondi Stone* (Fig. 74), named for the Peruvian geographer Antonio Raimondi, who discovered it in the 1840s. Its original location is not known, but possibly it was embedded in the floor of a temple corridor. The congested surface of incised lines on polished granite makes an initial reading of the imagery difficult as material, process, and style unite in an intentionally confusing, mysterious presentation. Like the architecture, the Chavín figural style cultivates bewilderment with shifting, maze-like images; it is visually dense, transformational, and reversible.

The dominant motif on the Raimondi Stone is a frontally posed, standing *polymorph* (a being assembled with parts from several animals) named the *Staff God*. Appearing in both male and female versions in Chavín-inspired art, it seems to have been the primary deity in later phases of the Chavín cult. Its exact associations are unknown, but it is hypothesized to have been an agriculture-earth god or a creator-sky god. The creature is an assemblage of human and animal parts tied together by *contour rivalry*, a phrase for the simul-

taneous presentation of multiple images, and *substitution,* the technique of re-
placing an element with a similar but disjunctive motif, such as snakes for
hair. It draws on raptorial birds and predatory cats and reptiles; ferocious jun-
gle animals, never hunted for food, define the deity's character. Chavín artists
selected the anaconda and cayman, the harpy eagle and owl, and the jaguar
and puma for their strength, beauty, cunning, and ability to move between
water, land, and sky. Talons substitute for hands and feet; snakes project as
belt streamers and hair; snarling cat faces appear repeatedly on the two
staves, the belt, and the Staff God's head. The elusiveness of the composite
being is underscored by the Raimondi Stone's reversibility; when inverted,
the headdress becomes telescoping caymans with superimposed bird beaks,
and the Staff God's face splits in two. To present the duality of its spiritual

Figure 74 Chavín (850–250 BCE). Raimondi Stone, 500–200 BCE; line drawing after
incised carving on polished granite; H. 6'6" (1.95 m). Nacional de Antropologia,
Arqueologia y Historia del Peru, Lima

essence, the artist has shown the Staff God firmly rooted to the earth while descending from the sky. The face is a Chavín hallmark, recognized by eyeballs with upward rolling pupils—as though in a trance—and a toothy mouth with extruded, interlocking fangs. With its reptilian, avian, and feline motifs, linear rendering, frontal pose, absolute symmetry, substitution, repetition, and contour rivalry—all compounded by an aversion to blank spaces (*horror vacui*)—the Raimondi Stone summarizes the features of the intentionally disorienting Chavín aesthetic. Drawing on its unilateral appeal to highland, desert, and jungle, it united peoples with shared visual expressions of abstraction and supernatural imagery.

EARLY INTERMEDIATE

Chavín cosmology and art were disseminated by trade in small-scale, portable arts of textiles, metals, and ceramics. Adaptations continued to be made, although the cultural sway held by the cult center diminished until it disappeared entirely in the second century BCE. The unified Early Horizon was followed by the *Early Intermediate period* (200 BCE–500), the first of two eras of regional diversity in ancient Andean art history.

Paracas

Art produced on the Paracas (meaning "wind storm") Peninsula in the southern coastal deserts is characteristic of the variations made on earlier Chavín-style monumental forms and imagery. From around 400 BCE people of the *Paracas culture* (1400/900–1 BCE) were creating adaptations of the Staff God and its supernatural assistants in the textile medium. They were heirs to the world's oldest fiber arts tradition (by at least 8600 BCE), which in South America predated pottery by six thousand years. As the most valuable commodity in ancient South America, fabric was a form of currency, a badge of authority, an emblem of social status, and the guide to family affiliation. When the Spanish invaded the highlands in the sixteenth century, the Andeans accused them of conspiring to steal cloth.

A significant portion of the value of Andean fabrics resided in the amount of time consumed in their production. Mastering the processes and meeting the design challenges of pictorial fabrics were learned in a teacher-apprentice system, as surviving "practice fabrics" document. Among the several Paracas fiber arts processes was weaving a fine cotton fabric on a *backstrap loom* (one end tied around the weaver's waist and the other around a pole) and embroidering both the design and the background color over the woven cloth.

Countless hours of tedious stitching produced hallucinatory images of spirit-beings shifting and twisting in improbable poses, such as the being in Figure 75. The entire mantle was worked in the *block-color style,* a comparatively naturalistic, late Paracas fiber arts style recognized by shapes filled

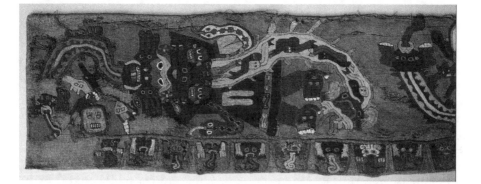

Figure 75 Paracas (500–1 BCE). Embroidered mantle, detail, 200–1 BCE; cotton; length of entire fragment 130″ (3.3 m). Goteborgs Etnografiska Museum, Sweden (35.32.198). Photo, Pal-Nils Nilsson

with solid colors. Outlines and interior details were drawn in thread, then the ground cloth was covered with tiny parallel stitches before color was sewn into the shapes. A clear figure-ground relation is established, but deciphering the image requires the patience we mustered for the Raimondi Stone. Oriented from above and outside the pictorial space, its position is an alternative to the frontal pose of the Staff God. Placed in the unorthodox position of looking down on the creature, we see the bottom of its feet, the back of its torso, and the front of its head, each view marked by a crisp bend in the cardboard-flat figure. Possibly it represents a deity named the *Oculate Being* or, more likely, an Oculate Being-impersonator dressed in a mask with serpent whiskers, a fabric streamer with monkey terminal in front, and a serpent streamer with a cat-face terminal in back. More animated in contour than the hard-edged Raimondi Stone, it also foregoes the absolute symmetry of Chavín design, with its hands—one holding a severed head and the other a snake—on the being's right side. Recalling the symbolic associations between snakes, water, and the fertility of the earth, the image may represent a shaman in a trance making a sacrifice to evoke rain on behalf of the people in his town.

The arid desert climate preserved Paracas textiles, which were interred in the *mummy bundles* of shamans and other dignitaries. The untreated corpse in a mummy bundle was wrapped in coarse cotton cloth and placed in a basket along with fine textiles such as tunics, mantles, and headbands with streamers. It is estimated that forty thousand hours were required to embroider the articles for one well-appointed mummy bundle. Many fine fabrics appear to have been special-occasion garments, so the living owners would have had the opportunity to enjoy the fine artisanship. While the excellence of the Andean fiber arts tradition never diminished, the village-based Paracas culture was absorbed by the *Nazca culture* (300/100 BCE–700), famous for its ceramics and enigmatic *geoglyphs*, gigantic line drawings made in the desert crust.

Moche

Moche (50–800) was a militaristic state in the northern coastal deserts during the Early Intermediate period. Previously called *Mochica* for the language spoken in the region when Europeans arrived, the ancient people and their culture are named for the river valley where major sites were built. From the capital, *Cerro Blanco* (founded by 100, destroyed by 600), the Moche moved over two hundred miles along the Peruvian coast, incorporating people by conquest and allegiance, capturing fishing ports and fields, building roads, aqueducts, palaces, and platform mounds of sun-dried brick. The largest of the mounds is the cruciform-plan *Pyramid of the Sun* (*Huaca del Sol;* originally H. 165', L. 2230', W. 1050') at Cerro Blanco. The badly eroded tiered platform mound once supported temples and high-status residences of perishable building materials, their brightly painted wooden columns and decorated gable roofs documented in ancient ceramic mortuary replicas.

Moche culture is known primarily through its funerary arts. Tombs in and adjacent to ceremonial mounds have yielded specially crafted items in feathers, metal, wood, and clay. Plates, bowls, single-spout bottles, and *stirrup-spout* vessels are among the ceramic shapes, the latter an important Andean vessel form recognized by an upright spout attached to an arched hollow handle. Ceramists handbuilt the clay vessels using coiling, modeling, and press-mold processes, often in combination. Reddish-brown images were painted on a cream ground with outlines and details frequently picked out in black paint after the vessel had been fired. The smooth globular chamber offered a perfect surface for Moche narrative paintings; action is conveyed by wrapping figures around the vessel. Many Moche vessels are miniature sculptures—men, animals, vegetables, buildings, and deities—with spouts. The entire vessel chamber could be formed into a representational shape, or a *deck figure* could be attached to the top. Anthropomorphic effigy vessels include full-length figures and the "parts-portrait"—a head, a hand, or a penis. All are intriguing, some are darling, and a few are outright bizarre.

The artist who shaped the vessel in Figure 76 combined two-dimensional pictorial and three-dimensional sculptural renditions of ritual runners, a popular theme in Moche art. In preparation for the activity represented below him, the seated deck figure secures the ties of his headdress. His face, modeled in the realistic style of Moche portrait vessels, captures the determination in his self-focusing act. Beneath, runners sprint across the sand dunes, represented by the wavy, speckled ground. Moche artists' depictions of environmentally specific settings, which could also be enhanced by a temporally specific night setting, is unique in Andean art. The bodies are stylized combinations of frontal eye and torso with profile head and legs, yet the lively contours communicate speed. Moche vessels with thin, nervous lines are called *fineline painting*. The effect is especially evident in the expressively ren-

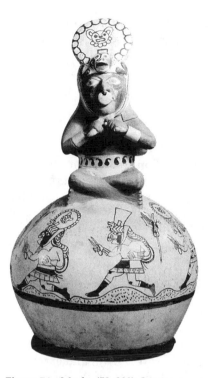

Figure 76 Moche (50–800). Stirrup-spout vessel depicting ritual runners, ca, 250–550; painted ceramic; 10 1/2″ (27 cm) × 7 3/4″ (19.7 cm). Courtesy of The Art Institute of Chicago. Buckingham Fund (1955.2291). Photo © The Art Institute of Chicago. All Rights Reserved.

dered legs and feet, the prancing figure's sinuously curved instep or calf a hallmark of Moche art. Specialists speculate that the runners are carrying bags of beans, possibly seeds for planting rites or, as some have postulated, message-encoded lima beans.

Messenger-runners are recognized by their distinctive uniforms; they wear kilts decorated with the *wave-scroll* pattern, lima bean belts, circular nose ornaments, and a cloth helmet with ornamental attachments and cloth streamers with the *mountain-step* pattern. The two animals associated with Moche runners are shown on the large circular attachment, which represents a metal ornament with stone inlay; the inlaid fox head connotes speed and the monkey-head frontal represents agility. Painted on the vessel chamber is a diving hummingbird, whose speed and stabbing beak gave it meaning to runners and warriors.

Moche artists were the experimenters in South America. In relation to the preceding Andean visual expressions, theirs are naturalistic, emotionally expressive, object oriented, and action packed. Novel poses, detailed settings,

and episodic themes challenged their technical skills and powers of visualization. Today, the ancient works continue to challenge researchers' attempts to decipher the meanings of Moche art.

MIDDLE HORIZON

The second period of unification (*Middle Horizon*, 700–1000) followed a severe environmental degradation brought on by a series of El Niño episodes in the sixth and seventh centuries. The Moche never recovered from the flood damage to their canal systems or from the generation of drought following the floods. But in the southern highlands a burgeoning Early Intermediate period culture survived and flourished. Perhaps their ability to withstand the disasters was the basis for the supernatural mystique that was the underpinning of their political supremacy during the Middle Horizon.

Wari-Tiwanaku

Over the centuries the highland village of *Tiwanaku*, located southeast of *Lake Titicaca* in Bolivia, grew into an urban residential-ceremonial complex with a population reaching sixty thousand at its peak. The resources-rich southern highlands provided access to precious metals, pastures for llamas, and reliable lake water for the canals. Sited at an elevation of 12,600 feet, with a command of the eastern forests and the western ocean, Tiwanaku exploited the political dynamics of symbolic place; positioned on top of the mountains and beside the inland sea, the city was the point where all zones converged. *Wari*, possibly a twin capital of the empire, was built later, north of Tiwanaku in the southern Peruvian highlands. As much as serving as a tag for the two ancient urban sites, the term *Wari-Tiwanaku* refers to the Middle Horizon political-religious power structure and the visual symbol system associated with it.

Tiwanaku was a ceremonial complex and a residential center for the ruling elite and their entourage. Canals from Lake Titicaca channeled water to the nonutilitarian moat surrounding the sacred precinct. Inside were palaces, a gigantic tiered platform mound (the *Akapana* H. 56', L. 650'), a sunken courtyard, and the flat *Kalasasaya* enclosure (L. 328'). Huge stone blocks were meticulously shaped and polished for the foundations of mud-brick buildings, the facing for dirt and rubble ritual mounds, the processional stairways, and the imposing gateways. A unique contribution to pre-Inca Andean architecture, the *post-and-lintel* gateways framed symbolic vistas and marked both the ruler's processional path and the sun's celestial east–west path.

For an unknown reason the rulers of Tiwanaku had the largest of the gateways, the *Sun Gate* (Fig. 77), moved from its original location to the Kalasasaya platform near the end of the Middle Horizon. In keeping with its original production method, the new placement transformed it from architecture into freestanding sculpture. In appearance the Sun Gate is post- and-lintel

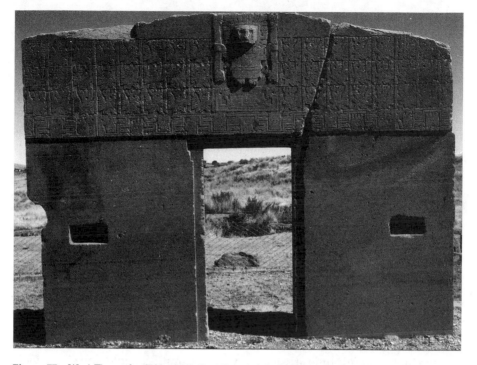

Figure 77 Wari-Tiwanaku (500–1000). Sun Gate, on the Kalasasaya, Tiwa: Bolivia,
500–900; H. 9′ (2.74 m); stone.

architecture, but the entire structure was carved, as sculpture, from a single
nine-foot-high block of stone. The lintel is decorated with a low relief frieze
featuring another version of the Chavín Staff God. By reviving a deity of great
antiquity the rulers of Tiwanaku gave themselves history and legitimized
their reign.

The *Gateway God* (sometimes called *Viracocha,* the Inca creator-god)
stands on a tiered platform or a mountain with animals gushing from its cav-
ernous U-shaped center; in one hand he holds two spears and in the other a
spear-thrower (*atlatl*). The artists employed several artistic devices to endow
the Gateway God with importance, none new to us as students of Non-
Western art. They include high relief projection, hierarchic scale, central
placement, and frontal pose. The blocks of staff-bearing avian attendants
around him are rendered in low relief and in profile pose. Examples of substi-
tution abound, but the contours are legible and logical; items represent cos-
tume elements rather than transforming beings. Tiwanaku artists strove for

the clarity of political propaganda rather than the mystery of religion. The absence of traditional supernatural-designating devices has led to the proposition that the Gateway God may have been a deified ruler from the early years of the empire, an ancestor dressed in resplendent crown and pendant jewelry who, in pose and proportions, emulates the ancient Chavín god. In four hundred years Inca rulers would use the same strategy, appropriating the Tiwanaku style to give credence to their fledgling empire. To the Inca the abandoned city of Tiwanaku was the center of the earth, the place where Viracocha shaped the first people from clay and painted them with different patterns, so each would have an identity.

LATE INTERMEDIATE

Chimú

Around the year 1000 (*Late Intermediate period,* 1100–1438) the *Chimú culture* replaced the *Labayeque culture,* which had replaced the Moche in the northern coastal desert by 850. From *Chan Chan,* their capital city in the Moche Valley, militaristic Chimú kings ruled a vast empire until they were reduced to vassals and their lands absorbed by the Incas in the early fifteenth century.

Among the fifty thousand residents of Chan Chan were an estimated twelve thousand full-time artists, many expert smiths in gold and silver. Gold was mined from the mountains and collected from coastal rivers, shaped into ingots, then cold hammered into sheets. Andean smiths fashioned jewelry, vessels, figurines, toys, crowns, mummy masks, and ceremonial weapons— but never money—by pounding the flat sheets of precious metal over a wooden form. Pieces were joined by wires, rivets, or solder. Precious metals were often painted red or inlaid with stone, such as the turquoise-accented eyes of the silver effigy panpiper beaker (Fig. 78). The enlarged fingers are naturally positioned, but the stocky proportions, similar to Moche and Tiwanaku figures, and the simplified anatomy stem from an Andean tradition that found beauty in fabric, rather than in the body beneath it. In the New World, a body concealed was preferable to one revealed, and in ancient American art nudity was a sign of humiliation and defeat. In our Chimú example the surface of the panpiper is embossed with patterns simulating textiles.

The rim molding of the effigy beaker functions as a cylinder crown, underscoring the high status of the piper. In Andean multifigural compositions that include musicians, the highest ranking figure plays panpipes and the lowest member the drum. Panpipes, flutes, and drums were associated with the world of the dead, and Andean art shows these instruments played by skeletons as well as humans. How music related to the ancient American afterlife remains unclear, and in the next chapter we will see a similar melody of death in Mesoamerican art.

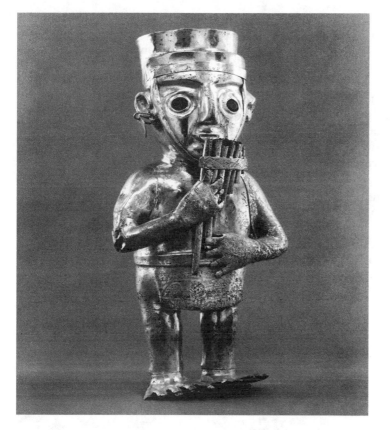

Figure 78 Chimú (1000–1438). Effigy vessel of a standing musician; silver and turquoise; H. 8 1/2″ (21.59 cm), W. 4 1/4″ (10.79 cm), D. 2 3/4″ (6.98 cm). The Metropolitan Museum of Art, New York. The Michael C. Rockefeller Memorial Collection of Primitive Art, Gift of Nelson A. Rockefeller, 1969 (1978.412.219)

LATE HORIZON

Inca

In less than a century—from 1438, the reign date of *Pachacuti*, the first documented Inca king, to the execution of the last Inca king, *Atauhualpa*, in 1533—the minor southern highland group amassed one of the largest empires in world history, consolidating three hundred eighty thousand square miles in Ecuador, Peru, Bolivia, Colombia, Chile, and Argentina. Although the Quechuan-speaking Inca comprised a small percentage of the Andean population of ten million, all owed allegiance to the *Sapa Inca*, the divine king, the Son of the Sun God, *Inti*. The Sapa Inca lived in the capital city of *Cuzco*, the "Navel of the World," located at the center of the "Land of the Four Quarters,"

Tawantinsuya. The Inca founded their empire by conquest and maintained it through statecraft. It was built with the taxes all subjects were required to pay in the form of food, manufactured goods, and, especially, time served on government building programs. *Mita,* the Inca labor tax, required everyone to work a portion of the year on imperial projects. To build the twenty thousand miles of paved roads connecting the Four Quarters, the canals and terraced farms, the king's palaces, and the city of Cuzco itself, populations were relocated thousands of miles across the empire, thereby weakening ties to local communities. Everything was documented with *quipus,* the Inca writing system of knotted cords.

Unlike Cuzco, which has been continuously inhabited since its founding, the mist-shrouded stone city of *Machu Picchu* (Fig. 79) was long abandoned when the ruins were discovered by Yale history professor Hiram Bingham in 1911. Only the buildings stood as silent reminders of the engineering genius of the ancient American architects. The site, seven thousand feet above sea level on a narrow ridge along the eastern side of the Andes, imparts enduring splendor to Machu Picchu. In a sympathetic adaptation of human

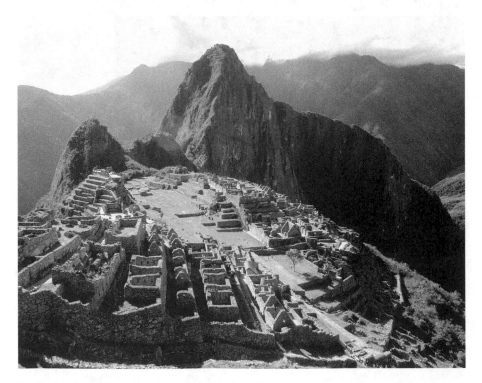

Figure 79 Inca (1438–1533). Machu Picchu, Peru, fifteenth and sixteenth centuries. Photo, Gregory Dimijian, MD

needs to the constraints of the natural environment, buildings are made to hug the terrain in a synthesis of nature and architecture.

The city, believed to have been an imperial vacation home, is surrounded by concentric rings of agricultural terraces cascading down the mountains like stone waterfalls. Levels of fieldstone dwellings share the plaza with sacred buildings, such as the circular Temple of the Sun, constructed of carefully shaped white granite blocks. Natural outcrops of granite, notably the "Hitching Post of the Sun" (*intihuatana*), were venerated as auspicious objects (*huacas*).

It is unlikely its main buildings were sheathed in beaten gold, as the walls of Cuzco were reported to have been, but the quality of masonry equals the finest in the capital. Characteristic of Inca construction, no mortar was used because each stone, regardless of its size, was shaped to perfectly fit the contours of those around it. With no ornamental vocabulary, Inca architecture tends toward refined functionalism. Its austere beauty is found in the materials, the construction, and the harmony of elegant shapes. Its aesthetic is based on principles of elemental form, pristine surface, and imposing scale. Its dominating, uncompromising, impersonal style befits the attitude of its imperial patrons.

FOR DISCUSSION AND REVIEW

1. Recount the specifics of the three Andean geographic zones and the general lifeways of people in each. How did long-distance trade contribute to a homogenous Andean artistic expression?

2. What are the differences between a Horizon and an Intermediate period? Review the entire chapter, charting the chronology of Andean cultures. Discuss the ideas of cycles, cultures, and time. Any parallels in the Indian worldview? In Chinese history? Other cultures?

3. Describe the Chavín culture, addressing the buildings and their plans, as well as the sculpture. Focus on its ability to synthesize aspects of life in all three Andean ecological zones.

4. Who is represented on the Raimondi Stone? Discuss the material, process, and style uniting in an "intentionally confusing" work of art. Include the following design strategies: contour rivalry, substitution, and horror vacui. Why would someone construct a "disorienting" composition? What are the effects of symmetry and frontality? Compare the meaning of "transformation" in Andean art with Aboriginal Australian art. With Chinese art.

5. The world's oldest fabrics are from South America. In light of its antiquity, review the roles played by the fiber arts in Andean history. Consider process, meaning, and myth. Focusing on Chimú, what

was the role of metal in Andean history. Consider also metalworking methods.

6. Discuss the relation between process and style in Paracas textiles. How is the Raimondi Stone echoed in Paracas fiber arts? How is it modified?

7. Catalog the animals and plants in Andean art. What are their meanings? Return to question 10 in the previous chapter for cross-cultural comparisons.

8. What are the implications of calling the Paracas "a culture," the Moche "a state," and the Inca "a civilization"? What differentiated the three groups?

9. Referring to the paragraphs on Moche ceramics, is it discourteous to describe any work of art as "outright bizarre"? "Darling"? "Intriguing"?

10. Compose an essay summarizing the points of style and symbolism for the Moche runner vessel. Include the following terms: stirrup-spout, fineline painting, wave-scroll, mountain-step.

11. Both an abstract style and a naturalistic style are found in Andean art. Select examples for a discussion of the two.

12. Recount the rise of Wari-Tiwanaku. What is meant by "the political dynamics of symbolic place"? Why was Tiwanaku's location advantageous?

13. List the main Andean cities and sites. Review each for location, principal buildings, and construction processes.

14. Describe the Sun Gate. Compare it with the Raimondi Stone, using the segment "clarity of political propaganda rather than the mysteries of religion" as a starting point.

15. What is a huaca? Focusing on Andean and augmenting with examples from previously studied cultures, identify "supernatural-designating" devices in art.

16. What was the relation between Tiwanaku and Chavín? Tiwanaku and the Inca?

17. Using the Chimú effigy vessel and at least two other examples, define an Andean canon of ideal proportions for the human body. Consider the effects of costume elements, especially masks and headdresses. What ambiguities result? For a person, a deity, a deity-impersonator?

18. Review the physical features of Machu Picchu. Discuss its aesthetics. Any similarities to Shinto architecture?

19. How did the Inca interlace art and statecraft? Taking the long view back through Andean history, was this unexpected? Why?

20. What observations can be made on the presence of the artist in Andean art? Who could be an artist?

FOR FURTHER READING

Berrin, Kathleen, ed., *The Spirit of Ancient Peru: Treasures from the Museo Arqueológico Rafael Larco Herrera*. San Francisco and New York: The Fine Arts Museums of San Francisco, and Thames and Hudson 1997.

Kauffmann-Doig, Federico, *Ancestors of the Incas: The Lost Civilizations of Peru*, trans. Eulogio Guzmán. Memphis: Wonders, The Memphis International Cultural Series, 1998.

Kubler, George, *Art and Architecture of Ancient America*. London: Penguin Books, 1990.

Moseley, Michael, *The Incas and Their Ancestors: The Archaeology of Peru*. London: Thames and Hudson, 1992.

Pang, Hildegard Delgado, *Pre-Columbian Art: Investigations and Insights*. Norman: University of Oklahoma Press, 1992.

Stone-Miller, Rebecca, *Art of the Andes, from Chavín to Inca*. London: Thames and Hudson, 1995.

Townsend, Richard, ed., *The Ancient Americans: Art from Sacred Landscapes*. Chicago: The Art Institute of Chicago, 1992.

8

Mesoamerica

Moving meter by meter through the jungles, archaeologists are mapping the spectacular legacy of the peoples of Mesoamerica. Meaning "Middle America," *Mesoamerica* is a mid-twentieth-century academic term that adds cultural dimensions to the geographic designation "Central America." Mesoamerica is the cultural zone of ancient Mexico, Guatemala, Belize, Honduras, and El Salvador. Recent research has shown that the area was more densely populated than previously supposed, with populations in the Maya territories alone between twelve and twenty million. Though the imposing masonry ceremonial centers capture everyone's imagination, there are also the less conspicuous remains of laborers' settlements, irrigated farmlands, causeways for overland links between cities, and portage stations along the rivers and coasts.

The visual arts shed light on the vibrant if demanding lives led by the ancient Americans. In their well-ordered societies, hereditary professions of warrior, priest, farmer, and artist were clearly defined. Kings led their independent city-states in perpetual warfare, acquiring sacrifices to revitalize the cosmos and validate their claim to power. Art and architecture were bearers of a complex symbol system blending religion and politics. Art was a tool of statecraft, and the theme of royal lineage with cosmic parallels to the gods and culture-heroes predominates.

Ideas about the relation between space and time directed all aspects of human interaction. They were manifest in permanent ways, such as architectural planning and complex calendrics. Mesoamericans shared the perception that space was divided into four horizontal parts—visualized as a cross oriented to the cardinal directions—and three vertical parts—the thirteen levels of the Upper World, the nine levels of the Lower World, and This

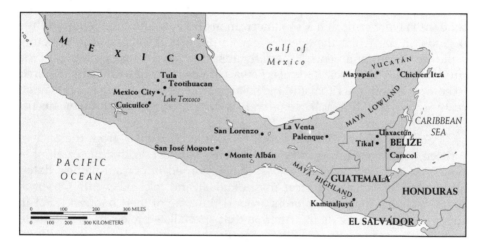

Mesoamerica

World, our world in between. The axis through all three worlds was at the center point of the cross, from which rose a mountain or a great World Tree to mark the sacred center. Mountains were transverse points from This World to the Upper World and the caves inside them the portal from This World to the Lower World. The Lower World was always a dark, watery place, the Night Sky in many Mesoamerican cultures.

Mesoamericans also shared the perception that time is a cycle of endlessly repeating, measured and named units. They maintained two calendars simultaneously. One was a 260-day ritual calendar with twenty day names and thirteen day numbers. The other was a 365-day solar calendar of eighteen named "months," twenty day numbers, and five frightful, "nameless" days. The calendars, months, and days were named differently across Mesoamerica, but the principles were the same. The Maya ritual calendar, for example, is called the *tzolkin* and the solar calendar is the *haab*. A day is a *kin*, a "month" is a *uinal*, a solar year is a *tun*, and twenty tuns is a *katun*. These time units were critical in Mesoamerican art because the completion of time periods, in particular the twenty-year katun, was the occasion for erecting buildings and monuments. Especially auspicious was the completion of the fifty-two-year time cycle (*Calendar Round*), the number of solar years required to complete both the ritual and the solar calendars so they began once again on the same day. Historical events were coordinated with mythical events using this dating system.

Some of what is known about Mesoamerica derives from the ancient written languages in use at the time of First Contact. With a pictorial, phonetic system of signs called *glyphs*, they recorded important names, dates, and places, as well as historical, mythological, and celestial events. Observations made by Spanish explorers around the time of the Conquest (1521 in Central Mexico) provide information that specialists project back in time to help interpret the art and ideology of earlier Mesoamerican cultures. Cultural continuity is clearly evident.

PRECLASSIC PERIOD

The foundations of Mesoamerican culture and society were laid in the *Preclassic period* (also called the *Formative,* ca. 1500 BCE–250). During this time, monumental public architecture, shamanic kingship, and representations of many deities appeared at sites along the Gulf Coast, Pacific Coast, in southern Mexico at Monte Albán in the modern state of Oaxaca, and in the Guatemalan highlands and lowlands.

Olmec

Despite occasional contenders for its title as the "Mother Culture" of Mesoamerica, the *Olmec* culture is still identified as the oldest sustained high civilization in Mesoamerica. Later ancient Mesoamericans, notably Maya

kings, looked to the Olmec as the Mother Culture, collecting old Olmec sculpture and inscribing it with their own names and dates. Olmec culture was centered in the rainforests along the coast of the Gulf of Mexico in the modern states of Tabasco and Veracruz. However, its influence spread far beyond the swamps, as the distribution of stylistically distinct ceramics, jade carvings, and rock art from Central Mexico to Guatemala proves. In the twentieth century, Olmec sculpture was recognized as a unique artistic style decades before historians created a name for the culture.

The earliest Olmec farmsteads (ca. 2200 BCE) were settled in the swamps near La Venta, Tabasco. By 800 BCE residents of the small villages were collaborating on the building of a monumental ceremonial site, *La Venta*. It was laid out on a north–south axis, alternating units of solid mounds and open plazas. The earthen Great Pyramid rises over one hundred feet on the southern end, descends to a rectangular plaza, a second plaza enclosed by earthen barrier mounds and a fence of basalt (volcanic stone) columns, and finally is matched on the north end by a tiered platform burial mound. The Olmec made massive offerings in the plazas; one large pit, thirteen feet deep and seventy-seven feet on each side, was filled with hundreds of tons of serpentine blocks and layers of colored sand. The plan of La Venta begins the Mesoamerican tradition of orienting sacred structures to the cardinal points, as well as pairing high, solid mountain-mound-shapes with low, open water-plaza-spaces.

The theme of kingship motivated Olmec architecture. Landscapes were modified according to symbolic plans in order to enhance the ruler's mystic standing with the public and to strengthen his ties with supernatural forces. Architecture was the stage for this critical play of politics and religion. The king was the leading actor; he was the mediator between This World and the Upper and Lower Worlds, interfacing with the ancestors, the source of his authority, and the deities, the manifestations of the forces of nature he sought to control on behalf of his people.

Sculptors created the setting and the props for the cosmic drama. For the entrance to La Venta, they transformed gigantic basalt boulders into colossal portrait heads of the kings. Imported jade, jadeite, and serpentine were especially meaningful materials because their clear blue-green and mottled gray-green hues were the colors of life-sustaining water. An anonymous Olmec carver shaped a small block of serpentine into the likeness of a seated figure holding a baby (Fig. 80), similar to monumental basalt versions of rulers with babies found at ceremonial sites. Although Europeans believed such statues represented the Virgin Mary and Christ Child, as they did the Chinese Guanyin (see Fig. 46), historians have interpreted the pair as a ruler holding an Olmec god-impersonator. The peculiar infant, a hallmark of Olmec art, has been named the *were-jaguar baby* because it resembles a human transforming into a jungle cat, as in "were-wolf." The basic jaguar-baby has an oversized head with a cleft in its forehead, almond-shaped eyes, a flat

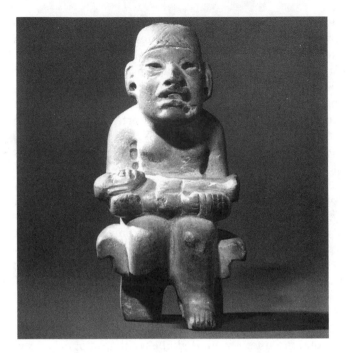

Figure 80 Olmec (1200–300 BCE). Seated figure holding an infant, ca. 900–500 BCE; serpentine; H. 4 3/8″ (11.4 cm). The Metropolitan Museum of Art, New York, the Michael C. Rockefeller Memorial Collection, bequest of Nelson A. Rockefeller, 1979 (1979.206.940)

feline nose, and fleshy lips curled back in a snarl to expose prominent canines. It was rendered in degrees of abstraction from blocky, fantastic hybrids to round, squirming humans.

Several theories have been proposed to explain the Olmec jaguar-baby, including a divine ancestor born of the intercourse between jaguar and woman, the shaman-king transforming from one state of being to another, and the Maize God with corn plants sprouting from the forehead cleft, symbolizing the furrow struck by a farmer's hoe. Holding the highest degree of credence, perhaps, is its long-standing reading as the Rain God, a Mesoamerican deity that endured through the Aztec times under the name of *Tlaloc* and in present-day Maya territories as *Chac*. Because the jaguar-baby appears in slightly different forms in Olmec art, it may have had seasonal manifestations. Certainly it personified the vital forces of nature, and with its imperial jaguar features, became an emblem of kingship, held like a scepter or sacred bundle. By using the jaguar-baby to entice moisture from the clouds, which appear as scrolls incised on the sides of this serpentine throne, the shaman-king of an agricultural community would be fulfilling his primary responsibility. The solemn tone of all jaguar-baby-bearer statues implies that a sacred

activity is being reenacted. Because the seated man—who stares with open mouth as though in a trance— appears to be presenting the inert baby to an unseen audience, it has been suggested the sculpture depicts a child-sacrifice, similar to actual sacrifices. The cosmic logic would be that the offering of an infant, itself at the beginning of the cycle of human life, initiates seasonal and dynastic cycles. Although the great Olmec sites, such as La Venta, were abandoned by 400 BCE, this worldview—manifest in religion, politics, art, and architecture—continued to impact Mesoamerican culture for nearly two thousand years.

West Mexico

The ancient cultures along the Pacific Coast in *West Mexico* (1500/1200 BCE–900) parallel those of the Gulf Coast Olmec in the east. Previously interpreted as village-based peoples who had imitated their high-style Olmec and Teotihuacan counterparts, the West Mexican cultures are being reassessed in light of current fieldwork at monumental ceremonial sites, such as Teuchitlán, Jalisco. Until the 1990s West Mexican traditions had been known through grave goods, which looters have been procuring illegally for sale on the international market The artistic quality of the imposing ceramic figures has made them irresistible to collectors, and although we are fortunate to be able to enjoy the beauty of these works of art, the loss of contextual documentation has seriously impeded an understanding of the objects. Nevertheless, they stand among the finest of the ancient Mesoamerican visual expressions.

West Mexican figural ceramics were made for the tombs of high-status families. In particular, the *shaft-tomb* mortuary tradition, which flourished from 300 BCE to 200 in the modern states of Nayarit, Jalisco, and Colima, produced regional interpretations of similar subjects, and within the regions, unique workshop styles with identifiable artists' hands. West Mexican ceramics are renowned for their variety and for their warmly human, visually appealing presentations of subjects that were probably solemn to the original audiences, not the amusing objects today's audiences find them to be.

Ceramic architectural models are unique to the Nayarit region. The painted tableaux reconstruct, in a miniature format, the space planning and building types that have come to light in excavations at actual residential and ceremonial sites. Many are models of platform mounds with stairways leading to a multiroom building with a tall, steep roof. Some include a room in the mound, which may represent the shaft tomb itself. A view into the room frequently reveals a dog, known to be the guide through the Lower World in Mesoamerican beliefs. Above, small clay figures of men, women, and children dance, feast, imbibe, and pierce their cheeks, all activities associated with funeral celebrations.

Other Nayarit architectural models show public ceremonial places arranged in the West Mexican *cruciform plan*, with four platform mounds

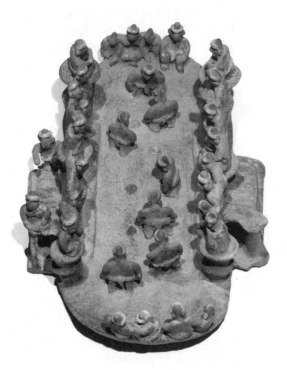

Figure 81 West Mexico (Nayarit; 300 BCE–250). Model of a ballcourt, 200 BCE–250; earthenware; L. 17 3/4″ (45.08 cm), W. 10 1/4″ (26.03 cm). Yale University Art Gallery, New Haven, Conn. Stephen Carlton Clark, BA 1903 Fund (1973.88.26)

forming a cross around a circular tiered mound. Adjacent to these actual sites are *ballcourts*, also replicated in miniature by Nayarit ceramists (Fig. 81). The existence of the ballgame has been documented to at least 1500 BCE in West Mexico, with permanent, masonry courts—preceded in history by "dusty courts" in the open fields—as old as 600 BCE. Hundreds of monumental, masonry ballcourts have been located across Mesoamerica, always in conjunction with major ceremonial and administrative centers. Characteristically, the courts are I-shaped with two endzones and a long playing alley. Tiered benches flanking the alley provided seating for spectators, as did the nearby platform mounds. In the little clay Nayarit ballcourt, the referee stands in the alley at the center marker waiting for one team to leave its huddle. Meanwhile, spectators mill around in the stands; bleacher bums, a mother and baby, and a late arrival walking up the steps are typical of the trivial details that strike a human note in Nayarit ceramics. The little solid figures, embellished with rolled and pinched clay, are positioned in an architectural context to give us a three-dimensional, frozen moment in ancient life.

The inclusion of the audience underscores the importance of community involvement in the ballgame, a salient cultural feature of the entire Mesoamerican tradition. To play the game, the athletes bounced a solid rubber ball off hip or thigh onto the court walls. In some regions the object of the game was to propel the ball through rings mounted vertically on the walls, while in others, stone discs in the alley floor served as scoring markers, as the Nayarit model documents. When the game was played for ritual purposes, such as divination, the captain of the losing team could be sacrificed by decapitation or heart extraction. But the rules varied from region to region and the outcome depended on the reason the game was being played. Gamblers wagered personal fortunes on the game, and the success of local teams galvanized communities. A political dispute could be resolved on the ballcourt rather than the battlefield, or a bloody military conquest reenacted on the home court against a team of doomed war captives.

By studying ballgame references in ancient written texts, accounts by Europeans who saw the game played at the time of Conquest, and depictions of courts and players in ancient works of art, researchers have been able to interpret the ballgame, on its most profound cosmological level, as a metaphor for celestial, seasonal, and human time cycles. The ball symbolized the sun passing back and forth across the court, which symbolized the watery Night Sky. The universe was nourished and the solar rounds sustained by human energy, materialized in the athletes' sweat and, when demanded, their living blood.

CLASSIC PERIOD

The *Classic period* (250–1100) was the golden age of great city-states, mighty warrior-kings, and brilliant artists. People developed regional versions of common themes, such as the character of the gods, the nature of kingship, the afterlife, and ceremonial space planning. Through the *Early Classic* (250–600), *Late Classic* (600–900), and *Terminal Classic* (900–1100) periods, works of art and ideologies were traded, but warfare was endemic.

Teotihuacan

Just twenty-five miles outside modern Mexico City stand the ruins of *Teotihuacan*, the largest city in the ancient Americas. It was a bustling metropolis with cultural and commercial ties extending far beyond the urban boundaries. Unencumbered by fortifications, Teotihuacan spread over eight square miles, and at its peak (between 350 and 650) the population is estimated to have numbered two hundred fifty thousand.

Centuries after the city had been decimated by fire (in 650) and finally abandoned (by 800), the Aztecs named the ruins Teotihuacan, meaning "The Place of the Gods," and the heart of the city the *Avenue of the Dead* (Fig. 82). However, the line of linking courtyards that makes up the Avenue of the

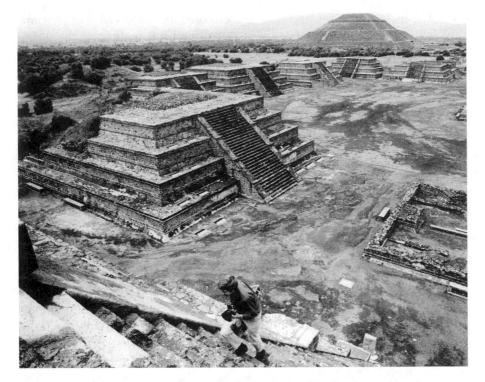

Figure 82 Teotihuacan (Central Mexico; 150–650). Avenue of the Dead, view from the Pyramid of the Moon (H. 215′ [65.5 m], base 738′ [225 m] each side) to the Pyramid of the Sun (H. 150′ [45.7 m], base 250′ [76.2 m] × 450′ [137.2 m]) in the distance, first to seventh centuries. AP/World Wide Photos

Dead is more accurately described as a processional plaza than a functional roadway. Its length is marked by ceremonial and administrative districts with densely packed residential compounds beyond.

The Avenue of the Dead, in its first stages of construction by 150 BCE, established the north–south axis of the city's unique grid plan. Facing west at a right angle to the Avenue of the Dead is the oldest and largest building in Teotihuacan, the *Pyramid of the Sun*. It and its companion at the north end of the avenue, the *Pyramid of the Moon,* are tiered platform mounds with single monumental stairways that once led to small temples on top. In their restored state, the tiers have smooth, sloping profiles. The Pyramid of the Sun was built twice, an early brick-faced, earthen mound identified inside the concrete-faced, stone and clay structure visible today. Many important Mesoamerican buildings were periodically renewed in this way. An old building was not demolished, but preserved intact as the symbolic heart and structural core of the new, enlarged building.

Several high status burials and a four-lobed cave have been found beneath the Pyramid of the Sun. It appears the placement of the symbolic mountain was predetermined by the location of this sacred cave. Together, the Pyramid of the Sun—with the sun rising over its summit—and the Pyramid of the Moon—perfectly framed by "Fat Mountain" (Cerro Gordo) behind it—create a symbolic landscape to harmonize with and give meaning to the natural landscape. In designing Teotihuacan, the first act was to orient the plan to the cardinal points with the Avenue of the Dead; the second was to mark the sacred cave (the Lower World entrance) with an artificial mountain (the Upper World entrance), the Pyramid of the Sun; the last was to link the built environment to the natural environment with the Pyramid of the Moon. The energy expended by these Mesoamericans on their replica of the universe—massive by human scale but miniature by cosmic dimensions—reflects their reverence for the structure of nature.

Noteworthy among the smaller buildings at Teotihuacan is the *Pyramid of Quetzalcoatl*. Representations of serpents with curling fangs and feathered collars, which decorate the exterior, have given the stepped mound its name. Quetzalcoatl (*quetzal*, meaning "bird" and *coatl*, meaning "snake") was the Aztecs' name for the ancient Pan-American feathered-serpent god. Also a wind god (*Ehectl*) to the Aztec and the sky god *Kukulcan* to the Maya, Quetzalcoatl is another example of a life-sustaining union of opposites in Non-Western art. Two versions of Quetzalcoatl are represented on the exterior of the pyramid. On vertical panels, his head projects in high relief, alternating with high relief depictions of a scaly, goggle-eyed creature identified as the War or Fire Serpent. On inclined panels he is shown in profile, his long body undulating through a space littered with sea shells. The alternating vertical (*tablero*) and inclined (*talud*) panels create the Classic period architectural profile called *talud-tablero*. The sculpture survives because the building was completed in two phases. The first Pyramid of Quetzalcoatl was completed by 250, and sometime in the next one hundred fifty years it was encased in a larger, more "modern" pyramid. By removing outside layers of the "new" building, archaeologists exposed the well-preserved painted stucco sculpture on the "old" building.

Among Teotihuacan's major exports were salt, obsidian (an extremely hard volcanic stone used for weapons and ceremonial objects), and ceramic wares, such as the *incensario*, a two-part incense burner (Fig. 83) for the ritual burning of copal (an aromatic resin), bark papers, and textiles. As complex as the object appears at first glance, it is actually constructed of two plain bowls placed lip-to-lip, one an inverted bowl for the pedestal and the other topped by a monumental superstructure assembled from prefabricated, stamped components. In Teotihuacan, vessels were mass-produced to meet the needs of the large population and for shipment to satellite territories, but while efficiency enhanced the output it never hampered the creative potential of the ceramic medium.

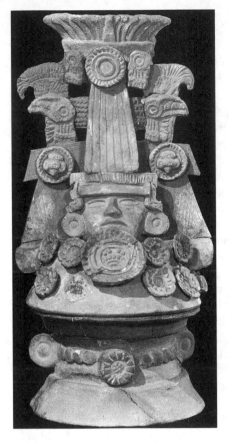

Figure 83 Teotihuacan (Central Mexico; 150–650). Incensario, 300–650; painted ceramic. Courtesy, Department Library Services (No. 118198), (Photo by T. Bierwert). Courtesy Dept. of Library Services, American Museum of Natural History, New York

Characteristic of Teotihuacan incensarios, the distinctive Teotihuacan-type face stares from a thicket of flowers and feathers. In some contexts the face can be a god or goddess, and in others a priest or warrior. Recognized by its broad, flat surfaces and impassive expression, the mask-like, genderless image was borrowed by other Mesoamerican artists, as were Teotihuacan motifs such as tassels, shells, rosettes, and bundles of clipped feathers. The art of Teotihuacan is symmetric, systemic, and impersonal. Its additive approach—building with interchangeable, geometric units—is characteristic of Teotihuacan mural painting and monumental stone sculpture also. Lacking names and dates, the art style, like the city, is anonymous and corporate. Associated with power and prosperity, the design principles were adopted by people across Mesoamerica in the Early Classic period.

The Maya

Among the Teotihuacanos' clients were the Maya, ancestors of today's Mayan-speaking peoples of Guatemala, Honduras, Belize, El Salvador, and the Mexican states of Tabasco, Chiapas, and Yucatán. Maya merchants traded jade, jaguar pelts, and iridescent green feathers of the quetzal bird, all equally precious commodities, into Central Mexico. Maya artists found few buyers outside their own territories, however, probably because Maya art is individualistic and naturalistic, compared to the generalized, geometric, all-purpose Teotihuacan style. Maya art centered on the kings and queens who ruled the independent, fiercely competitive city-states. Maya art glorified "the man," while Teotihuacan celebrated "the state."

Because their works of art were annotated with glyphic inscriptions, more is known about ancient Maya history than about other Mesoamerican cultures. Thanks to intensive research in the last decades of the twentieth century, the structure and grammar of the written language is understood, and the majority of the glyphs have been deciphered. Texts on sculpture, murals, and vessels preserve a wealth of information about important people, places, and activities; the activities of the gods share equal space and time.

Tikal. Tikal was the largest and most prestigious Maya city. The urban plan follows the natural terrain across six square miles in the Guatemalan rainforest, with paved roads (*sacbe;* pl. *sacbeo*) connecting elevated building compounds across low-lying swamps. The site had been occupied in the Preclassic period, since 800 BCE, but the city took shape in the Early Classic period when trading ties with Teotihuacan were established and Jaguar Paw (died 376) founded the Tikal dynasty. At its height of prosperity the city accommodated around forty thousand people, but only a select few had their names and faces included in art; predictably, they were the hereditary kings of Tikal. The last monument near Tikal was constructed in 889, and by the close of the century the city had been abandoned.

The Maya kings often honored themselves with the dedication of a large stone monument. The distinctive type of public sculpture, called a *stela-and-altar complex,* is composed of a tall, vertical slab behind a low, horizontal drum. Throughout the Maya territory, stela-and-altar complexes were created on the occasions of accessions and temple dedications and, especially, to commemorate the twenty-year katun period endings. The period-ending monuments summarized the achievements of the king to that point in time and traced his lineage, frequently back to the founding of the universe.

Among the two hundred stela-and-altar complexes at Tikal is *Stela 31* (Fig. 84), raised in 445 to celebrate Stormy Sky's completion of his first katun as the eleventh king of Tikal. Capitalizing on the political successes of his father, Curl Nose, and his uncle, Smoking Frog, *Stormy Sky* (426–56) consolidated power to become Tikal's greatest Early Classic period ruler. On the

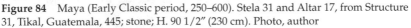

Figure 84 Maya (Early Classic period, 250–600). Stela 31 and Altar 17, from Structure 31, Tikal, Guatemala, 445; stone; H. 90 1/2″ (230 cm). Photo, author

front of Stela 31 he crowns himself in the presence of his dead father. At the very top of the stela, the head of Curl Nose materializes from the body of a *Vision Serpent*. Below, Stormy Sky stands in a profile pose, his right hand raising the crown toward his father, his left hand cradling his scepter—a bundled head of the god of the Night Sky, the *Jaguar God of the Underworld*—like a baby. The ornate style of Stela 31 is characteristic of Early Classic period sculpture. Showing the Maya artists' debt to the Teotihuacan style, the human body is concealed behind a screen of power symbols. The bodies of the auxiliary figures on the sides of the stela are shown more clearly. Standing in full profile facing Stormy Sky, the two armed soldiers wear Teotihuacan-style battle gear, including shields marked with the goggle-eyed face of War-Storm God,

Tlaloc, helmets adorned with clipped feathers, and shell necklaces. On Stela 31, Stormy Sky draws strength from the three worlds, his ancestors in the Upper World, the gods in the Lower World, and in This World, his military alliance with Teotihuacan, cemented a generation earlier by his father.

In 562 Tikal's king Double Bird was captured and sacrificed by the neighboring city-state of Caracol, and no monuments were created for several generations. *Ah Cacaw* (meaning "Lord Chocolate"; 672–734) restored Tikal to power, and under his tutelage the city experienced a cultural renaissance. One of his first acts was to honor Stormy Sky's memory with a ritual smashing of Stela 31 and its burial in a new temple he ordered built over the former king's tomb.

Ah Cacaw's own tomb, *Temple I* (Fig. 85), faces west across the Great Plaza. With Temple II directly opposite, the pair of buildings creates a set of beautiful brackets for the ceremonial space. The limestone-faced mortuary mound was built as a series of nested rubble cores, each with its own ramp for hauling gravel to fill the spaces between the mortar-and-stone retaining walls. While undeniably the most impressive component of the building, the pyramid is merely a platform for the tiny, three-room stone temple on top. Crowning the temple is a two-level, hollow stone *roofcomb*, an architectural element unique to Maya buildings. A roofcomb accentuated the height of the building and provided ample space for carved images glorifying the king.

Some architectural features are consistent with the Teotihuacan pyramid style, which inspired the Early Classic period buildings at Tikal, but by the Late Classic period, when Temple I was designed, a Maya style had been established. In addition to the uniquely Maya roofcomb and stone temple, the Maya pyramid style is compact and proportionally taller. The size ratio of talud to tablero is exaggerated so the sloping *apron panel* resembles the planes of a mountain face. A steep stairway, covering nearly one-third of the front surface, heightens the rapid ascent up the nine tiers, the number of levels in the Lower World.

Palenque. The "Resplendent Persons" of Palenque, a city-state in Chiapas, Mexico, traced their lineage to the creation of the world. Inscriptions on stone monuments begin the Palenque dynasty with First Father (*Hun Nahl Yeh*) and First Mother (*Zac Bac,* or "Lady Beastie"), who voluntarily shed her blood to nourish the corn from which humans would be made. Exact dates, recorded in the Maya *Long Count* dating system, include First Mother's birthday on December 7, 3121 BCE and her inauguration as the world's first sovereign on August 13, 2105 BCE. The inscription conveys the acute specificity characteristic of Maya art, as well as the reality of myth in Maya politics.

What transpired in the remote past was a prelude to the accession in 702 of an historical king of Palenque, *Ma Kinah* (Great Sun Lord) *Kan Xul II* (born 644). On the low relief limestone carving entitled the *Palace Tablet* (Fig. 86) (discovered on a wall in the Palace begun by his grandmother, Sak K'uk',

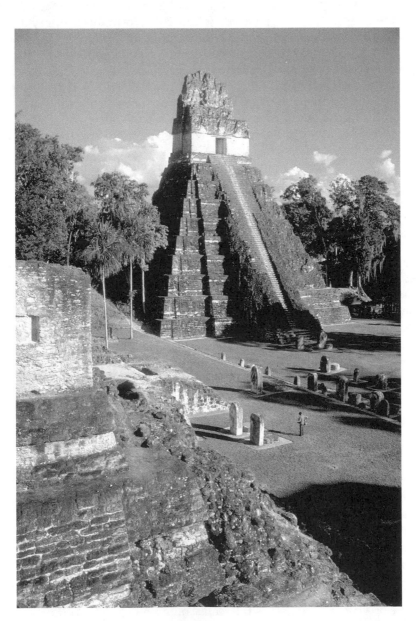

Figure 85 Maya (Late Classic period, 600–900). Temple I (Pyramid of the Giant Jaguar),
Tikal, Guatemala, 727–34; view from North Acropolis; stone and stucco; H. 145' (44.2 m).
Photo, Robert Frerck/Odyssey/Chicago

who ruled as a king of Palenque), Kan Xul II accepts the emblems of power from his dead parents. On the right side of the composition his mother, Ah Po Hel, presents a flint war shield, while on the left side his father, *Pacal II* (603–683), offers his son a tall crown of jade plaques and quetzal feathers. Kan Xul sits on a bundled double-headed serpent, the Maya royal scepter and symbol of the sky. Headdress emblems—Ah Po Hel's netted water lily and Pacal's fish in a lily bud—place the parents in the watery Lower World, as do their thrones, Pacal's bundled Jaguar God of the Underworld, and Ah Po Hel's Water Lily Serpent, the god of still waters. Columns of glyphs record names, dates, and activities from the First Lineage Event to Kan Xul's accession. Words and images validated his right to rule but, unfortunately, Kan Xul II did not complete a katun as king of Palenque. Ten years into his reign, at age 67, he was captured and eventually sacrificed by his neighbor, the king of Toniná.

The Palace Tablet, carved in the elegant imperial Palenque style, represents the best in Late Classic period sculpture. Sensitive contour lines and gently modeled shapes are worked in a low relief carving that is both delicate and commanding. Family members interact naturally, as though the dead parents were giving their son a few last-minute pointers on the art of administration. Particularly arresting is Kan Xul's attentive pose; he seems genuinely interested in what his father will say. His nonchalantly placed hands and the attention to other insignificant details, such as the soles of his parents' feet, contribute to the casual mood. The parents' bodies are convincingly foreshortened, while the side view of the head allows for an advantageous display of the artificial Maya profile, achieved in life by binding boards to the infant's head.

Codex-style Narrative Vase Painting. Maya artists also mastered monumental painting, for temple and palace walls, and miniature painting, for ceramic vessels. Because many vessels show evidence of use, they probably were not made specifically for burial but were placed with the deceased because they were prized possessions. Frequently, a standard text along the rim will date, dedicate, and bless the vessel, identify the method of decoration (to write, paint, or carve); the type of vessel (drinking jar, plate, or tripod plate) and its contents (tamales or *cacaw,* a drink of chocolate, honey, corn, and water); the name of the owner; and, sometimes, the occasion for commissioning the vessel and the artist's name.

Even when no name appears, the work of specific artists can be recognized because the calligraphic brushwork of Maya painting is as unique as handwriting. This is particularly true for *codex-style paintings,* named for their stylistic resemblance to pictures in illustrated Maya books (a *codex* is a book with flat pages). Codex-style paintings reveal the close ties between words and images in Maya thought. Often the glyphs are integrated into the picture as implements, landscape elements, and costume ornaments. Codex-style

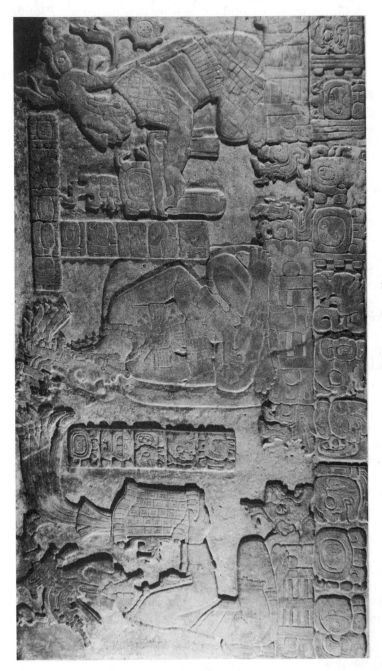

Figure 86 Maya (Late Classic period, 600–900). *Palace Tablet*, from Palenque, Chiapas, Mexico, 702; limestone. Photo copyright Merle Greene Robertson, 1976. Courtesy Pre-Columbian Art Resource Institute

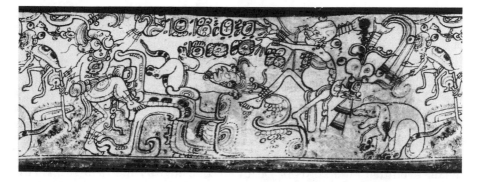

Figure 87　Maya (Late Classic period, 600–900). Narrative codex-style vessel, ca. 600; roll-out photo of painted ceramic jar. Codex Vessel #K521. Courtesy of The Metropolitan Museum of Art, New York. Rollout Photograph © Justin Kerr 1975

paintings were ordinarily worked in brown paint on a cream ground with red accents on the rim and the base. Their nervous buoyancy results from the quality of line and the disposition of figures within the composition. Springy lines with a so-called "whiplash flare" energize the design. Artists rarely resorted to interior modeling because the modulated contour lines conveyed the impression of mass. The prancing characters in Maya painting invite comparison with Moche painting (see Fig. 77), both being New World styles where symmetry and frontality have no place. In our example, gyrating creatures fill the space from rim to base, rising on tiptoes to reach into the inscription; even the skeleton moves with a ballerina's grace. The interaction is lively, but the final effect is not illusionistic.

　　Now we face the herculean task of identifying the subject of a painting on one drinking jar, shown in the rollout photograph in Figure 87. Many Maya vase paintings narrate court etiquette, the ballgame, and ritual activities, while others, such as this one, were inspired by the activities of gods and mythic culture-heroes. No stranger to us in this painting is the chunky infant with jaguar paws and tail. Although we encountered the jaguar-baby as the Rain God in Olmec art, in Maya cosmology the jaguar is associated with the Night Sun as the Jaguar God of the Underworld we have seen earlier. In Maya art the jaguar-baby is paired with a god associated with ritual decapitation, *Chac-Xib-Chac*, a manifestation of the rain and lightning god, *Chac*. The oldest continually worshipped Maya deity, Chac is recognized by his stone ax, shell earspools, catfish barbel (or snake) on his cheek, and scales on his body (here along the backs of his legs). Chac lives on mountaintops and in caves; he strikes his ax to bring thunder, lightning, and wind, all preludes to rain.

　　In the codex-style painting, the jaguar-baby sacrifice takes place on a mountain-altar, marked with the earth glyph (*caban*) and a cave-mouth opening to the Lower World. Accompanying Chac-Xib-Chac in his macabre dance

is a cigar-smoking insect and the Death God, a bloated skeleton with eyeballs dangling from his topknot and backrack. A dog, the guide through the maze of the Lower World, waits expectantly for the dying jaguar-baby's arrival.

No doubt this information made perfect sense to the ancient Maya audience, but a conclusive reading of the scene has eluded today's Mayanists. In one interpretation, the jaguar-baby is the dying sun sinking below the horizon at night to enter the Lower World, the watery hell the Maya called *Xibalba;* from his death he arises new every morning. Others link it to an episode in the Maya creation text, the *Popol Vuh* (Book of Council). The *Popol Vuh* describes Xibalba and its rulers, the stinking Lords of Death, in graphic detail. Eventually the Lords of Death are defeated by the *Hero Twins*, Hunahpu and Xbalanque. Their victory over death followed the deaths of the Hero Twins' uncle, Vucub Hunahpu, and their father, *Hun Hunahpu* (First Father, Hun Nahl Yeh), who was decapitated after losing a ballgame to the Lords of Death. The Hero Twins recover their father's equipment, destroy the Lords of Death, and rise as the sun and the moon. Regardless of the exact episode represented on the vessel, the theme is the cyclic renewal of life through death.

Jaina Figurines. The tiny island of Jaina (*ha*, meaning "water"; *na*, meaning "house"), off the Campeche coast, was a watery realm on the western fringes of the Maya world. People from Campeche, Tabasco, and Yucatán apparently sought burial in the necropolis of the real-world Xibalba, where an estimated twenty thousand graves remain undisturbed despite centuries of looting and a few cursory mid-twentieth-century excavations. In these graves, a unique type of mortuary object was placed in the arms of the deceased. The "minor masterpieces" are the justly famous ceramic Jaina figurines.

Most Jaina figurines are musical instruments, whistles with a mouthpiece inserted in the back or rattles with pellets in the body. Where they were made remains a mystery because no clay deposits or kiln sites have been found on the island. The exceptional, early Jaina products are made of fine-grain clay, usually with mold-pressed heads and handbuilt bodies; the later, less animated examples were entirely mold-pressed of coarse clay. Mass production expedited the ceramic process, but the Maya style is naturalistic compared to the abstract assemblages of the Teotihuacan ceramic industry.

Lords and ladies, gods and dwarves, and old men and babies are among the subjects of Jaina figurines. The variety in pose—some lunging, others weaving—and costume—some with removable headgear—is astonishing. They range in style from closed-contour, rectangular shapes to animated figures with open silhouettes. Our ballplayer (Fig. 88) is suited in cumbersome protective gear with an *hacha* in the likeness of a human head protruding from a padded belt called a *yoke*. A review of the Nayarit ballgame tableau shows players wearing these same items five hundred years earlier on the other side

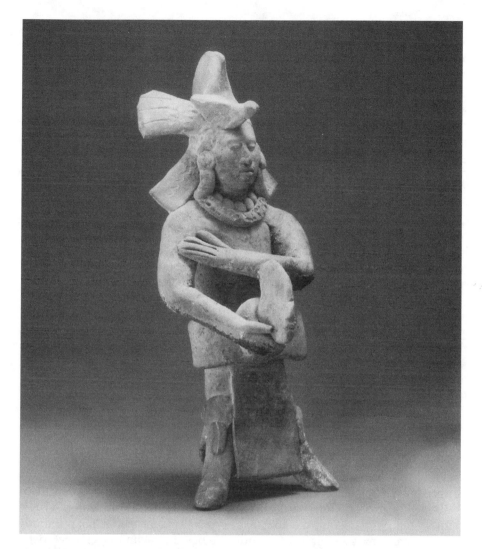

Figure 88 Maya (Late Classic Period, 600–900; Island of Jaina, Campeche, Mexico).
Ballplayer wearing a yoke and hacha, 600; red earthenware; H. 3″ (7.6 cm), W. 3 1/2″
(8.9 cm), D. 4 1/4″ (10.8 cm). The Seattle Art Museum, Eugene Fuller Memorial
Collection. Photo, Paul Macapia, © Seattle Art Museum

of Mesoamerica. Stone effigy yokes—heavy ritual versions of the lightweight
leather or wicker yokes worn by ballplayers—are incised with images of gods,
toads, earth-monster mouths, and interlacing water-blood scrolls. Stone
hachas are often shaped like human heads, probably a reference to the trophy
heads taken at the conclusion of a ritual game, as well as the cosmic ballplayer
of the *Popol Vuh,* First Father Hun Hunahpu, who lost his head in competition

with the Lords of Death. The position of the Jaina ballplayer's right arm, a sub-ordination gesture associated with respect, allegiance, and submission, may relate to the zigzag lines incised on the paper streamers on the headdress, a motif found frequently on depictions of penitents and captives.

POSTCLASSIC PERIOD

Centuries of imperial expansion during the *Postclassic period* (1100–1521) culminated in the meteoric rise of the Aztecs (1350/1427–1521) in Central Mexico. For style, iconography, and technical virtuosity, Aztec artists owed a debt to all the Mesoamericans who had preceded them.

Aztec

Purportedly, the nomadic Nahuatl-speaking Aztecs arrived in the Valley of Mexico from their mythical homeland, *Atzlan,* during the early thirteenth century. Established communities in the area tolerated the ragtag band only because the immigrants were excellent mercenaries and they paid their taxes. In no time, their battle skills enabled them to subjugate their neighbors and create an empire of over eleven million people. The Aztecs terrorized Mesoamerica for territory, tribute, and captives for the priests' blades. Before the temples atop the pyramids in their capital city, *Tenochtitlán,* victims were stretched over a sacrificial stone, their beating hearts extracted, and the bodies cast down the stairways. Artists and architects shared the responsibility for convincing the population these activities were necessary.

Tenochtitlán is underneath the streets of downtown Mexico City. Since the ceremonial district was discovered by accident in 1978, excavations have been ongoing northeast of the Cathedral in the Plaza Mayor, where the *Main Pyramid,* the most sacred building in the Aztec empire, still stands, albeit underground. According to the Aztec migration story, their tribal-god and culture-hero, *Huitzilopochtli* (Hummingbird-on-the-Left), had ordered them to divide the area into four parts and to build his house in the center. A rudimentary temple dated around 1325 has been found, encased in six pyramids of ever-increasing size. Figure 89 shows the nesting technique characteristic of many buildings discussed in this chapter. The Aztecs renewed the Main Pyramid six times, but the building visible at the time of the Conquest was destroyed by the Spaniards.

The ceremonial district was the sacred center of the empire, and the Main Pyramid was its heart. While incorporating traditional principles of Mesoamerican space planning, the precinct is unique in its fortifications. The high walls, with only four gates to the cardinal directions, excluded the city's population of three hundred thousand from witnessing the life- and state-sustaining rituals performed inside. Two wide stairways led up the west face of the Main Pyramid because it was the substructure for twin temples, a blue

Figure 89 Aztec (Central Mexico; 1350–1427–1521). Main Pyramid, ritual district, Tenochtitlán; now northeast of the Cathedral and the Plaza Mayor, Mexico City; six nested twin-temple pyramids, ca. 1390–1521; Temple II, ca. 1390, earliest extant and visible today (upper left under shed roof); Temple VI, 1500, latest extant and visible today; Temple VII, built 1520 and destroyed 1521, height 197' (60 m). Photo, author

temple on the north dedicated to Tlaloc, the ancient Mesoamerican god of rain and storms, and a red temple on the south to Huitzilopochtli, the Aztecs' ancestral god of sun and war. Pairing rain and sun in ritual architecture magnified the importance of interactive opposites. Without the constant conflict between sun and storm, life would not exist. In Aztec ideology, the battle between cosmic opposites and the human toll it exacted in blood sacrifices were inescapable in the cycle of life.

The cycle of past and future cosmic destructions is narrated on the *Stone of the Five Suns* (Fig. 90), a monumental carving dated July 15, 1503, the coronation date of Emperor Moctezuma II. Carved in a flat, linear, book-derivative style, it predicts the destruction of the world with all the passion of a mechanical drawing.

In Aztec cosmology, four eras called "suns" preceded our own. Imperfect humanoids lived in the four prior suns, and each was destroyed by natural forces. On the Stone of the Five Suns the four prior suns are shown with their ritual calendar (the *tonalpohualli*) names in the rectangles around the center. Starting in the upper right and moving counterclockwise, they are the 4-Jaguar era (giants destroyed by jaguars of the Lower World); 4-Wind (monkeys destroyed by hurricanes); 4-Rain (bird-men destroyed by fiery rain,

Figure 90 Aztec (Central Mexico; 1350/1427–1521). *Stone of the Five Suns,* from
Tenochtitlán, ca. 1502; basalt; D. 141 3/4″ (360 cm). Museo Nacional de Antropología,
Mexico City. Art Resource

probably a volcano); and, 4-Water (fish-men destroyed by great floods). The
entire center of the radial composition is made of the date-name of the Fifth
Sun, our era, believed by the Aztecs to have been created at Teotihuacan. The
Fifth Sun is 4-Motion, the "calendar" predicting destruction by earthquake.
In the center of the glyph for "motion" (*ollin*) is the face of the sun at its mo-
ment of annihilation as it is swallowed by the earth-monster, represented
with a flint-knife tongue and claws holding sacrificial blades. To show the
event will take place in a great ball of fire, the carvers wrapped two Fire Ser-
pents (a *Xiuhcoatl*) around the outer edge of the stone; their faces meet at the
bottom, their tails at the top, and their segmented bodies carry flames in be-
tween. Blade-like sun rays shoot from the Fifth Sun and the ring of twenty
day-names in the Aztec ritual calendar which encircles it. Between the tails of
the two Fire Serpents is the beginning date for the Fifth Sun, 13-Reed. The
Aztec date is the European year 1427, the year the Aztecs consolidated power
and took control of Central Mexico. Therefore, the beginning of their empire
was the beginning of the world. Embedded in the ideology of the Stone of the
Five Suns we can find such grains of truth as the persuasiveness of ethno-
centrism and the ferocity of the forces of nature. Not predicted on the "calen-
dar" was the destruction on August 31, 1521, when Hernán Cortés and his
ragtag band of mercenaries brought down the empire.

FOR DISCUSSION AND REVIEW

1. "Space" was a theme in Mesoamerican art, but it was never shown realistically. What are the Mesoamerican cosmological spatial components? What is the function of the World Mountain or the World Tree in delineating cosmic space? Cite specific works of art to illustrate the concept. Conclude with examples of cosmic spaces from other cultures.

2. Review Mesoamerican calendrics. What is a tun? A katun? The haab? The tzolkin? The tonalpohualli? Why were period endings important in art? In politics? Choose specific works to document the importance of time as a unifying concept in Mesoamerican art, history, and worldview. Where have we seen cycles of time before?

3. Why might the Olmec be considered the Mother Culture of Mesoamerica?

4. What is the significance of the layout of La Venta? Include the mountain–water components. Compare with the Chavín Old Temple in South America.

5. How did Olmec architecture unite the themes of kingship and landscape? What were a king's duties? Compared with divine-kings in other cultures?

6. Discuss the theme of transformation in Mesoamerican art. Begin with the were-jaguar baby and select examples through the Maya. How does it compare to the theme in other cultures? Use specific examples.

7. Why was jade a precious material in Mesoamerica? In China?

8. Discuss the religious, political, social, and cosmological implications of the ballgame. Include specific works of art and narrations from the *Popol Vuh*. Was the ballgame a "sport" in our sense of the word? Do sports in today's world have any of the implications the game had in ancient Mesoamerica?

9. What is the West Mexican shaft-tomb tradition? Compare with the Paracas burial tradition in South America. What factual information can the ceramics give about architectural forms? What other cultures put architectural miniatures in tombs? Why would the living think that the dead wanted small buildings? For a final thought on context, what makes an item "amusing" to one audience and "solemn" to another?

10. Teotihuacan incorporated the natural landscape into their city planning. Describe the layout and construction methods for the main structures. Discuss reasons for using the landscape as an architectural prototype.

11. Commerce was booming in Teotihuacan. What were its artistic exports? Why were they popular commodities? Compare with exports from China during the Yuan dynasty.

12. Catalog all the deities in the text. What was the essence of each? How is each recognized in the arts? Does an entity comparable to Brahman emerge? If so, which one? If not, but one had existed, what might it have been? If one did not exist, why do you suppose it was unnecessary?

13. List all the architectural sites, reviewing space planning, building construction, and design elements. What are common threads? What makes each unique?

14. Using the Pyramid of Quetzalcoatl and Temple I at Tikal, and the incensario and Jaina figurine, compare the Teotihuacan and Maya aesthetics. What are similarities? Differences?

15. The theme of "cosmic parallels" appears frequently in Maya art. With Stela 31 and the Palace Tablet, first identify all the characters, then discuss royal lineage, the gods, and kingship. Incorporate the vertical zones of space in Mesoamerican cosmology. In what situations would "the reality of myth" be important to a person or culture?

16. Review the time periods in Mesoamerican history. For the differences between Preclassic and Classic period art analyze the presentation of the were-jaguar baby. For stylistic and thematic differences in Early and Late Classic Maya art compare Stela 31 and the Palace Tablet.

17. What information is given in the inscriptions on codex-style vessels? What additional information would you appreciate having in the inscriptions? Why might the Maya audiences have considered such information unnecessary? How does it compare (for purpose and style) with writing on Chinese paintings? Harappan seals? Is it always possible to arrive at a full understanding of a work of art when we know the meanings of all its individual components? Why or why not?

18. Compare the Moche and Maya vessels for style, subject, and function.

19. What is the *Popol Vuh?* Discuss the major events it narrates. Is it a sacred text, comparable to the sutras, the *Vedas,* or the *Qur'an?*

20. Choose specific buildings to discuss the Mesoamerican practice of "renewing buildings" by encasing them in larger buildings.

21. Identify the characteristics of the Jaina style. Compare with monumental sculpture. Are some subjects possible in one sculptural form and not another? Why or why not?

22. Develop the theme of cyclic time as represented on the Stone of the Five Suns. Discuss it in light of the statement "blood sacrifices were inescapable in the cycle of life."

23. Who were the Aztec? Where did they come from? Compare their rise to power and their statecraft with their contemporaries in South America, the Inca.

FOR FURTHER READING

Coe, Michael, *The Maya*. London: Thames and Hudson, 1991.

Coe, Michael, et al., *The Olmec World: Ritual and Rulership*. Princeton: The Art Museum, Princeton University, and Harry N. Abrams, Inc., 1996.

Freidel, David, Linda Schele, and Joy Parker, *Maya Cosmos: Three Thousand Years on the Shaman's Path*. New York: William Morrow and Company, 1993.

Miller, Mary Ellen, *The Art of Mesoamerica, from Olmec to Aztec*. London: Thames and Hudson, 1996.

Miller, Mary and Karl Taube, *The Gods and Symbols of Ancient Mexico and the Maya: An Illustrated Dictionary of Mesoamerican Religion*. London: Thames and Hudson, 1993.

Reents-Budet, Dorie, *Painting the Maya Universe: Royal Ceramics of the Classic Period*. Durham and London: Duke University Press, 1994.

Scarborough, Vernon L. and David R. Wilcox, eds., *The Mesoamerican Ballgame*. Tucson: The University of Arizona Press, 1991.

Schele, Linda and David Freidel, *A Forest of Kings: The Untold Story of the Ancient Maya*. New York: William Morrow, 1990.

Schele, Linda and Peter Mathews,*The Code of Kings: The Language of Seven Sacred Maya Temples*. New York: Scribner, 1998.

Schele, Linda and Mary Ellen Miller, *The Blood of Kings: Dynasty and Ritual in Maya Art*. New York and Fort Worth: George Braziller and the Kimbell Art Museum, 1986.

Schmidt, Peter, Mercedes de la Garza, and Enrique Nalda, eds., *Maya*. New York: Rizzoli, 1998.

Sharer, Robert J., *The Ancient Maya*. Stanford: Stanford University Press, 1994.

Taube, Karl, *Aztec and Maya Myths*. London and Austin: The British Museum Press and the University of Texas Press, 1995.

Tedlock, Dennis, trans. and commentary, *Popol Vuh*. New York: Simon and Schuster, 1986.

Townsend, Richard E., *Ancient West Mexico: Art and Archaeology of the Unknown Past*. Chicago: The Art Institute of Chicago, 1998.

See also Chapter 7, South America, For Further Reading.

9

Native North America

Native North Americans' special sensitivity for nature is evident in their cosmologies and visual arts, where everything is potentially sacred and, therefore, deserving respect. An awareness of the interdependence of life has helped shape the view that life is a cooperative venture for people, animals, spirits, and the earth.

A kinship with nature is especially evident in the abundance of animal imagery and materials, an underpinning of all ancient American art. In Native North American creation stories, animal spirits teach people to live honorably and to prosper; they are role models for virtuous behavior. Being older than people, animals are said to be closer to the Creator and the ancestors, therefore totemic animals are often symbols for family identity. Animal imagery also affirmed social rank and cemented political alliances with special emblems designed for rulers and their family members and for fraternal societies of warriors and healers.

The presence of other unseen forces operative in the Native North American worldview is suggested in art. Atmospheric spirits exist in the wind and clouds, terrestrial spirits in the mountains and streams, but, in comparison to the Japanese kami, Native North American spirits are interactive and seek humans. For example, spirits on the Great Plains are said to have drawn their own pictures to attract people. Spirit forces do not reside in images although they are captivated by them; objects possess power by virtue of their potent substances and ritual activation. Objects and images would be respected and often feared for their potential strength, but not worshipped. Art's purpose was to help ensure the community's livelihood, protect an individual from harm, and preserve personal health. It also documented honorable deeds, family lineage, and great events, both actual and mythical.

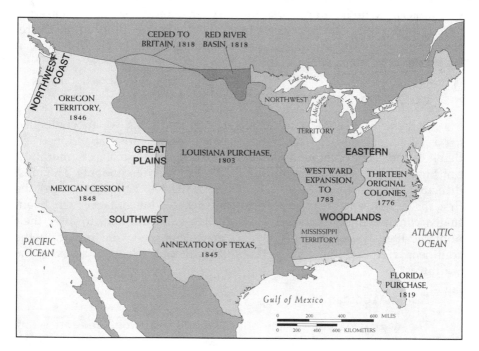

Continental United States

Our overview of the Native North American artistic experience is divided into two parts; ancient art made before contact with Europeans and the art of the subsequent historic period. The arrival of Europeans is referenced as the seminal event for two reasons. The first acknowledges that the forces set in motion by their presence in the New World altered traditional lifeways and challenged traditional belief systems. *First Contact* denotes a pivotal moment in the lives of indigenous peoples throughout the Americas. Many Precontact traditions continued in the Postcontact era, but after the fifteenth century, the art grew out of encounters with a different cosmology. The second reason stems from the importance we place on written accounts for historical documentation. From the time of their arrival, Europeans recorded their observations in written and pictorial form. When adding researchers' observations, photographs, and interviews to this body of early information, the resources on which we draw for an understanding of Native North American art appear to be much richer in the Postcontact period.

PRECONTACT PERIOD

Because all Precontact cultures were oral traditions, we are compelled to coax their histories from the things they left behind—long-abandoned settlements and ceremonial centers, everyday and special-use objects, modifications to the land, and narratives of their Postcontact descendants. The most difficult to understand is the *Paleoindian period* (32,000/12,000–8000 BCE), the first, the longest, and the most academically debated Precontact epoch. Eventually, climatic changes forced the early big-game hunters to alter their nomadic lifeways, so by 8000 BCE regional cultures were replacing the continent-wide Paleoindian, especially in the Eastern Woodlands and in the Southwest.

Eastern Woodlands

The major geographic boundaries of the Eastern Woodlands are set by the Mississippi River and the Atlantic Ocean; the Gulf of Mexico marks the southern terminus, and in the north, the region extends well into Canada. The land was resource-rich, and it offered people choices. It supported animal and plant life for food, provided stone for tools and ornaments, clay for ceramics, fields for crops, and building materials for earthworks.

Earthworks. The conspicuous visual legacy in the Eastern Woodlands is the *earthwork,* a monumental form built of mounded dirt. We will never know the full scope of these sculptural and architectural achievements because they have been assimilated into the landscape, modified by plows and bulldozers into grassy bulges and arcs that follow the rivers and grasslands from Wisconsin to the Louisiana bayous. Had they survived intact, the numbers of mounds would be legion and their dimensions prodigious. Vestiges

of these projects hint at the immensity of the undertakings, the comprehensive vision of their planners, and the communal investments of time made by their assemblers. Aesthetically, the ancient earthworks are the finest expressions of the Native North American quest for a harmony of natural and artificial forms.

Earthworks dated to the *Archaic period* (8000–1000 BCE) attest to the antiquity of the monumental mound building and civic space planning traditions. Between 3900 and 3300 BCE people built eleven earthen mounds around an oval plaza, over nine hundred feet in diameter, in the swamps of northeastern Louisiana. Firm dates for this once seasonally occupied site, *Watson Brake*, place its construction at least a thousand years before Egypt's Great Pyramids. Two thousand years later and sixty miles away people began work at *Poverty Point* (1800–500 BCE), the largest and most complex Archaic period site. Disadvantageously situated in a resources-poor locale, Poverty Point appears to have been instrumental in coordinating long-distance trade in the Lower Mississippi Valley. The site is a nearly four-thousand-foot-wide semicircle of six concentric earthen embankments, each about one hundred feet apart, six feet high, and eighty feet wide. Both Watson Brake and Poverty Point challenge the traditional perception of early New World peoples living small-scale, subsistence-driven lives, but the meaning of the designs and the motivation for their construction remain under discussion.

Finding construction materials posed few problems for earthwork builders; soil from designated sites was hauled in baskets to shape the structures. However, archaeologists have found dates for dirt to be especially difficult to secure, relying instead on a mound's contents and the debris around it. Mounds with no contents, such as *Serpent Mound* (Fig. 91) in southern Ohio, pose special problems. Since the 1880s it had been attributed to the *Adena culture* (1000/800–1 BCE) primarily because three conical mounds with Adena remains are close by. In 1991 splinters of charcoal excavated from the earthwork produced dates to the later Mississippian period, and the mound is now dated around 1070.

Because it appears to have a coiled tail at one end and a mouth filled with an oval shape at the other, Serpent Mound is interpreted as a striking snake with a wide-open mouth, possibly devouring an egg or a frog. The quarter-mile-long earthwork is the largest surviving *effigy mound* in North America. Drawing on Postcontact Woodlands mythologies, it has been interpreted as the sun in eclipse and, because snakes shed their skin, a life-renewal symbol. In the early Postcontact period, people associated snakes with rain, fertility, and healing. The snake was feared and avoided, while at the same time revered and coveted; sinister in its beauty and power, it was critical to human life. Nearly a millennium after its construction, a local Ohio minister interpreted Serpent Mound as the devil in the Garden of Eden swallowing the fruit from the Tree of the Knowledge of Good and Evil.

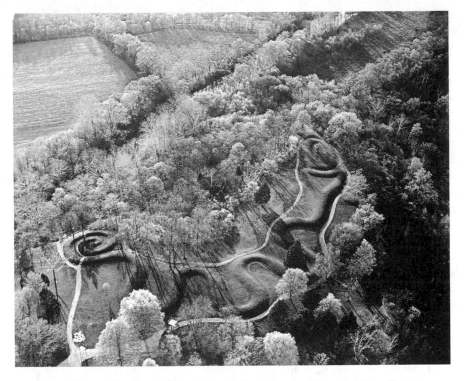

Figure 91 Eastern Woodlands (Fort Ancient culture). Serpent Mound, Adams County, Ohio, previously dated 1000 BCE–400, currently dated 1070; dirt and clay; L. 1,348′ (380 m), W. 20′, (608 m) H. 2-6′ (.6 m-1.6 m). Division of Archaeology, Ohio Historical Center

Serpent Mound is located on the edge of a promontory above the Ohio Brush Creek. The outline of stones and clay was filled with a foundation of yellow clay and capped with baskets of dirt. Serpent Mound transforms the landscape, but the monument is neither visually nor ecologically intrusive. It gives the landscape direction, definition, and special purpose. Proposals for its original function include a territorial boundary marker, a site for communal feasting, an astronomical chart, a summer solstice marker, and a geoglyph of Halley's Comet (1066).

Hopewell culture. Precontact cultures in the Eastern Woodlands are grouped chronologically into four major periods: Paleoindian, Archaic, Woodland, and Mississippian. The *Woodland period* (1000 BCE–700/1000) is subdivided into the *Adena* (or Early Woodland) and the *Hopewell* (or Middle Woodland; 300/100 BCE–600), named after a man on whose farm a major mound group was excavated in the nineteenth century. From the Hopewell core sites, concentrated in the Ohio River Valley, the culture extended into Illinois, Georgia, Louisiana, and across the Mississippi River into Kansas.

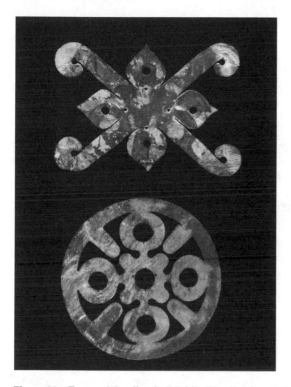

Figure 92 Eastern Woodlands (Middle Woodland period, Hopewell culture, 300/100 BCE–600). Plaque, 300 BCE–600; copper geometric ornaments. Neg. # A110027 © The Field Museum, Chicago 56164

Geometric earthworks, defined with *embankment mounds,* surrounded Hopewell ceremonial sites, which were linked to other sites by paved roads and long embankment mounds. Other embankments surrounded groups of *conical burial mounds* where the elite of Hopewell society buried their dead with exotic items, such as barracuda jaws from the Gulf of Mexico and grizzly bear teeth from the Rocky Mountains. The imported goods confirm the existence of long-distance trade networks, which provided avenues for the movement of styles and symbols.

Pure copper nuggets extracted from the Upper Peninsula of Michigan were pounded into sheets to form rattles, earspools, beads, blades, and plaques (Fig. 92), then embossed and sanded to create a textured appearance. The Hopewell aesthetic, like the stencil process used to produce the object, favors precision and efficiency. Clean-cut edges, interior piercing, and curvilinear symmetry are characteristic of the spartan designs. Images are direct and to-the-point, rendered in a style that would have been highly visible to the population. The polished copper plaques are presumed to have been badges of authority attached to garments or ceremonial objects. Our example

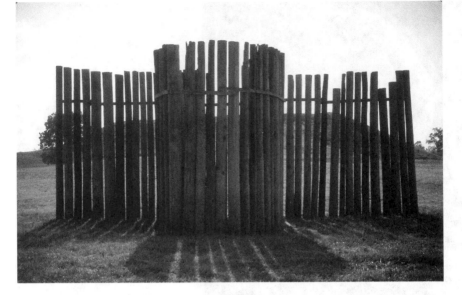

Figure 93 Eastern Woodlands (Mississippian period, 1000–1300/1600). Monks Mound and palisade reconstruction, Cahokia, Illinois, 900–1250; dirt; H. 100′ (30.5 m), W. 710′ (216.5 m), L. 1080′ (329.2 m); mound covers 14 acres. Photo, author

may be a schematic rendering of a power space, conceivably the four cardinal directions with logs in the center forming the *Sacred Fire,* a Postcontact symbol for the sun. The Hopewell copper ornament may be part of a shared symbolism among Eastern Woodlands chiefs who, in the early Postcontact period, were revered as human manifestations of the sun.

 Mississippian period. The *Mississippian period* (1000–1300/1600) was the final phase of Precontact culture in the Eastern Woodlands. River valleys from Wisconsin to Florida supported settlements from single-family farmsteads to cities with populations in the tens of thousands.

 Cahokia, located in Illinois just south of the confluence of the Mississippi, Illinois, and Missouri rivers, was the largest ancient Native North American urban center. At its height in the late twelfth century Cahokia covered six square miles and contained several types of earthworks within its palisaded central district. Rectangular, flat-topped platform mounds were substructures for special-use buildings, such as temples, elite residences, council houses, and charnel houses. *Monks Mound* (Fig. 93), renewed in several stages until it reached a height of one hundred feet in four terraces, is the largest platform mound at Cahokia, as well as the largest structure built by Precontact Native North Americans. The mounds still stand along the central north–south plaza, although the wooden buildings they once supported have long since disintegrated. Rectangular, gable-topped *ridge mounds,* located at the cardinal points,

possibly served as directional markers when the city was planned. Cahokia's axial alignment, cardinal orientation, and plaza-mound sequence recall Mesoamerican space planning. However, the decision to construct earthen rather than masonry mounds was in the Native North American traditions of pragmatism, efficiency, and ecological sensitivity. Dirt, quarried from nearby *borrow pits*, was carried to the construction sites in baskets. When the pits grew large and deep, they appear to have been stocked with fish.

As the center of a political, social, economic, and religious network, Cahokia made its presence felt throughout the Mississippi River Valley long after it was abandoned in the fourteenth century. Fortified, plaza-mound urban planning was the norm in the southeastern Mississippian communities encountered by European adventurers in the early sixteenth century. Often recording their experiences in words and pictures, the Europeans seemed particularly impressed by the mounds, but they rarely mentioned the figural arts. Perhaps foreigners were not permitted in restricted spaces where objects were kept, or the chroniclers assumed their readers had no interest in detailed accounts of objects they dismissed as "idols."

The Mississippians' methods for communicating vital information took forms other than the fragile paintings and texts on paper preferred by Europeans. Ideas were encoded in a visual symbol system permanently engraved on shell, incised in clay, and hammered in copper. A few among the many motifs they used were the cross-in-circle directional sign, swastika-shaped wind sign, winged serpent with horns, eye-in-hand, severed head, bird, spider, warrior, and athlete. When archaeologists began recognizing similarities in specially crafted, nonutilitarian objects—which they had recovered primarily from late Mississippian burials in the Southeast—they coined the phrase *Southeastern Ceremonial Complex* (SCC) or *Southern Cult* to identify the group.

A characteristic Mississippian special-use object is a *gorget,* a pendant suspended on a cord passed through two perforations along the edge. A gorget may have functioned as a warrior's throat protector, although at the Hixon site in eastern Tennessee, where the example in Figure 94 was found, gorgets were also recovered from the graves of women and children. The socially restricted ornaments probably defined group affiliations. Rectangular stone gorgets from the Late Archaic period (3000–1000 BCE) document the antiquity of the gorget tradition inherited by Mississippians. But while the concept was thousands of years old, Mississippian gorgets are easily distinguished from their predecessors by material, format, and imagery. They were made of marine shell or fired clay with symbolic patterns and images engraved in the surface. A circular format with linear designs and a minimal number of pierced areas are also characteristic.

The "bird-men" or "eagle-beings" on the Tennessee gorget make up a distinct category of SCC representations. They have been interpreted as spirit beings, totemic ancestors, costumed warriors, and shamans. Bird-men are recognized by a feathered cape spread like wings from outstretched arms and

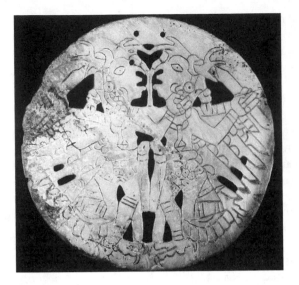

Figure 94 Eastern Woodlands (Mississippian period, 1000–1300–1600). Gorget, from eastern Tennessee, ca. 1350–1500; shell; D. 4 1/2″ (11.43 cm). Courtesy Frank H. McClung Museum, The University of Tennessee, Knoxville

a feathered backrack positioned like a tail. This particular pair also has beak-shaped noses and claw feet. Marine shell pendants and antler headdresses add water and earth associations to the predominantly celestial bird-men.

The flexed legs, typical of many bird-men representations, have prompted interpretations ranging from running, fighting, and dancing, to flying. However, the circular format makes a firm reading of the activity problematic. The importance of a groundline in identifying activities in the visual arts is demonstrated in a comparison between the Mississippian gorget and the Moche vessel (see Fig. 77). On both, elements are painted with thin lines and the composite figures assume similar poses, but the absence of a groundline on the gorget contributes to the narrative ambiguity character-istic of so much Native North American art. Details such as clenched fists holding flint blades would suggest the bird-men are engaged in a ceremonial battle. Because the bird attributes are incorporated into the costumes, the fig-ures probably are not supernaturals. Possibly they were associated with a well-dressed ruler class, making them reasonably accurate renditions of men described by explorer Giovanni de Verrazzano (1524) as "clad in feathers of fowls of diverse hues."

In Mississippian art complementary themes of passivity, harmony, and sustenance existed alongside those of aggression, conflict, and conquest. Male hunter-warrior subjects were generally confined to two-dimensional representations, and female mother-cultivator subjects were rendered in three-dimensional freestanding figures.

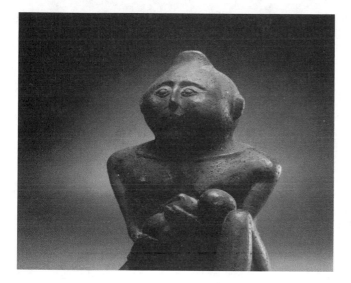

Figure 95 Eastern Woodlands (Mississippian period, 1000–1300/1600). Woman and child effigy bottle, from outside Cahokia, Illinois, ca. 1100; fired clay; H. 5 7/8″ (14.9 cm), W. 3 1/2″ (9.7 cm). WL-23. Photograph © 1985 the Detroit Institute of Arts

Among the many utilitarian and ceremonial vessels shaped by Mississippian ceramists are effigy wares representing women (Fig. 95). Occasionally holding a small figure and frequently shown with a hunchback and exaggerated vertebrae, the figures have been associated with concepts of nurturing and renewal, as well as the special powers old women and people with physical abnormalities were believed to possess. While our initial inclination might be to label it a "mother-and-child," the theme probably relates to a broader concept of the earth as the sustainer of life, the earth as Mother and Grandmother. Similar Mississippian images have been linked to community-wide folk traditions, focused on agriculture and domesticity. In comparison to the Olmec sculpture (see Fig. 80), also a socially restricted power image like the bird-man gorget, the Mississippian woman is less hieratic and ceremonial. In her static position she is expectant and watchful; her pose suggests latent power. Our example, recovered from a Cahokia suburb, has a substantial body with legs positioned like mountains and plains. Although not quite six inches high, its simplified shape, closed-form contour, and stylized anatomy create the impression of monumental sculpture.

The Southwest

The introduction of corn cultivation from Mesoamerica to the Southwest about 1500 BCE was certainly a significant impetus for the nomadic hunter-gatherers, who had populated the territory through the Archaic period, to

modify their lifeways with permanent settlements, ceramic production, and a new social ceremonialism visible in the arts. By the first century, groups were localized in areas of Arizona, New Mexico, Colorado, and Utah, and within a few hundred years three distinct but interrelated Precontact cultures—the Hohokam, the Anasazi, and the Mogollon—were flourishing in the Southwest. Each developed a self-defining approach to art and architecture, yet basic principles of space planning, construction, and pictorial design were shared.

All lifeforms in the Southwest shared a common concern: unreliable water sources. People responded in two ways. Those who maintained a hunter-gatherer existence created portable, perishable art forms, such as the intricately fashioned baskets by the Postcontact Chumash people of southern California. Others aspired to secure their futures by controlling the environment, and they banked on agriculture. With engineering and ritual, art and architecture, they made a bid for security in an unpredictable world. Art helped alleviate stress.

Over the centuries each culture became master of its unique environment, building more roads to connect larger towns to accommodate growing populations supported by vast corn fields planted farther and farther across the landscape. But as happens too often in history, their success led to their demise because nature failed to cooperate. Floods quickly followed droughts, and the peoples' carefully constructed, diligently maintained, artificially modified environment disintegrated. Dwindling populations consolidated until towns were finally abandoned; the visual arts steadily coarsened until production ceased. However, the ancient people did not "disappear"; they changed lifeways in response to the demands of nature. For example, the Pima and the Papago are the descendants of the ancient Hohokam culture, and the ancient Anasazi culture is the ancestor of the historic Pueblo People.

Hohokam. The features that attracted the *Hohokam* (Pima, meaning "vanished" or "all used up") to their heartland in the Phoenix Basin have lost none of their appeal for the millions of people who still reside and vacation in south-central Arizona. Phoenix was a small section of the original Hohokam territory, which extended some forty thousand square miles across the Sonoran Desert. The arid land of basins and low mountain ranges was made productive by an irrigation system which, at its greatest extent around 1200, carried water from the Salt and the Gila rivers through a thousand miles of canals. Only short sections of the hydraulic marvel are visible today because the canals in Phoenix and its suburbs are routed through the ancient courses.

Of the three Precontact agriculture-based cultures in the Southwest, the Hohokam coalesced earliest, around the year 1, and collapsed last, by 1350/1450. People lived in villages of semisubterranean pithouses and assembled for communal activities in public plazas. Huge piles of garbage, which had accumulated near residences adjacent to the plazas, were coated with plaster and converted to ceremonial platform mounds. Near the

mounds oval-shaped ballcourts were dug, the excess dirt heaped onto embankments around the playing alley for spectators' seating. After 1200, the ballcourts were used as trash pits, and elite residences were built on the trash mounds. Of the ancient Native North American peoples, the Hohokam culture shows the closest ties to Mesoamerica. In addition to space planning, other items that point to a Mesoamerican connection include the remains of tropical birds and thousands of West Mexico-type clay figurines.

The Hohokam maintained a long-distance trade network in all directions from their homeland. Exports included salt, cotton, and especially their carved and acid-etched marine shell jewelry recovered from ancient towns across the Southwest. Shells from the Gulf of California were processed by artisans in the Phoenix Basin and traded north to the Anasazi and east to the Mogollon.

Many sites along the trade routes are marked with images on loose rocks and mountainsides. They are examples of *rock art*, the term for pictures created on boulders, escarpments, and rock-shelters. Pecking or scratching into the crust of a weathered rock produced a drawing of light lines on a dark ground. This method, preferred by the Hohokam, is one of two processes used by rock art image-makers the world over. Engraving on stone produced a durable *petroglyph* and painting on stone the fragile *pictograph*, mentioned in the introduction to Ancient Africa and Aboriginal Australia.

Rock art is one of the oldest art forms in North America, with hundreds of thousands of examples surviving in nearly all areas of the continent. Clearly, stone was available to Native North Americans but, unlike their Mesoamerican neighbors, they rarely used it for buildings and never shaped it into monumental sculpture. They modified stone unpretentiously.

Hohokam rock art has been found along rivers and trails, at quarries and food processing sites, and near towns and fields. At *Painted Rocks* (Fig. 96), located on the extreme western edge of Hohokam territory along the shell trade route to the Gulf of California, thousands of petroglyphs were pecked into the isolated basalt outcrop in the middle of the desert. The *superimposition*, or layering image-on-image, suggests travelers frequented the site over a long period of time. Motifs include representational lifeforms such as lizards and humanoids, and nonrepresentational zigzags, spirals, and rectilinear grids. Lizards—shown from a top view with oval bodies, long tails, and appendages akimbo—have been interpreted as clan symbols and as sacred beings associated with water. Identifications for the humans—usually composite figures with frontal, hourglass-shaped torsos and profile, flexed legs—include shamans, dancers, hunters, ballplayers, and merchants. The zigzags may have been lightning symbols, the spirals celestial phenomenon or migration signs, and the grids architectural or irrigation plans. They have been explained as calendars, trail markers, inventory tallies, maps, boundary markers, and hunting shrines, to mention only a few of the current interpretations. The original motivation for creating the rock art probably varied according to the purpose of the site.

Figure 96 Southwest (Hohokam culture, 1–1350/1450). Painted Rocks petroglyph site, outside Gila Bend, Arizona, before 1450. Photo, Robert C. Bradley

Mogollon. Contemporaneous with the Hohokam on their eastern border were people of the *Mogollon culture,* named for the mountain range in Arizona. The Mogollon territory was larger than the Hohokam, encompassing sections of Arizona and New Mexico, and extending south into the Mexican state of Chihuahua. Based on the Mogollon pottery at Hohokam sites, and visa versa, the two groups kept close trading ties. The Mogollon appear to have been the middlemen between the Hohokam and the Anasazi to the north. Hohokam ballcourts were of no interest to the Mogollon, but they borrowed motifs from Hohokam ceramics and rock art for their own paintings.

Finely crafted and imaginatively decorated ceramics have been a hallmark of Southwest art. However, evidence points to the probability that pottery manufacture, a technology believed to have been imported from Mexico around 300, did not take hold in the Southwest until the mid-eighth century, thousands of years after its appearance in the Eastern Woodlands. Lightweight, rugged baskets were probably more attractive to the Archaic period hunter-gatherers than the heavy, fragile containers eventually adopted by their descendants. Some ceramic vessels were utilitarian wares for preparing, serving, and storing food and for transporting water and trade goods. These vessels appear as the foreign pottery at non-Mogollon sites. Ritual wares, on the other hand, stayed at home.

The *Mimbres* branch of the Mogollon culture, named for the river along which many sites have been found, is distinguished for its special-use bowls with figural paintings. Mimbres bowls are dated from 1000 to 1150, a time marked by unstable weather patterns which severely undermined the agricultural base. At the same time, the Mimbreños were making drastic changes in their living patterns, replacing pithouse dwellings with aboveground residences constructed of river cobbles and adobe. We might ask what the people hoped to accomplish with the painted bowls, since the highest level of Mimbres artistic complexity coincided with major threats to their lives.

Mimbres bowls were created to be broken and buried. Around ten thousand examples have been recovered from the graves people had dug beneath the floors in their houses. Most have been found virtually intact, except for a small hole punched in the center. Apparently, a vessel was ceremonially "killed" before it was placed over the head of the deceased. Some believe the hole released the spirit of the vessel to accompany the deceased. Others interpret the hemispheric bowl itself as a replica of the dome of the cosmos and the hole as the portal through which the person's spirit passed to reach the Otherworld. In both interpretations, making the bowl useless in this world transformed it into an Otherworld object whose function was to release rather than to contain.

Linear renditions of animals and people were painted on the inside of the mortuary bowls. Those with multifigural compositions (Fig. 97) have been interpreted as narratives from ancient mythologies. In our example, the pictorial field is defined by thin lines along the rim; the solid square inscribed in the center of the painted circle may represent, on a symbolic level, a world map or, on a physical level, a woven mat. The figures may be the Guardians of the Four Directions or people performing funeral rites with prayer wands, feather bundles, and symbolically marked baskets, similar to those shown on the backs of "burden-bearers" in other Mimbres paintings. The figures, outlined and infilled with flat paint, are typical of the stylized but animated Mimbres figures. Their flexible, larva-like bodies are quite different from the Hohokam humans with cinched waists and angular contours. In this painting two females, identified by tiny breasts and gender-specific striped belts,

Figure 97 Southwest (Mogollon culture, Mimbres branch, ca. 450–1350). Mortuary
bowl, ca. 1000–1150; painted ceramic; D. 11.8″ (30 cm). Maxwell Museum of
Anthropology, Albuquerque, New Mexico. Werner Forman Archive/Art Resource, NY

face each other across the corners of the square; "behind" them are two males.
Taking advantage of the vertical incline of the vessel wall, the painter created
a convincing illusion of people sitting in a circle, although photographs will
flatten the curve and make the figures appear to hover in space. A setting is
not indicated, but Mimbres figures obey the laws of gravity.

Women made Mimbres bowls using the coiling method. Laying ropes of
clay atop one another expanded the bowl upward and outward. Scraping the
surface sealed and concealed the ridges. A white slip was brushed on to create
a uniform surface for the freehand paintings. Finally, the vessel was fired in a
pit. Mimbres bowls created between 1000 and 1150 are called *Classic Black-on-
white* wares; the reddish-brown color of many Classic Black-on-white wares re-
sulted from firing in an oxygen-rich atmosphere, not from colored slips.

Anasazi. The Ancestral Pueblo People, whose culture was named
Anasazi (Navajo, meaning "enemy ancestors") in 1936, are renowned for the
multistory masonry structures they built in the Four Corners Region of New
Mexico, Colorado, Arizona, and Utah. *Pueblo* (Spanish, meaning "town") is
the name explorers gave the building type in the sixteenth century.

The high plateau of Mesa Verde (Spanish, meaning "green table") in
southwestern Colorado had been occupied by the Anasazi from about 550. In
a mountainous setting of pine and pinyon-juniper forests they planted corn,

hunted game, and built towns, which changed significantly over the centuries. Until around 1200 they had lived on top of the mesas, near their cornfields. Towns were clusters of semisubterranean *pithouses* arranged around a plaza. A pithouse, the residential type found across the Southwest, is a roughly oval-shaped structure of timbers, sticks, and mud built in a shallow pit and covered with dirt. One entered the house through an opening in the roof. All activities took place in the single large room, which was linked by a tunnel to a small storage room. Important interior features included a central firepit, a stone slab between the firepit and tunnel to deflect drafts and circulate fresh air, and a continuous earthen sleeping bench built into the walls. By 950 the Mesa Verdean Anasazi were building aboveground storage rooms, and after 1000 they were living in aboveground stone residences. In a short fifty years they had profoundly altered their living spaces, "emerging," as were the Hohokam and the Mogollon, from a life underground. They had changed from underground dirt-and-pole excavations to aboveground stone-and-timber constructions.

The first ventures into masonry building at Mesa Verde were the finest. Walls were constructed of rectangular sandstone blocks laid in even courses on both sides of a rubble core. After 1200 the quality of construction declined, with cobblestones and rough-cut stone laid in a single course. The shift coincided with the final dramatic change in the architectural siting at Mesa Verde. After living in pueblos on top of the mesas for about two hundred years the Anasazi abandoned these towns to construct new pueblos in the alcoves nature had carved in the canyons' sandstone walls millions of years earlier. The move was most inconvenient, as fields, firewood, and building supplies were on top of the mesas, and water, sometimes nearly a mile away, was down in the canyons. Hand-and-toe trails chipped into the sheer rock faces facilitated movement to and from the *cliff dwellings,* as these uniquely sited pueblos are popularly called.

Cliff Palace (Fig. 98) is a beautiful example of a late Anasazi pueblo. Tucked into a deep alcove, it faces south across a breathtaking drop into the canyon. Residents heaved their garbage over the edge, where it accumulated to such depths that the trash heaps provided convenient burial grounds for the dead. Although each of the six hundred cliff dwellings at Mesa Verde would appear to be very isolated, scores can be seen at one time from strategic sites on the mesas. Defense probably motivated the Mesa Verdeans to choose the troublesome sites, but it would seem everyone in the canyon community of five thousand knew what everyone else was doing.

Cliff Palace began with the construction of the retaining walls. Next, rubble was hauled in to level the alcove floor. Finally, two types of structures were built, rectangular aboveground rooms and circular subterranean rooms; together they form the basic "pueblo unit." Characteristic of all pueblos, the two-hundred-or-so rectangular rooms of Cliff Palace are stacked vertically and horizontally into compact, conjoined blocks. The flat roofs—made of

Figure 98 Southwest (Anasazi culture, ca. 450/700–1350). Cliff Palace, Mesa Verde, Colorado, 1209–1270s. Photo, author

heavy timber beams (*vigas*) sealed with branches and mud—and the walls—constructed of rough-cut sandstone blocks, rubble chinking, and mud mortar—were coated with a pinkish-brown plaster. Doors were made tiny to keep out the cold. Goods were stored in back rooms and alcove crevices; other rooms were multifunctional domestic spaces. However, the estimated two hundred fifty residents of Cliff Palace performed most activities outdoors rather than inside the dark, stuffy rooms.

The domestic room blocks face onto a large public plaza where the ceremonial *kivas*, the second structure in a pueblo unit, could be found. A kiva (Hopi, for "ceremonial space") is a roughly circular subterranean structure whose roof is the plaza floor. Kivas were special-use spaces; they served then, as they do Pueblo Peoples today, as places for religious activities and boys' initiations, as men's clubs, and for the production of textiles. The number of kivas at Cliff Palace (twenty-three) suggests each family had its own communal space.

The layout of a kiva is nearly identical to the pithouse, and it is probable the sacred space preserved the memory of the ancestral house. Entrance was down a ladder through a hatch in the plaza floor. Most kivas had a continuous bench (*banquette*) along the wall, rectangular stone pillars to support the timber roof, and a fire pit with a vertical deflector slab. Some kivas were equipped with sub-floor vaults for floor drums. The most sacred part of a kiva, the *sipapu* (Hopi, meaning "navel" or "descended from") is the small-

est, and like the kiva itself in the town plan, nearly undetectable. A sipapu is a small hole in the kiva floor; it is the spirit entrance, the emergence point at creation. According to the Emergence story in Hopi narratives, people had lived a miserable life in the Lower World until they were liberated by the Two Brothers, hero twins who climbed down a ladder through a hole in the earth to bring people up into the light. Creation was birth from Mother Earth, which every generation experienced symbolically. The kiva was the setting for this great event; climbing the ladder to the plaza reenacted the first emergence from beneath the earth.

Many cliff dwellings were inhabited for only a generation or two and others for less than a decade; all were deserted by 1300. Several factors compelled the Anasazi to abandon their homes. Their success had led to overpopulation, which stressed the natural resources; consider, for example, the number of trees needed to build the pueblos and fire the pottery. Two decades without rain (1273–1285) caused competition for dwindling resources, which in a short time escalated into armed conflict. The environmental degradation that had spurred the great artistic achievements in the eleventh and twelfth centuries exacted its toll; cultural fatigue set in. To the Anasazi, it seemed a good time to move on.

POSTCONTACT PERIOD

Many Native North American traditions had been seriously disrupted or had disappeared entirely by the time Europeans arrived. Their presence aggravated an already unstable situation, propelling the indigenous peoples into a new era. Art helped preserve cultural integrity and keep the old beliefs alive.

The Southwest

When the Anasazi abandoned their ancestral lands in the late thirteenth century they ventured south into the Rio Grande and the Little Colorado river valleys, where they built new pueblos, planted new cornfields, and practiced ancient ceremonialism. During their wanderings about Arizona and New Mexico in the mid-sixteenth century, Spanish explorers encountered their descendants, who by this time were living in three-hundred-year-old pueblos.

Hopi. The Anasazi ancestors of the Hopi (meaning "peaceful") migrated to northeastern Arizona. Following a major conflict with the Spanish in 1680 (the Pueblo Revolt), the Hopi relocated their pueblos from lower terraces to the tops of the mesas, where many continue to reside. At these inconvenient but defensive locations they could maintain ancient ways centered on *kachina ceremonialism,* a religious practice presumed to have appeared in Mimbres territory and to have spread into Anasazi lands in the

late eleventh century. Kachina ceremonialism preserved cultural continuity in times of crisis, during the period of the Great Migrations of the late thirteenth century, into the period of Spanish colonization, and through the subsequent centuries of Western acculturation to the present era. Kachina ceremonialism is a living tradition, and our understanding of its symbol system derives from the accounts of those who continue to practice the ancient ways.

The Hopi perceive existence to be a harmonious interaction between visible entities, such as people and animals, and invisible *kachina* entities, the spirits of clouds and mountains, for example, and the spirits of the dead. The beneficent kachina spirits assist people in living well; their cooperation is vital during the months of planting through harvest because kachinas travel in moisture. In February they are petitioned to enter the Hopi pueblos, and in late July they are encouraged to return to their homes in the San Francisco Peaks. Kachina impersonators summon the spirits during public performances. The men sing and dance single-file in long lines, each wearing the kachina mask of painted wood and feathers he has made. Each mask and costume identifies a specific kachina, and the maker follows traditional design requirements exactly. Unified appearance and action signify the community's unified purpose. Women were not maskers, but their attendance at performances was expected. From this information we can make the following observations: Individual artistic interpretation was not beneficial to the future of the community; the proper display of art was vital to the community's well-being; and, creating art was a right and responsibility of manhood.

Men learned kachina ceremonialism when they were children, as part of their preparation for initiation into adulthood. A woman, on the other hand, received no formal training in the intricacies of the kachina pantheon. Instead, as a girl she would have learned all that was necessary for a woman to know from little wooden figures (Fig. 99). This does not reflect a diminished view of women, for girls are prized in the matrilineal Hopi society; boys and girls are simply expected to master different information. Old kachina figurines (*tihu*), or "kachina dolls" as collectors call them, were carved by a male relative and presented to the girl at the start of the kachina season. By studying the figurines the girl would learn to recognize the hundreds of kachinas.

Old kachina figurines are made of painted cottonwood root; they are compact with no limbs protruding. Their popularity outside the Hopi community has led to a change in style, because collectors prefer naturalistic representations of kachina dancers, rather than abstract representations of kachina spirits. Kachina figurines in "action poses," made by professional artists for the non-Hopi market, are larger, livelier, and more detailed than the older, simpler, closed-form examples. The poor survival rate of old kachina figurines and masks reflects the Hopi attitude toward the objects. Neither is considered "holy," although they are treated with respect. It is the context in which they are used that is sacred and gives them value.

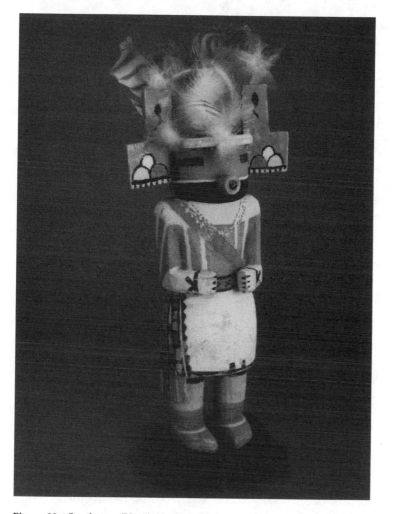

Figure 99 Southwest (Hopi). Kachina figurine, 1951; painted wood, feathers. Shungopovy Pueblo, Arizona. Gift of Byron Harvey, 1951. Neg. # A109975. © The Field Museum, Chicago (82863)

Pueblo pottery. Pueblo People living in the towns of Ácoma, Santa Clara, and San Ildefonso are descendants of the Ancestral Anasazi who migrated into the Rio Grande River Valley, New Mexico. Their art continues the processes, vessel forms, and motifs of the thousand-year-old ceramic heritage, enhanced by individual sensitivity and by contemporary attitudes and aesthetics.

Traditionally associated with pottery production, women were the forces behind the resurgence of Southwest pottery in the twentieth century.

Maria Montoya Martinez (ca. 1881–1980) at San Ildefonso Pueblo was one among many women who founded potters' dynasties. Taught to make pottery by old women in her family, she grew up to tutor generations of boys and girls so that today extended families of potters join pueblos by marriage and profession. The artistic enterprises are noncompetitive because individual activities are seen to benefit the entire community. For example, Maria Martinez would willingly sign her name on other potters' works so they could profit from her reputation.

Maria and **Julian Martinez** (1885–1943) were the premier Southwest art couple. Until Julian's death their works were collaborative ventures, with Maria shaping the vessels in the ancient coiling method and her husband painting the designs. To create their famous *black-on-black ware* (Fig. 100), or "Maria-ware" as it is sometimes called, they used the *closed-fire*, or reduction firing, process. The unfired vessel was polished with a stone before the designs were painted with a black slip. Smothering the vessel during firing forced carbon into the clay to produce black matte designs on a shiny black ground. Satin pattern and lustrous surface harmonize with the pristine proportions of the vessel itself.

Inspired by ancient potsherds unearthed near their pueblo, Maria and Julian revitalized the Native North American ceramics tradition with innovative firing methods and new interpretations of old decorations. The elegant purity of their pottery attracted art collectors, and in the 1920s their works were circulating in the fine arts market. While the twentieth-century vessels no longer serve the same utilitarian and ceremonial roles as their ancestral prototypes, they still function as "special-use" objects with the context changed from the kiva niche and the grave to the collector's shelf and the museum case.

Navajo. The Navajo (meaning "great fields"; also called the *Diné*, meaning "People") are relative newcomers to the Southwest. They emigrated into Anasazi lands from Canada sometime after 1300 and have come to reside principally in northern Arizona. Pueblo cosmology and aesthetics have provided the underpinnings of Navajo art since the seventeenth century, and many visual and thematic similarities are apparent in the two traditions.

Sandpainting is one component in Navajo multimedia healing ceremonies. Before a days-long performance begins, the painting is created by any number of men in the community. They work under the direction of the *singer*, the ritual specialist who has diagnosed the patient's illness and prescribed the appropriate curative ceremony. The singer knows the correct colors, details, and compositions for all six hundred Navajo sandpaintings. Without a perfect painting, the entire effort will be wasted because the goal of the performance is the restitution of perfection, righting the imbalance causing the patient's illness. In the Navajo worldview, sickness is the outcome of disharmony; the ceremony is the activity by which harmony is restored.

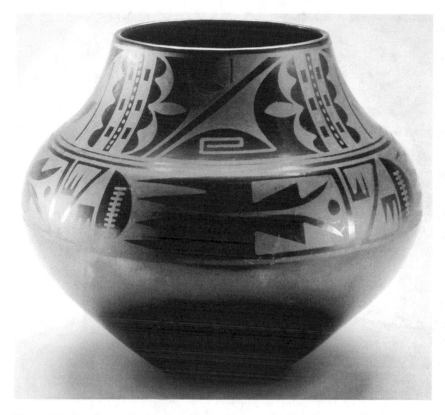

Figure 100 Southwest (Pueblo People, San Ildefonso Pueblo, New Mexico). Maria Montoya Martinez and Julian Martinez. Pot, 1939; black-on-black pottery; H. 11 1/8″ (28.24 cm), D. 13″ (33.02 cm). Gift of Wallace and Wilhelmina Holladay. The National Museum of Women in the Arts, Washington, D.C.

Whirling Logs (Fig. 101) is a sandpainting for the nine-night-long *Nightway* ceremony. It provides the setting for the dramatic recounting of the adventures of *Self-Teacher*, a mythic culture-hero who overcame obstacles and learned from adversity. From the black lake in the center of the composition grow stylized renderings of the four sacred plants painted in the four directional colors (corn/east/white; beans/south/blue; squash/west/yellow; and, tobacco/north/black). The plants alternate with four black location bars to form a radial composition with all parts in perfect balance. The pairing of elements, a fundamental principle of Navajo design, implies completeness. Standing on the location bars are frontally posed pairs of *ye'ii*, or Holy People; they are recognized by long slender bodies and blue sky-heads (round for males and rectangular for females). Four large profile figures are positioned at the cardinal directions, with the leader, *Talking God*, holding his squirrel medicine bag to the east at the top of the illustration. Opposite him

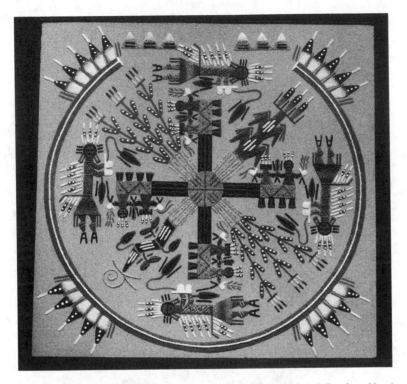

Figure 101 Southwest (Navajo). *Whirling Logs,* by Leonard and Geralene Yazzie after
destroyed sandpainting, 1998; colored sand on board; 30.3 cm square. Private collection.
Photo, Robert C. Bradley

is *Calling God,* and alongside, two *Humpback gods* with medicine canes
(*gishes*), who bring seeds in their backpacks. The long body of *Rainbow
Guardian* circumscribes the space, but she leaves the east, the direction from
which good comes, open.

In style, purpose, and process, traditional Navajo sandpainting differs
from traditional Western painting. Gravity is dismissed and mass is dimin-
ished with flat color and sharp outline. Through its clarity, repetition, and bal-
ance, the sandpainting reenacts the harmony in the universe. Also, the
process and the experience offer alternatives to traditional Western ap-
proaches to creating and viewing art. The painting's "support" is the sandy
floor in the "patron's" house; the patron, who is the patient, "sits in the art"
for the duration of the ceremony. The "brush" is the image-maker's fingers.
The "paint" is natural pigment, such as charcoal or ground corn, mixed with
a "binder" of sand. Sandpainting is also called *drypainting* because no fixative
binder is mixed with the pigment. Therefore, sandpaintings are impermanent
and last only as long as the music and dance they accompany. When the cer-

emony ends, the painting is discarded outside the homestead. Because sand-paintings are uncollectable, Navajo artists have satisfied collectors' needs with sand pictures glued on cardboard and with pictorial textiles, the famous "Navajo rugs," first made after 1900 specifically for commercial sale.

Northwest Coast

The congested surfaces of Northwest Coast art stand in sharp contrast to the pristine voids in Southwest art, yet both are rooted in the principles of balance and repetition. Communities along the northern Pacific Coast from Alaska to Washington State supported full-time professional artists who maintained this unity of vision in all the media, from architecture through fiber arts, and in every scale, from towering sculpture to hats. While most surviving examples of Northwest Coast art were made in the nineteenth century, the recovery of textile fragments and small-scale stone statues at sites dated from 3500 to 2500 BCE corroborate the antiquity of the artistic traditions.

Art thrived on the Pacific Coast because the conspicuous display of goods affirmed social standing; objects with restricted-use decorations were expressions of political power and family affiliation. Initially, commercial exchange with the West had a favorable impact on Northwest Coast communities in the late eighteenth and early nineteenth centuries, as families amassed fortunes trading sea-otter pelts to merchants who sold them in Qing China. Wealth and status were legitimized through the pubic display of art, and the increased demand for art stimulated production. The availability of imported metal tools advantageously affected the quality of sculpture, permitting greater detail, larger formats, and more rapid execution. Fortunes declined after 1900 and art suffered miserably, but since mid-century Northwest Coast art has experienced a renaissance.

The cedar forests provided material for all the art forms recorded in a commercial photograph staged by the firm of Winter and Ponds around the turn of the twentieth century (Fig. 102). The objects and their architectural setting were associated with potlatching and with theatrical performances, both critical activities in maintaining social standing. A family hosted a *potlatch*, a communal feast, to demonstrate its right to hold power. The more food and goods a family could afford to give away or destroy publicly, the higher was its standing in the community. The men to the left in the photograph wear tall *potlatch hats* with woven rings recording the number of potlatches their family had hosted. The *clan hat* worn by the man to the right center is distinguished by the frontal crest carved from cedar and inlaid with abalone shell. Crests were also woven into special-use garments made from shredded cedar bark and goat wool. A crest was a family's exclusive property, the emblem showing the family's totemic animal ancestor, such as a bear, raven, or eagle.

During the winter months a clan's house was transformed into a theater for the reenactment of family legends. The performances dramatized mythic encounters with spirit beings who, in the primordial past, awarded the family

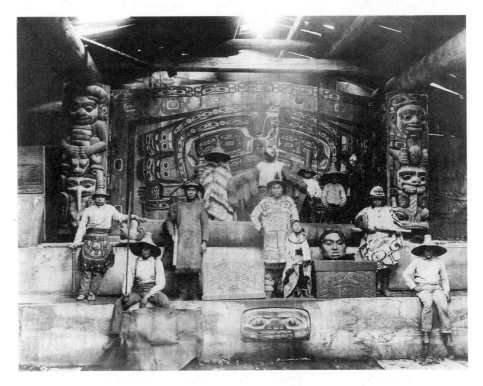

Figure 102 Northwest Coast. Klart-Reech House interior, late nineteenth century; commercial photograph. Photo courtesy the Alaska State Library/Winter and Pond Collection, Photo No. PCA 87-10, Alaska State Library

its privileged status. A painted *dance screen* provided the mythical setting. Players would emerge from the opening in the screen (obscured by the individual with outstretched arms) wearing fantastic costumes and maneuvering huge wooden masks. Northwest Coast theatrical masks are among the world's largest and most mechanically complicated. *Transformation masks,* for example, were crafted with wooden animal parts that opened and closed like doors over a carved human face; probably the bird-masks in this photograph had strings and hinges for that purpose.

Flanking the dance screen is a pair of *crest poles* (or totem poles), perhaps the most famous Northwest Coast art form. These compact sculptures served many purposes, inside the house to support ceiling beams, outside the house for symbolic doorways, and as freestanding memorials and crypts in public spaces. A crest pole is a vertical sculpture fashioned from a halved, hollowed cedar log; surfaces are wrapped with family crests stacked into a visual record of the clan's history. Restating the message from the theater season, crest poles chronicle the events on which the family based its claim to status, land, and material resources. The relation of animal and human forms on the

vertical surface would document the interaction of clans through marriage, alliance, or war.

The fluid arrangement of crests, chronicling the realignment of political forces over time, is one of the key features of Northwest Coast art. It relates to the theme of transformation, because changing from a person into an animal was the power act of a ruler, shaman, or culture-hero. In the arts, the blend of animals and humans is achieved by substituting parts, similar to the approach by Andean artists. The aversion to blank spaces and repetition of substituted elements on the dance screen—where faces and eyeballs fill backgrounds, facial features, and limbs—sets up spatial ambiguity. Using exchangeable parts underscores a worldview that sees all life forces as interactive. Frontality combines with *split representation* (dividing an image in two equal flat halves) to create symmetry in a seemingly irrational world.

Easily named naturalistic shapes may be absent in Northwest Coast art, but specific "art shapes" are clear and consistent. For example, Northwest Coast art shows a propensity for the *ovoid*, the curved-corner rectangles seen on the two cedar chests in the foreground, and the *formline*. Formlines are contour lines that swell into shapes when they meet other contour lines. By shaping spaces between shapes and borrowing eyes to define knees, Northwest Coast artists materialized the fluid nature of existence, yet the principles of balance and repetition enforce order. The stylistic consistency across time and media implies that artistic rules, passed on by apprenticeship, governed the presentation of visual information in Northwest Coast art.

Eastern Woodlands

On the opposite side of the continent descendants of the Precontact Mississippian warriors did not fare as well as the Northwest Coast merchants in their dealings with Europeans. Members of the *League of Iroquois,* a confederacy of five Iroquoian-speaking peoples, were consolidated on reservations in Canada and New York State. Military fraternities became defunct, but curative societies continued into the Postcontact era.

The *Society of Faces* is an Iroquois medicinal fellowship and masking society. The masks, called *False Faces,* are mixed-media sculptures of wood, horse hair, and metal. In the past, carvers had been specialists but not full-time professional artists. Today, although the Society of Faces is a living tradition, most new masks are created by professional artists for sale outside the Iroquois community. Because the masks have been disassociated from their original healing functions, carvers no longer use chants and tobacco to empower the tree before they harvest its wood to make the mask.

False Face masks were inspired by personal visions of spirits, but they exhibit remarkable homogeneity. The mask in Figure 103 represents the *Great Doctor,* an Iroquois culture-hero and the most powerful False Face spirit. The Great Doctor conveys healing powers to those who carve his image and give him tobacco and corn mush. He acquired his crooked face in a test of strength

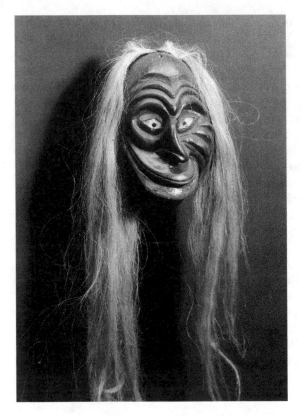

Figure 103 Eastern Woodlands (Iroquois). Great Doctor False Face mask, early twentieth century; painted wood, metal, horse hair. American Museum of Natural History

with the Creator. According to the story, the Great Doctor challenged the Creator to a duel for control of the earth. The task was to summon the Rocky Mountains while they sat facing the east. The Great Doctor moved the mountains slightly, but, doubting his rival had drawn them any closer, he turned around and smashed his face into the mountains. The asymmetric design, a study in expressive distortion, summarizes the narrative and underscores the theme of sudden confrontation. Deep undercutting creates lines of shadows while the metal discs accentuate and brighten the eyes. Large metal eyes, also found on Northwest Coast theatrical masks, are metaphors for the special powers of spirit vision.

Great Plains

When people visualize Native North Americans it is usually the horse-riding, bison-hunting warriors on the grass fields of the Great Plains who come to mind first, yet their culture was the last indigenous tradition before

the acculturation process of the Reservation Era and the subsequent sepa-
ratist movements of the twentieth century.

The Great Plains stretches from Canada south into Texas and from the
Rocky Mountains east to the Mississippi River. Almost all the Postcontact
Plains people had migrated from the Eastern Woodlands, many fleeing raids
by Iroquois warriors. Few people had been there as long as the *Mandan,* who
had lived on the Plains for a thousand years. Mandan lifeways were typical
of one group of Plains dwellers, the semi-sedentary farmers with settlements
of *earth lodges.* Most, however, were nomadic hunters who followed the buf-
falo herds with families and portable houses (*tipis*) in tow. Spirit-Dog—
known to us as the horse—made their lifeway possible.

A coherent artistic expression is detectable in the diverse heritages of
the Plains people because their requirements for good art are clear. It had to
be portable, for both nomadic hunters and semi-sedentary agriculturists, and
it had to be personally emblematic. Everyone with an experience worth
retelling was a potential artist on the Great Plains.

When Plains People used art to publicize personal accomplishments, they
adhered to gender proscriptions on processes. For example, men and women
could paint, but only women were permitted to create beadwork. A woman
took personal pride in narrating her victories over difficult beadwork passages,
while men listened courteously to the accounts of the obstacles she had over-
come to bring the beautiful object into existence. Always receptive to new ma-
terials, if they enhanced the effectiveness of their works, women phased out the
traditional *quillwork* process (flattened porcupine quills) in the mid-nineteenth
century, replacing it with brilliantly colored, tiny glass trade beads (*seed beads*),
which eventually gave way to the larger glass *pony beads.* Plains painting expe-
rienced similarly beneficial technological changes when lightweight cloth and
paper replaced the cumbersome buffalo hides of earlier paintings.

In general, men were the painters on the Plains. They specialized in the
narrative style, suitable for recording military and hunting experiences, and in
the *visionary style,* which drew its images from experiences known only to the
painter. Visionary style paintings recorded encounters with spirits during
dreams or on vision quests. On a *vision quest* an individual met the personal
animal spirit-helper who would guide life choices and protect against harm.
Through physical depravation—isolation, exhaustion, and starvation—a
person transcended physical reality to experience the reality of the spirit
world. A child undertook his or her first vision quest before initiation into
adulthood. Every person was expected to have had contact with the spirit
world at least once, but shamans were expert at making the trip on demand.
In trances they made the dangerous journey on behalf of others to find cures
for sickness or to coax animals to the hunt.

Following the visionary experience, one could produce his or her own
painting or hire someone else to produce it following a verbal description.
Although each visionary image preserved in Plains painting was uniquely

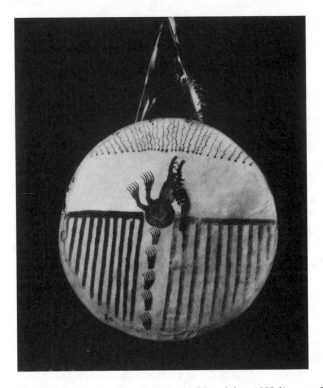

Figure 104 Great Plains (Crow). Shield with bear. 23" diameter late nineteenth century; buffalo hide with painted skin cover, beads, cloth. Neg # CSA11993_2 © The Field Museum, Chicago (62578-2)

inspired, individual visions and dreams drew on communal beliefs, resulting in paintings that resembled each other; the situation is similar to the Iroquois False Face maskers who dreamed the same masks.

Men were in special need of guardian spirits because militarism had become a way of life, especially for the nomadic Plains people such as the *Crow* in eastern Wyoming. A spirit-helper's image painted on a war shield magically safeguarded its owner; its protective potency was heightened by attaching a medicine bundle filled with sacred crystals, tobacco, hair (one's life force), or feathers (awards for achievements).

The image on the Crow shield (Fig. 104) was particularly effective because Bear spirit-helper occupied a central place in the Native North American worldview. The bear is fierce, implacable, and quick to anger, and on the Crow shield it rushes from vision clouds into a hail of bullets. A bear was also an anomaly because its habits and physical appearance struck parallels with the human condition. Bears could walk upright and use their paws like hands. Their paw prints had five "toes" like a human's. Hibernation was a metaphor for the vision quest and the cycle of life itself; a bear retreated into the dark, cold earth and emerged into light and warmth.

FROM SPECIMEN TO ART

We concluded the first chapter with a note on the impact African art had made on European modernism, and a similar statement can be made about Native North American art and its influence on American modernism. Initially, collectors considered Native North American works to be the curios and relics of primitive cultures, holdovers from a savage state that Western civilization had progressed beyond. Objects were shown in anthropological settings alongside stuffed animals and dinosaur bones. The attitude began changing with the 1942 exhibition curated by the Museum of Modern Art in New York City. Works were shown as singular objects worthy of sustained aesthetic contemplation, and in the new setting they were transformed into "art" for the modern art community. European surrealists were especially interested in visionary imagery and mixed-media assemblages, which they saw as the products of artists who had tapped directly into the primordial human experience. Few, if any, understood either the antiquity or the traditionalism of the arts they admired and appropriated for their own work. However, twentieth-century Western art experienced major changes as a result of its own cultural First Contact. Inspired by Navajo sandpainting, Abstract Expressionist artist Jackson Pollock, for example, disposed of his easel and spread his canvases on the floor. To the end of the twentieth century traditional imagery and processes continued to inspire non-Native artists. Noteworthy are the monumental earthworks by Michael Heizer, who came to appreciate the scope of the ancient arts through the work of his father, Robert Heizer, a leading North American archaeologist.

Needless to say, artists who live in the places we have visited in this book continue to create art. Some have totally assimilated Western styles and processes, while some replicate ancient works with the goal of preserving traditional ways. Others temper culture-specific aesthetics and traditional symbol systems with personal perspectives on living under the pressures of the Postmodern experience. Their goal is to pull the strengths of the past forward, to be sustained by tradition, on one hand, and, on the other, to enrich its visual vocabulary. In this way cultures remain dynamic, living things.

FOR DISCUSSION AND REVIEW

1. How does one "cooperate with nature"? Give examples in this chapter and throughout the text of the consequences of a lack of cooperation. What ritual activities demonstrated cooperation?

2. When are animals "role models for virtuous behavior"? List animals (and plants) in Native North American art. Where does each appear? What is the meaning of each? Choose three to compare with your lists from earlier chapters.

3. How do spirit-entities react to humans and artificial objects, such as works of art and architecture? Give specific examples from this chapter and earlier chapters.

4. What is meant by the phrase "First Contact"? Why is it important to New World cultures? In the study of New World art? Is the idea Euro-centric?

5. List and review the major geographic regions and the main features of each. Should geographic location be a concern in a study of Native North American art? Why or why not? In the study of any other Non-Western cultures?

6. List and review the time periods, including at least two features of life-ways and art unique to each. Should chronology be a concern in a study of Native North American art? Why or why not? In the study of any other Non-Western cultures?

7. Discuss earthworks as a cultural expression. Consider the relation between the shape and the space around it. Can art be made of dirt? Why have the great earthen mounds not drawn crowds of tourists, like the masonry mounds of Mesoamerica and Egypt?

8. List all the mound types in this chapter. Describe the construction methods and the function of each.

9. Review the mound-building tradition for all cultures in the text.

10. Consider Watson Brake and Poverty Point, especially dates and size. What may have been the motivation for their construction? Do they "challenge the traditional perception of New World peoples"?

11. What evidence exists for long-distance trade? How would trade affect art? Consider the Precontact Eastern Woodlands and the Southwest. The Postcontact period. Compare with Medieval Africa.

12. Describe the layout of Cahokia. Compare with Teotihuacan.

13. Ethnohistoric records are used as primary documents in Native North American studies. What cautions, if any, should be exercised? Consider the Precontact period. The Northwest Coast photograph.

14. Describe the Southeastern Ceremonial Complex.

15. Review depictions of the human figure in this chapter. What aspects, if any, are consistent? Could you propose a canon for the human body in Native North American art? Compare the Mississippian effigy bottle with the Olmec seated figure.

16. Does Native North American art have a yin–yang component? Is there a male–female component? Cite specific examples, including images and production, to illustrate your conclusions. Any comparisons with other cultures?

17. Summarize the similarities and differences in the architecture and pictorial arts for the three Precontact cultures in the Southwest.

18. "Art helped alleviate stress." What can stress people? In the Southwest? In other cultures studied in the text? In general? How did art help? Any examples of art being the cause of stress?

19. Recount the achievements of the Hohokam. Considering the canal system, can a society's "infrastructure" be art?

20. Discuss the processes, functions, forms, and decorations for Pre- and Postcontact Southwest pottery.

21. Discuss the dilemma of words and names keeping in mind the following usages. In the Southwest today, Pueblo potters find the word "ceramics" demeaning and refer to their works as "pottery." "Ceramics" is taken to mean "factory-made" and "mold-produced" while "pottery" means "handmade." The Navajo prefer to be called Diné. Who is an "Indian" in a text that includes India? Does the word "native" have any negative connotations?

22. Compare the pithouse and the pueblo. Consider the ideas of privacy and convenience. Review the purposes and parts of a kiva. What explanation can you propose for a religious building underground?

23. On what points, if any, are Mesoamerican and Native North American art and cosmology similar? Give specific examples.

24. What is a kachina? A totem? Compare to a kami.

25. Describe the process, purpose, and symbol system of Whirling Logs. Identify the "art" components of the Navajo healing ceremony. The Hopi kachina performances. Northwest Coast theatrical performances.

26. Although Native North American art never shows a setting, it often suggests a place. Although never a narrative, it often tells a story. Beginning with the Great Doctor mask, cite examples to support or refute these statements.

27. Northwest Coast, Andean, and early Chinese art share many characteristics. Agree or disagree with the statement, using specific examples. What worldviews might account for similar artistic expressions?

28. Review the lifeways on the Great Plains. What were the roles and requirements of the artist? In other Postcontact cultures?

29. Review the sources of inspiration for Plains visionary painting. How have artists recorded "the reality of the spirit world"? How is it possible for different people to "dream the same mask" or experience the same visions? What does that say about the relation of an individual to the community? To the physical world? To the unseen world?

30. Conclude with question 3, Introduction.

FOR FURTHER READING

Berlo, Janet C. and Ruth B. Phillips, *Native North American Art*. Oxford and New York: Oxford University Press, 1998.

Brose, David S., James A. Brown, and David W. Penney, *Ancient Art of the American Woodlands Indians*. New York: Harry Abrams, 1985.

Dittert, Alfred E. Jr. and Fred Plog, *Generations in Clay: Pueblo Pottery of the American Southwest*. Northland Publishing, 1980/1991.

Feest, Christian F., *Native Arts of North America*. London: Thames and Hudson, 1992.

Galloway, Patricia, ed., *The Southeastern Ceremonial Complex: Artifacts and Analysis*. Lincoln and London: University of Nebraska Press, 1989.

LeBlanc, Steven A., *The Mimbres People: Ancient Pueblo Painters of the American Southwest*. London and New York: 1983.

Mathews, Zena Pearlstone and Aldena Jonaitis, *Native North American Art History: Selected Readings*. Palo Alto: Peek Publications, 1982.

Morrow, Baker H. and V. B. Price, *Anasazi Architecture and American Design*. Albuquerque: University of New Mexico Press, 1997.

Nabokov, Peter and Robert Easton, *Native American Architecture*. New York: Oxford University Press, 1989.

Pauketat, Timothy R. and Thomas E. Emerson, eds., *Cahokia: Domination and Ideology in the Mississippian World*. Lincoln and London: University of Nebraska Press, 1997.

Plog, Stephen. *Ancient Peoples of the American Southwest*. London: Thames and Hudson, 1997.

Schaafsma, Polly, *Indian Rock Art of the Southwest*. Albuquerque: University of New Mexico Press, 1980.

Williamson, Ray A. and Claire R. Farrer, eds., *Earth and Sky: Visions of the Cosmos in Native American Folklore*. Albuquerque: University of New Mexico Press, 1992.

See also Chapter 1, Africa and Chapter 7, South America, For Further Reading.

Glossary and Pronunciation Guide

For the pronunciation of vowels, the following system is used.

ey, in pr*ay*er *ay*, in p*ie* *a*, in *a*pple
i, in p*i*t *ah*, in f*a*ther *oh*, in *o*pen
ee, in b*ee* *oo*, in b*oo*t *e*, in b*e*t
u, in c*u*t

abstraction A style that alters imagery; modifications can include exaggeration, abbreviation, elimination, or substitution

ade (AH.dey) Conical beaded crown worn by Yoruba kings

Adena (ah.DEE.nah) A Native North American culture, 1000/800–1 BCE

adobe Sun-dried mud, often shaped into bricks

adze Ax with blade at a right angle to handle

age-grade A social system structured by initiation into age-restricted fraternities, each with specific rights and responsibilities; especially in West Africa

Ah Cacaw (ah.kah.KAHW) A king of Tikal (672–734); cacaw, meaning "chocolate"

Akan (ah.KAHN) A language group in West Africa

Akbar (AHK.bahr) Mughal emperor in India (reigned 1556–1605)

Akhenaten (ahk.en.AH.ten) Amarna period pharaoh (reigned 1378–62 BCE)

akuaba (ah.kooah.BAH) Asante statue of an infant

album leaves Loose paintings in a portfolio

Allah Arabic word for "God"

Amarna period (ah.MAHR.nah) Era in Ancient Egyptian history, 1378–1362 BCE

Amaterasu Omikami (ah.mah.te.RAH.soo.oh.mee.KAH.mee) Shinto sun goddess

ambulatory A continuous walkway; a gallery or corridor
Ananta Indian serpent of eternity
Anasazi (ah.nah.SAH.zee) A Precontact Native North American culture in the
 Southwest
Andean (an.DEE.an) South American cultural region west of the Andes
 mountains
Angkor Ancient capital of Khmer empire
Angkor Thom City within Angkor
aniconic Art without figural depictions of humans
animism Belief that life forces inhabit inanimate objects
anthropomorphic Having human shape
Anyang (ahn.yahng) Last capital of the Shang dynasty
apron panel Sloping panel on a Maya building
arabesque An intertwining, curvilinear ornamental motif, usually floral
Archaic period Era in Precontact Native North American history, 8000–1000
 BCE
Aryans Semi-nomadic people who entered ancient India from the West
Asante (ah.SHAHN.tey) A West African people in Ghana
Ashikaga (ah.shee.KAH.gah), also **Muromachi** Era in Japanese history,
 1338–1573
Ashoka (ah.SHOH.kah) Indian emperor (reigned 269–32 BCE)
Asmat (AHS.maht) An indigenous people of Irian Jaya
asye usu (AH.sey.OO.soo) Baule statue for a nature spirit
asymmetric Composition with an unequal distribution of elements on either
 side of a central axis
Atauhualpa Last Inca king (died 1533)
atlatl Counterweight on a spear thrower
atman An individual's indestructible soul
attributes Objects or costume elements that identify a character
Atzlan (ahtz.LAHN) Mythic homeland of the Aztecs
avatar (AH.vah.tahr) Reincarnation of a Hindu deity
axis mundi Literally, "the world axis," uniting zones of sky, earth, and
 underworld
Aztec Last ancient civilization of Mesoamerica, 1350/1427–1521

backstrap loom Portable weaving device
Banpo (bahn.poh) Neolithic town in China
banquette Wall bench in a kiva
basalt Volcanic stone
Baule (BAHW.ley) An African people in Ivory Coast
Benin (bey.NEEN) An African kingdom in Nigeria; also the city
Bhagavad Gita (BHU.gah.vahd.GEE.tah) Sacred Hindu text about Krishna;
 meaning, "Song of the Blessed One"
bhakti (BHUK.tee) Personal devotion to a chosen Hindu deity
bi (bee) In Chinese art, a ritual disc

black-on-black ware Ceramics with black decorations on a black ground
block-color style Andean fiber arts style
blolo bian (BLOH.loh.bee.AHN) Baule statue of a spirit husband; **blolo bla,** a
 spirit wife
Blue-and green style See *decorative style*
blue-and-white ware Glazed ceramics with blue decorations on a white
 ground
bodhi (BOH.dhee) Enlightenment
bodhisattva (boh.dhee.SAHT.vah) A Buddha-to-be
Bon Pre-Buddhist shamanic religion in Tibet
boneless style Asian painting style with no prominent lines
borrow pit Soil quarry
boshan xianglu (boh.shahn.shee.ahng.loo) Mountain-shaped incense burner
Brahma (BRAH.mu) Hindu creator god
Brahman (BRU.mun) The World Soul
brahmin (BRAH.min) Priestly caste in India
brocade print Japanese polychrome woodblock print
the Buddha Honorific title, meaning the "Enlightened One"; especially the
 historical Buddha (ca. 556–483 BCE)
Buddhism Religion and philosophy founded in India in the sixth
 century BCE
burnish To rub or polish a surface
byobu (bee.YOH.boo) Portable folding screen

caban (cah.BAHN) Maya earth glyph
Cahokia (cah.HOH.kee.ah) Mississippian period city in southern Illinois
Calendar Round 52-year period to complete the Mesoamerican ritual and
 solar calendars
caste Hereditary social class
Cerro Blanco Capital of Moche empire
Chac Maya god of lightning and rain
Chac-Xib-Chac (chahk.sheeb.chahk) Maya god of ritual decapitation
chaitya (CHAYT.yah) Buddhist assembly hall; also a horseshoe-shaped arch
chakra Wheel
Chamunda (chah.MOON.dah) A Hindu destroyer goddess
Chan (chahn) Form of Buddhism combining Daoist and Buddhist principles
Chan Chan Capital of Chimú empire
Chandella dynasty Era in Indian history, 950–1203
chanoyu (chah.NOH.yoo) The Way of Tea; literally, "hot water of tea"
Chavín (chah.BEEN) Andean civilization, 850–200 BCE
chigi Crossed rafters on a Japanese building
Chimú (chee.MOO) Andean civilization, 1100–1438
Chola dynasty (CHOH.lah) Era in Indian history, 846–1250
Chumash A Native North American people in California
Churning of the Milk Ocean A Hindu creation story

circumambulation Ritual act of walking around something
Classic Black-on-white ware Mimbres ceramics, 1000–1150
Classic period Era in Mesoamerican history, 250–1100
closed-fire, also **reduction firing** Firing process that smothers the pottery
closed-form Composition with little or no integration of space and shape
cloud collar Decorative motif in Islamic and Far East Asia design
codex-style Maya painting style resembling painted pictures in books
coiling Handbuilt ceramic process using ropes of clay
cold-casting Process to inlay precious metals in bronze
Colonial period Era of European domination in Africa, 1885–ca. 1960
composite figure Combined frontal and profile views of a body
composition The placement and relation of all elements in a work of art; its organization
Confucianism Ethical code of social behavior in Far East Asia
Confucius Chinese philosopher (551–479 BCE)
cong In Chinese art, a ritual tube
cosmology A culture's worldview
cowrie Small, oval shell
crest pole, also **totem pole** Vertical wooden sculpture with ancestor animals
Crow A Postcontact Native North American people on the Great Plains
cruciform Cross-shaped
Cuzco (KOOZ.koh) Capital of Inca empire

daimyo (DAYM.yoh) Japanese feudal lord
dance screen Stage set for a Northwest Coast theatrical performance
Daoism (daow) A philosophy originating in China; as a religion, called **popular** or **religious Daoism**
darshan Meritorious gazing
deck figure Ceramic figure on top of a Moche vessel
decorative style, also **Blue-and-green style** Tang dynasty painting style; also a Japanese screen style
Devi (DEY.vee) The Great Goddess
Dharma (DHAHR.mah) Cosmic law
diviner A ritual specialist
Dogon (DOH.gahn) An African people in Mali
dravida (drah.VEE.dha) Southern style Hindu temple
Dravidians An indigenous people of India
the Dreaming Aboriginal Australian stories about the supernaturals
drum Architectural term for a cylindrical base
Durga Hindu warrior goddess

eagle-being Mississippian period militaristic figure with bird emblems
earth tones Colors from natural materials, especially reds, browns, yellows
earthenware Ceramics of fairly coarse clay
earthwork Monumental sculpture made of dirt
the Eccentrics A group of Qing dynasty painters

Edo (EY.doh) Modern Tokyo; also, a language group in Nigeria
effigy Representational image or likeness
Ehectl Aztec wind god; a version of Quetzalcoatl
the Eightfold Path Last of the Four Noble Truths taught by the Buddha as the way leading to enlightenment; 1) right understanding; 2) right thought; 3) right speech; 4) right action; 5) right livelihood; 6) right effort; 7) right mindfulness; and, 8) right concentration
e-maki (ey.MAH.kee) Japanese horizontal handscroll
ere ibeji (ee.BEY.gee) Yoruba statue of a dead twin
Eshu Yoruba trickster god
expressionistic, expressive A style using abstraction to heighten the emotional, personal, or spiritual qualities of the subject

False Faces Iroquois spirits; also masks worn by the Society of Faces
fei-i (fey.ee) T-shaped Chinese silk; literally, "fly-away garment"
filial piety Respect for parents, elders
fineline painting A style of Moche painting
First Contact Arrival of Europeans in the Americas
foreshortening In the pictorial arts, compressing a shape to create an illusion of depth
formline In Northwest Coast art, a line with shape
Four Corners region Arizona, Utah, Colorado, New Mexico
Fumeripits Asmat culture-hero
fusuma (foo.SOO.mah) A fixed screen

Gandharan (gahn.DAHR.ahn) An Indian art style originating in the state of Gandhara, Pakistan
Ganesha (gah.NEY.shah) Hindu god of good beginnings
garbhagriha (gahrb.hah.GREE.hah) Sanctuary in a Hindu temple; literally, "womb chamber"
Garuda (gah.ROO.dah) Sun-bird vehicle of Vishnu
Gautama A name of the historical Buddha
Genghis Khan Leader of the Mongols (ca. 1162–1227)
geoglyphs Earth-drawings in South America
gishe Navajo medicine cane
glyphs (glifs) Mesoamerican writing system
gopura (goh.POO.rah) Monumental gateways on a late southern style Hindu temple
gorget (GOHR.jit) Pendant
grain pattern Chinese decorative motif of tiny raised dots
Great Doctor Iroquois culture-hero
Great Plains Territory east of the Mississippi River and north of the Rocky Mountains, excluding the Four Corners region
guan (gwahn) Chinese ritual vessel form
Guanyin (gwahn.yin) Chinese bodhisattva of compassion
Gupta (GOOP.tah) The Classic Indian art style; also, the dynasty, 319–500

haab Maya 365-day solar calendar
haboku (hah.BOH.koo) Japanese wet ink painting
hacha (AH.chah) A protective item worn by Mesoamerican ballplayers; also a
 ballcourt marker
Han dynasty Era in Chinese history, 202 BCE–220
Hangzhou (hahng.joh) Capital of Southern Song dynasty
haniwa (HAH.nee.wah) Japanese clay mortuary figure
Harappan (hah.RAH.pahn) also, **Indus Valley Civilization** Ancient Indian
 civilization, ca. 2600–1750/1500 BCE
Harihara Hindu deity combining Shiva and Vishnu
harmika Terrace on top of a stupa
Heian period (HEY.ahn) Era in Japanese history, 897–1185
Heiankyo Capital during the Heian period; present-day Kyoto
Hero Twins Maya culture-heroes **Hunahpu** and **Xbalanque**
Hideyoshi (hee.dey.YOH.shee) Japanese ruler (1536–1598)
Hindu An indigenous religion of India
Hohokam Precontact Native North American culture in the Southwest
Hopewell Native North American culture, 300/100 BCE–600
Hopi (HOH.pee) A Native North American people in the Southwest
Horizon In Andean studies, the term for a period of cultural unification
horror vacui Aversion to blank spaces
Horyuji (hohr.YOO.gee) Buddhist monastery in Kyoto
hu Half of one's soul that remains in the tomb; the **hun** half joins the ancestors
huaca (WAH.kah) An auspicious object
Hun Nahl Yeh (hoon.nahl.yey) Maya First Father, the Maize God; also, **Hun
 Hunahpu** in the *Popol Vuh*
Hui Neng A leader of Chan Buddhism, the Sixth Patriarch (638–713)
Hui Zong (hwey.zohng) Last emperor of Northern Song dynasty (reigned
 1101–1125)
Huitzilopochtli (weet.zee.loh.POCH.tlee) Aztec god of sun and war

Ichikawa (i.chee.KAH.wah) Family of Kabuki actors
idealism A style that shows the subject perfected, according to established
 canons of excellence; representational but not realistic
Ife (EE.fey) African kingdom in Nigeria
imagery Objects or situations represented in a work of art that correspond
 visually, with any degree of recognition, to real-world encounters
the Immortals Eight supernaturals in popular Daoism
Inca Empire in South America; also the people
incensario Incense burner
Indonesia Islands off the southern coast of continental Asia
Indra Hindu god, a warrior-king
inkstick Bar of compressed ink and glue
intaglio Incised or engraved
Inti Inca sun god
Irian Jaya (i.ree.ahn.JAY.yah) Western New Guinea

Iroquois A Native North American people in the Eastern Woodlands
Islam Religion founded by the Prophet, Muhammad, in the seventh century
iyami (ee.YAH.mee) In Yoruba culture, old women

Jaina (HAY.nah) Maya island necropolis in the Gulf of Mexico
jamasji Asmat war shield
jataka tales (JAH.tah.kah) Stories of the former lives of the Buddha
Jayavarman II (jah.yah.VAHR.mahn) Cambodian king (died 850)
Jayavarman IV Cambodian king (reigned 1181–1219)
Jenne, also **Inland Niger Delta** African culture in Mali, 300 BCE–17th century;
 also the city Jenne-Jeno
Jomon (JOH.mahn) Neolithic period in Japan, ca. 11,000–300 BCE

ka Part of the Ancient Egyptian soul that remains in the tomb
Kabuki (kah.BOO.kee) A form of Japanese theater
kachina (kah.CHEE.nah) Hopi spirit-beings; also, a wooden figure
Kaifeng (kay.feng) Capital of the Northern Song dynasty
kaitiaki Maori ancestor spirit
Kali (kah.lee) A Hindu goddess of destruction and death
Kaliya An evil naga in the Krishna epic
Kamakura period (kah.mah.KOO.rah) Era in Japanese history, 1185–1333
kami (KAH.mee) Shinto spirit-beings
Kan Xul II (kahn.shool) A king of Palenque (born 644)
Kannon Japanese bodhisattva of compassion
kare-sansui Japanese dry garden
karma Action and consequence; cause and effect
Karttikeya, also **Skanda** Hindu god of war
katun (kah.TOON) Maya 20-year time unit
key block Alignment block in woodblock printing
keyhole-shape mound Japanese imperial burial mound
Khamerernebty (kah.mr.r.ne.BEE.tee) Senior wife of pharaoh Menkaure
Khmer (KHOO.mer) A people of Cambodia
kin (keen) Maya day
kiosk Small pavilion or gazebo
kiva (KEE.vah) Sacred semisubterranean structure in a pueblo
Kofun period (KOH.foon) Era in Japanese history, 300–600/700
Kota (KOH.tah) An African people in Gabon and Cameroon
kpele Mask associated with Senufo poro
Krishna (KREESH.nah) An avatar of Hindu god Vishnu
kshatriya Ruler-warrior caste
Kuba (KOO.bah) An African people in the Democratic Republic of Congo
Kublai Khan Mongol emperor during Yuan dynasty (reigned 1260–94)
Kukulcan Maya sky god, the feathered serpent
Kurma Second avatar of Vishnu, as a turtle
Kush Nilotic civilization in Nubia
Kushan dynasty (koo.SHAN) Indian empire, 50–320

Lao Zi Chinese philosopher associated with ideas of Daoism
(ca. 604–531 BCE)
League of Iroquois Federation of five Iroquoian-speaking peoples
li (lee) Chinese tripod vessel
Liao (lee.ahw) A kingdom in China, 907–1125
literati painting In China, amateur painting
Lokeshvara (loh.keysh.VAH.rah) Bodhisattva of royalty, the Lord of the
Worlds
low relief In sculpture, shapes raised slightly from a background
Luba (LOO.bah) An African people in the Democratic Republic of Congo
lyrical style Southern Song poetic landscape painting

Mahabharata (me.HAH.BHA.re.te) Sacred Hindu epic
Mahayana (mah.hal.YAH.nah) A form of Buddhism that recognizes multiple
buddhas; meaning "the Greater Vessel"
Maitreya (may.TREY.ah) A bodhisattva, the Buddha-of-the-Future
mandala (mahn.DAH.lah) Buddhist or Hindu diagram of the universe
Mandan (man.DAN) Semi-sedentary Native North Americans on the Great
Plains
mandapa (mahn.DAH.pah) Assembly hall in a Hindu temple
mandorla (mahn.DOHR.lah) A full-length halo
manuscript illumination Painting in a book
Maori (MOO.ree, or MEY.o.ree) An indigenous people of New Zealand
Mathuran An Indian art style, centered at the city of Mathura (MUTH.er.ah)
matrilineal Descent passing through the female line
Maya Mayan-speaking peoples of Mesoamerica, also their ancient cultures
mbis Asmat spirit poles
Mecca Holy city of Islam, birthplace of Muhammad, in Saudi Arabia
Menkaure Old Kingdom Egyptian pharaoh
Mesoamerica Central America, and its Precontact cultures
mihrab (mi.RAHB) In a mosque, a niche in the wall closest to Mecca
Mimbres (MEEM.brays) Subset of the Precontact Native North American
Mogollon culture, also the ceramics
mimi (mee.mee) Aboriginal Australian spirit-beings
Minamoto Yoritomo First shogun, 1147–99
minaret Tower on a mosque, for announcing prayer hours
Ming dynasty Era in Chinese history, 1368–1644
Ming Huang Tang dynasty emperor (reigned 712–756)
Mississippian period Era in Native North American history, 1000–1300/1600
mita (MEE.tah) Inca labor tax
mithuna A loving couple
mixed-media A work of art made of several different materials
Moche (MOH.chey) An ancient Andean people
Mogollon (MUG.ee.yohn) A Precontact Native North American culture in the
Southwest
Mohenjo-daro (moh.hen.joh.DAH.roh) Ancient Harappan city in Pakistan

moksha In Hinduism, cessation of rebirths
Momoyama (moh.moh.YAH.mah) Era in Japanese history, 1573–1615
Mon Indigenous people of Thailand
Mongols Semi-nomadic people from eastern Siberia
monochrome painting Chinese ink painting
Mopti (MOHP.tee) Islamic city in Africa
mosque Islamic religious building
mound building Constructing with dirt; including earthworks, embankment-
 conical-, platform-, and ridge-mounds
Mount Meru (MEY.roo) In Indian cosmology, the World Mountain
mountain-step An earth-mountain motif in Andean art
mudra (MOO.drah) Meaningful hand gestures in Indian art, including
 teaching (dharmachakra); reassurance (abhaya); meditation (dhyana); gift-
 bestowing (varada); and, earth-touching (bhumisparsha)
muezzin (moo.EZ.in) Meaning "crier," man who announces Islamic prayer
 hours
Mughal dynasty (MOO.gahl) Indian Islamic empire, 1526–1857
Muhammad (or Mohammed) Meaning "praise-worthy," the Prophet and
 founder of Islam (ca. 570–632)
Mukenga Regional variation of the Kuba royal Mwaash-aMbooy helmet
 mask
multimedia Incorporating sound and movement in the work of art
mummy bundles Andean burial form
Mumtaz Mahal Mughal empress (1608–1631)
Murasaki Shikibu Author of *The Tale of Genji* (ca. 970–1015)
Muslim A follower of Islam

naga A serpent-king; nagina, a serpent-queen
Nahautl (NAHW.aht) Language of the Aztecs
Nandi (NAHN.dey) Bull vehicle of Shiva
narrative style Plains painting that retells an event
Nataraja A form of the Hindu god Shiva, as the Lord of the Dance
naturalism A style that presents the imagery according to "the laws of
 nature," especially the effects of gravity and lighting; particular details are
 negligible
Navajo, also Diné A Native North American people in the Southwest
Nayarit (nay.yah.REET) Modern state in Mexico and the ancient cultures there
Nazca (NAHZ.kah) Andean culture, 300/100 BCE–700
neolithic Stone technology-based cultures
Nilotic (nay.LAH.tic) Ancient African cultures along the Nile River
nirvana In Buddhism, the cessation of rebirths
nishiki-e Japanese multicolor woodblock prints
Nok Ancient African culture in Nigeria, ca. 500 BCE–200
nonrepresentational, also nonobjective A style without recognizable imagery
Northern and Southern dynasties Era in Chinese history, 265–581
Northern Wei (wey) Kingdom of the Toba Wei in China, 386–535

Northwest Coast Cultural region along the Pacific Coast, Oregon to Alaska
Nubia (NOO.bee.yah) Ethnographic area in eastern Sudan
nyim Title of divine kings of Kuba

oba Title of divine kings of Benin
Oceania Islands in the Pacific Ocean
Oculate Being Descriptive name of an Andean deity
Odudua Founder and culture-hero of Ife
ogoga Title of Yoruba kings
Old Kingdom Era in Ancient Egyptian history, 2700–2180 BCE
Ollin (oh.LEEN) Aztec glyph for "motion"
Olmec (OHL.mek) Early Mesoamerican civilization along the Gulf Coast
Olokun (OH.loh.koon) West African deity of wealth and the sea
one-corner Ma Descriptive term for asymmetric designs in Southern Song
 painting
oni (OH.ney) Title of divine kings of Ife
onna-e (ohn.NAH.ey) Literally, "woman-painting," Heian handscroll
 paintings in the Yamato-e style
Oranmiyan (oh.rahn.MEE.yahn) Ife prince who founded Benin
ore inu In Yoruba cosmology, one's inner head
orisha (oh.REE.sha) Yoruba gods and spirit-beings

Pacal II A king of Palenque (603–83)
Pachacuti First Inca king
pagoda A tower-like version of the Buddhist stupa
Paleoindian period Pan-American cultural period, 32,000/12,000–8000 BCE
palma Part of the protective equipment worn by Mesoamerican ballplayers
Paracas (pah.RAH.kahs) Andean culture, 1400/900–1 BCE
Parvati (PAHR.vah.tee) Wife of Hindu god Shiva; goddess of mountains
petroglyph A rock art process, engraved or scratched
pharaoh Title of the god-kings of Ancient Egypt
pictograph A rock art process, painted
piece-mold casting Bronze casting with sectional molds
pithouse Semisubterranean dwelling
polychrome Many colors
polymorph A being composed of different animal elements
pony beads Large glass beads
Popol Vuh (poh.pohl.VOO) Maya epic text
porcelain Glazed fine-clay ceramics
poro A West African men's society
post-and-lintel Architectural form with a horizontal crosspiece and vertical
 supports
Postclassic Final era in ancient Mesoamerican history, 1100–1521
Postcontact In North America, indigenous cultures after European arrival
potlatch Northwest Coast communal feast

Preclassic Early era in ancient Mesoamerican history, 1500 BCE–250
Precontact Native North American cultures before European arrival
pueblo Multistory masonry town in the Southwest
Pueblo people Postcontact era descendants of the Anasazi
Pueblo Revolt Native North American uprising in the Southwest, 1680–93
Pyramid of the Sun Name of the two largest platform mounds in the
 Americas, at Teotihuacan and Cerro Blanco

qibla In a mosque, the wall closest to Mecca
Qin dynasty (chin) Era in Chinese history, 221–206 BCE
Qing dynasty (ching) Era in Chinese history, 1644–1912
Qin Shih Huang Di (chin.shr.huahng.dee) First emperor of China (259–
 10 BCE)
Quechua (KE.choo.ah) Language of the Inca
queen-mother Mother of the reigning king, in Africa
Quetzalcoatl (ket.zahl.koh.AHTL) Aztec name for the feathered-serpent god
quillwork Fiber arts process using porcupine quills
quipu (KEE.poo) Inca writing system, using knotted cord
Qur'an (also *Koran*) Islamic holy scripture

Radha (RAH.dhah) Beloved consort of Krishna
radial composition Visual elements disposed from a center point in the
 design
Rainbow Guardian A protecting deity, as a border in Navajo painting
Rainbow Serpent Aboriginal Australian creator spirit
Rajput (RAHJ.poot) A Hindu prince, also an Indian painting style
Ramayana (rah.MAH.yah.nah) Sacred Hindu epic of Rama, the fifth avatar of
 Vishnu
rarrk Aboriginal Australian patterns
rath A Hindu temple form, meaning "chariot"
realism A style that attempts to replicate as closely as possible the physical
 appearance of the model; generally predisposed to surface details
reliquary Container for sacred objects (**relics**)
rock art Images on in situ stone surfaces
roofcomb Vertical stone architectural member on top of a Maya building

sacbe (SAHK.bey) Maya paved road
Sacred Fire Native North American sun symbol
samsara Rebirth, reincarnation
samurai Japanese warrior; a knight
sandogo Senufo women's society
sandpainting, also **drypainting** Painting process using no binder
sankin kotai Policy of "alternate residences" during Tokugawa period
Sanskrit Ancient sacred written language of India
Sapa Inca Title of an Inca king

seed beads European manufactured glass beads
Self Teacher Navajo culture-hero
Sen Rikyu (sen.REE.kyoo) Japanese tea master (1522–91)
Senufo An African people in Ivory Coast
serdab "Statue room" in an Egyptian tomb
Shah Jahan Mughal emperor of India (reigned 1627–58)
Shaivite (SHAY.vayt) A devotee of Shiva; also as an adjective
Shakyamuni (shahk.yah.MOO.nee) An honorific title of the historical
 Buddha
shaman Person with powers to interact with the spirit world
Shang dynasty (shahng) Era in Chinese history, 1766–1045 BCE
shikhara (shee.KAHR.hah) Northern style Hindu temple
Shino ware (SHEE.noh) A ceramic form associated with the tea ceremony
Shinto (SHIN.toh) Indigenous religion of Japan
Shiva (SHEE.vah) Hindu god, the "Destroyer"
shogun Japanese military dictator
Shotoku Prince who promoted Buddhism in Japan (574–622)
Shri Lakshmi (shree.LAHK.shmee) Hindu goddess of wealth; Vishnu's wife
Siddhartha A name of the historical Buddha
singer Navajo shaman
sipapu (SEE.pah.poo) Emergence hole in a kiva
Society of Faces Iroquois fraternity of healers
soffit Underside of an arch
Song dynasty Era in Chinese history, divided into Northern, 960–1127, and
 Southern, 1127–79
Southeast Asia Mainland Indochina and Indonesian Islands
Southeastern Ceremonial Complex (SCC), also **Southern Cult** Group of
 Mississippian period objects with shared symbols
spirit spouse Among the Baule, one's spouse before birth
split representation Flattened shapes with two identical sides
Staff God Descriptive name of an Andean deity
stela (STEE.lah; pl. **stelae**, STEE.lee) Vertical stone monument
stirrup-spout vessel An Andean ceramic shape
Stormy Sky A king of Tikal (426–56)
stupa (STOO.pah) Indian reliquary mound
style Manners of presentation in the visual arts. See *abstraction, expressionistic,*
 idealism, naturalism, nonrepresentational, realism, stylized
stylized A form of presentation based on pre-established methods of
 abstraction; frequently used interchangeably with "abstract"
sub-Saharan African cultures south of the Sahara Desert
sudra Laboring caste
Sulka An indigenous people of Papua, New Guinea
superimposition Images overlaid on one another
Surya (SOOR.yah) Hindu sun god
sutra (SOO.trah) A sacred text

symmetry Composition with an equal distribution of elements on both sides of a central axis

Taharqa (tah.HAHR.kah) Kushite king (died 664 BCE)
The Tale of Genji (GEN.gee) Japanese novel, ca. 1000
Tales of Ise (EE.sey) Collection of Japanese poetry, ca. 950
Talking God Leader of the Navajo Holy People
talud-tablero Architectural profile of alternating vertical and sloping panels
Tang dynasty (tahng) Era in Chinese history, 618–906
tanka Meditative, magical painting
Tenochtitlán (ten.ohch.teet.LAHN) Aztec capital city
Teotihuacan (tey.oh.tee.hwah.kahn) Ancient Mesoamerican city in Mexico
terra cotta Coarse clay
Theravada, also **Hinayana** Early form of Buddhism that recognizes only the historical Buddha
Three Friends Bamboo, pine, and plum blossom
Three Jewels of Buddhism, also **triratna** The Buddha, the Law, and the monastic community
Three Perfections Poetry, calligraphy, and painting
thunder pattern Decorative motif of square spirals
tihu Hopi kachina figurine
Tikal (tee.KAHL) Ancient Maya city in Guatemala
tipi Portable residence of Plains peoples
Tiwanaku (tee.wah.NAH.koo) Ancient Andean city near **Lake Titicaca,** Bolivia
Tiy (tay) Queen-mother during Amarna period
Tlaloc (TLAH.lohk) Mesoamerican rain god
Toba Wei (toh.bah.wey) A Turkish people in China
tokonoma (toh.koh.NOH.mah) Alcove in a teahouse
Tokugawa Ieyasu (ey.YAH.soo) Founder of the Tokugawa period (1542–1616)
Tokugawa period (toh.koo.GAH.wah), also **Edo** (EY.doh) Era in Japanese history, 1615–1868
tonalpohualli (toh.nahl.poh.HWAH.lee) Aztec 260-day ritual calendar
torana Gateway on a vedika
torii gate Portal marking a Shinto site
toron Exposed scaffolding on a West African building
totem Mythical animal ancestor
triple-flex pose, also **tribhanga** Hip-shot pose in Indian art
tun (toon) Maya solar year
the Two Brothers Hopi culture-heroes
tzolkin (TZOHL.keen) Maya 260-day ritual calendar

uinal (WEE.nahl) Maya month
ukiyo-e (oo.kee.YOH.ey) Pictures of Japanese entertainments, literally, "picture of the floating world"
underglaze painting In ceramics, painting before glaze is applied

Upanishads Sacred Indian texts, 9th century BCE
urna (ER.nah) Mark on forehead, a sign of enlightenment
ushnisha (oosh.NEE.shah) Protuberance on top of the head, a sign of enlightenment

vaishya (VAYSH.yah) Merchant-artisan caste
Vajrayana (vahg.rah.YAH.nah) A form of Tibetan Buddhism
Vedas Earliest sacred Indian texts
Vedic period (VEY.dik) Era in Indian history, ca. 1750/1500–500 BCE
vedika (VEY.di.kah) A fence around a sacred site
viga (VEE.hah) Wooden roof beam
vimana Southern style Hindu temple
Viracocha Inca creator god
Vishnu (VISH.noo) A Hindu god, the "Preserver"
visionary style Paintings inspired by personal contact with spirits
vision quest Personal search for spirit-beings

Wari Ancient Andean city; also the **Wari-Tiwanaku** culture complex, 700–1000
waterfall drapery Descriptive term for fabric treatment during certain phases of Chinese art
wave-scroll A water motif in Andean art
wen ren Literati, or amateur painting
were-jaguar baby Descriptive term for an Olmec supernatural
Western, the West General term for cultures deriving from Greek culture
woodblock print Printing process using a matrix of wood
Woodland period Era in Native North American history, 1000 BCE–700/1000
Woodlands, Eastern Region east of the Mississippi River
Woot Mythical founder of Kuba kingship
World Tree, or **World Mountain,** also **axis mundi** Axis uniting zones of existence
worldview, also **cosmology** Communal attitudes about existence, its meaning and structure
wu wei Principle of "non-trying" as a creative technique

Xibalba (shee.bahl.BAH) Maya Underworld
Xiuhcoatl (sheeu.coh.aht) Aztec Fire Serpent

yakshi (YAHK.shee) Indian female nature spirit
Yamato (yah.MAH.toh) Japanese imperial family
Yamato-e (yah.mah.TOH.ey) Japanese-style painting
yang The active force of nature
Yang Guifei (yahng.gwey.fey) Consort of Tang emperor, Ming Huang
Yangshao (yahng.shaow) Chinese neolithic culture, ca. 5000–2000 BCE
ye'ii (YEYee) Navajo spirit-beings, the Holy People
yin The passive force of nature

Yingarna An Aboriginal Australian Rainbow Serpent
yoke Padded belt worn by Mesoamerican ballplayers
Yoruba (YOHR.oo.bah) An African people in Nigeria
Yoshiwara (yoh.shee.WAH.rah) Entertainment district of Edo
you (yoo) A Chinese vessel shape
Yuan dynasty (yoo.ahn) Era in Chinese history, 1279–1368

Zac Bac Mythical First Mother at Palenque; also "Lady Beastie"
Zen Form of Buddhism in Japan; called **Chan** in China
Zhang Yan Yuan Ninth-century Chinese art historian
Zhou dynasty (joh) Era in Chinese history, 1045–256 BCE; Late Zhou (770–256)
 also called the **Warring States period**
zoomorphic Animal-shaped

Index